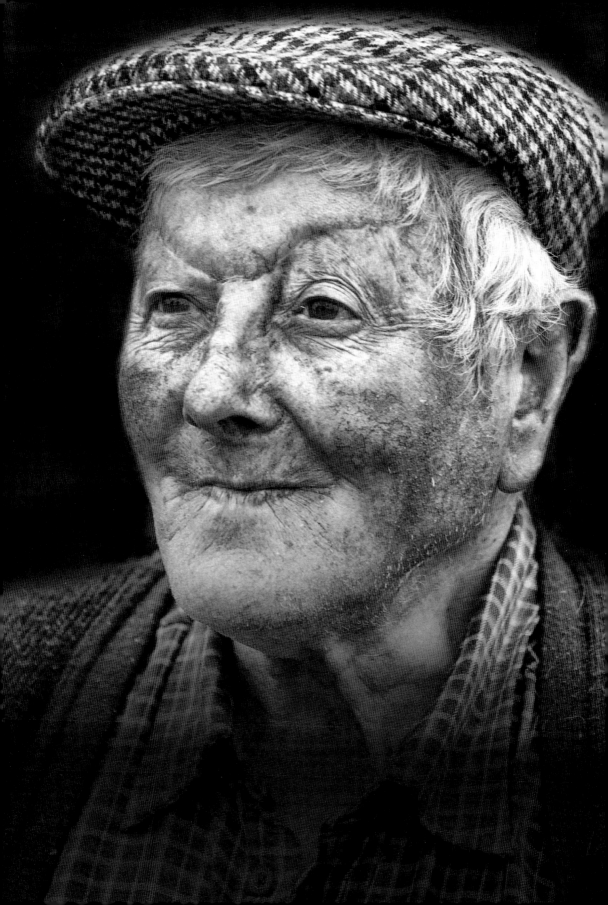

FAIR FACES

IMAGES FROM A DISAPPEARING IRELAND

JOHN HALL

MERCIER PRESS

IRISH PUBLISHER – IRISH STORY

MERCIER PRESS

Cork

www.mercierpress.ie

© John Hall, 2017

ISBN: 978 1 78117 515 6

10 9 8 7 6 5 4 3 2 1

A CIP record for this title is available from the British Library

Printed and bound in the EU.

Contents

Foreword

The circumstances that led to the shooting of these images happened completely by accident. I was a dedicated landscape and seascape photographer for over twenty years, content to travel the length and breadth of Ireland's west coast in search of light and photographs. Then a chance visit to a local steam rally in Innishannon a few years ago resulted in a few monochrome portraits of the participants with which I was happy. This was quickly followed by a spur-of-the-moment decision to visit the famous Puck Fair in Killorglin, Co. Kerry, which added a few more portraits to the collection and, subsequently, this project was born.

I began to avidly scan the local press and social media for notices of festivals, fêtes and fairs so that I could further add to the portfolio of faces I was building. I realised that, in many cases, I was photographing not just people but a way of life that could well be gone within my lifetime. Many of the subjects were proud, simple people, in tune with the land and the vagaries of the weather and its effect on their animals as they carried on the old traditions of their fathers and their grandfathers before them.

This project is a first attempt at a 'social documentary' on my part, the objective being to create a record of the ordinary people of Ireland in their natural environment. I wanted to carry on the great tradition of street photography that has been an important means of recording each generation over the last hundred years and more, to modestly attempt to emulate the greats in this field of photography – Stieglitz, Atget, Cartier-Bresson and Doisneau.

Due to the candid nature of the images (shot without the knowledge of the subject, resulting in more natural photographs), I have spoken to only a few of the subjects in this book, but I am indebted to each and every one of them. If any of you happen upon your portrait in the book, I hope you are pleased with the final image.

I would like to close with a word of thanks to my long-suffering family for giving me the space and freedom to undertake the countless trips away to gather the necessary material for the book.

Puck Fair

Where else but in Ireland would a wild mountain goat be captured, brought into a town, crowned king for three days and raised on a pedestal to watch over a period of hard drinking, dancing and general debauchery? Welcome to Killorglin and the Puck Fair – where a goat is crowned king and everyone in the town acts the goat!

There are varying accounts relating to the origins of 'King Puck'. The most popular one describes how, during the reign of terror of Oliver Cromwell in the mid-seventeenth century, his soldiers disturbed a herd of wild goats as they pillaged the area around Killorglin. The goats fled before the raiders and the 'Puck' made his way into the town, thus warning the inhabitants of the impending arrival of Cromwell's troops. It is said that in recognition of this the locals decided to hold a special festival in his honour, and thus the festival of Puck was born.

Each year, a group of local men go into the surrounding mountains to catch a wild goat. The goat is brought back to the town and the 'Queen of Puck', who is traditionally a young girl from the town, crowns the goat 'King Puck'.

Whatever its origins, Puck Fair is a time when one's cares are put aside for a few days, old friends meet again, new friendships are forged and music and song take pride of place on the streets and in the hostelries of Killorglin.

The traditional early morning horse fair takes place on the opening day of Puck Fair (10 August) and is a treasure trove for any photographer seeking to capture 'traditional Ireland' at its best. It draws horse dealers, farmers and travelling people from all corners of Ireland. It originally took place on the streets of the town but in recent years has moved to a large field on the outskirts.

This is the main event of the three-day festival for me as a photographer. I always get a real sense that I am recording a proud, centuries-old tradition that may be lost to future generations as the attractions of the modern age swallow up the so-called 'old ways'.

The horse traders are usually so engrossed in doing deals that I can wander around, largely unnoticed, shooting candid images of the events of the day.

For me, it is hugely important to photograph these characters and traditional events before they are no more.

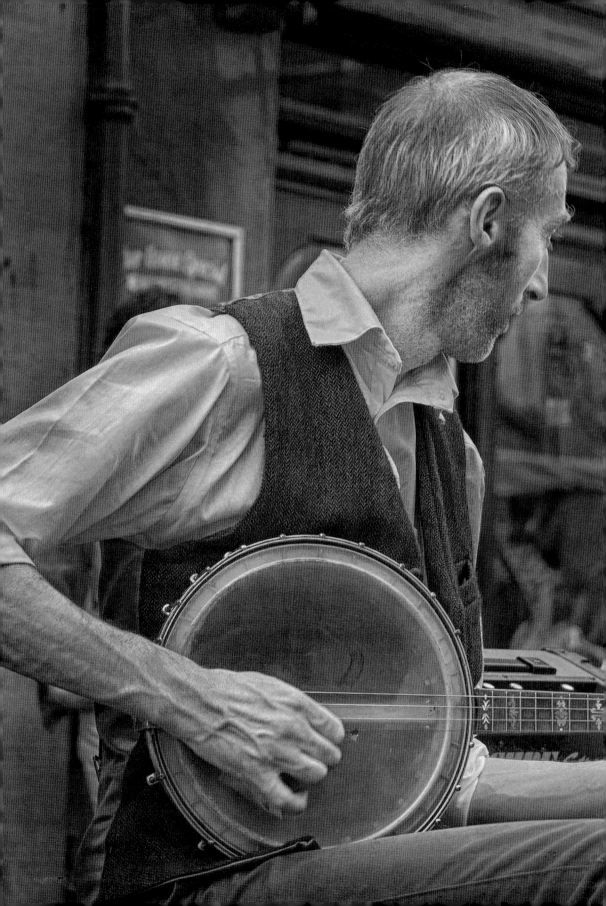

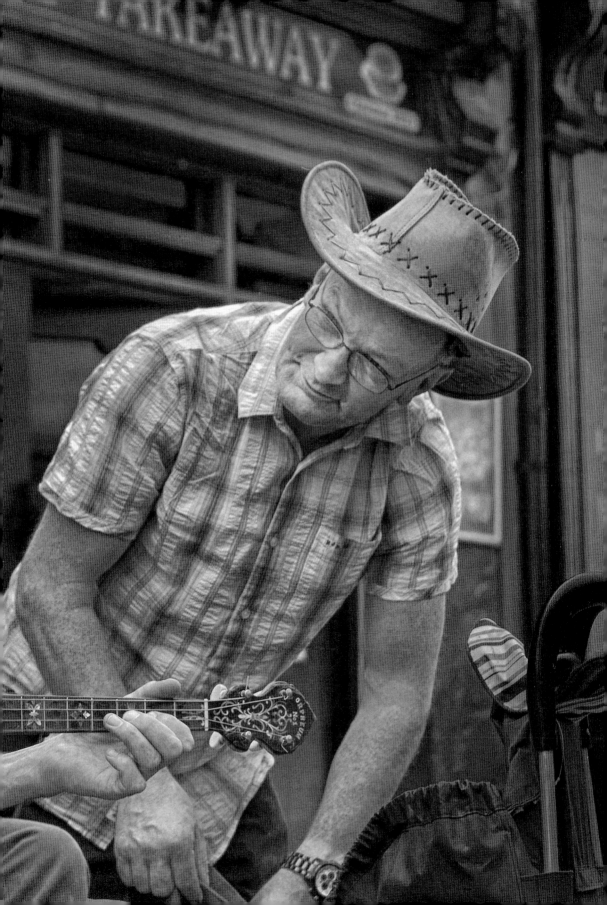

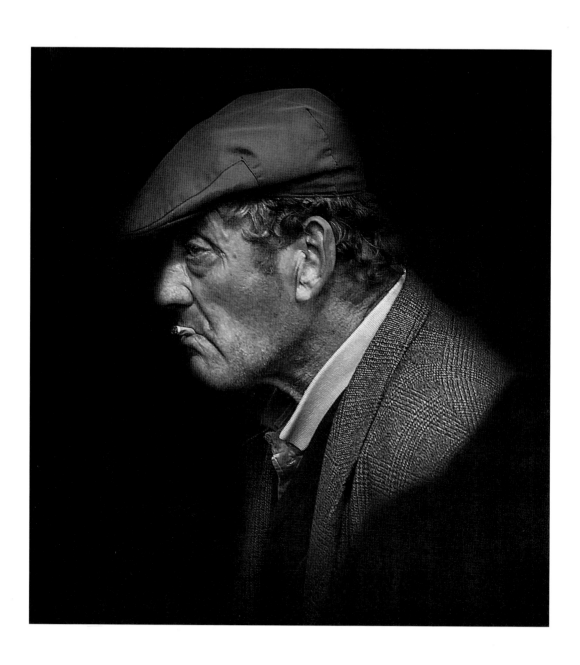

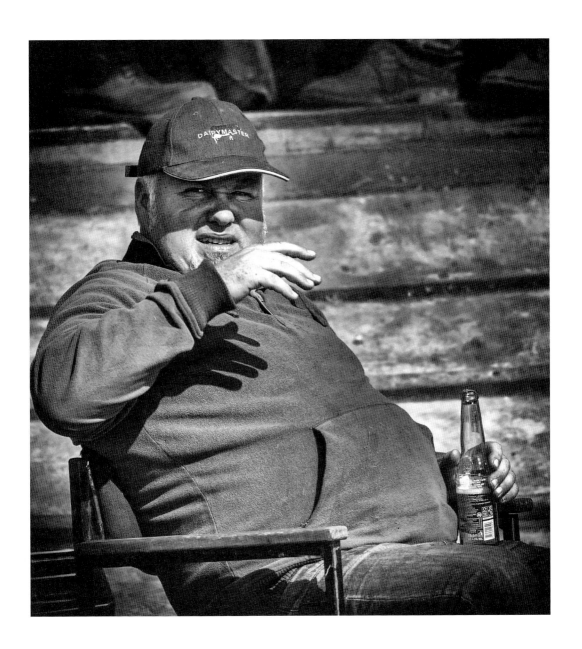

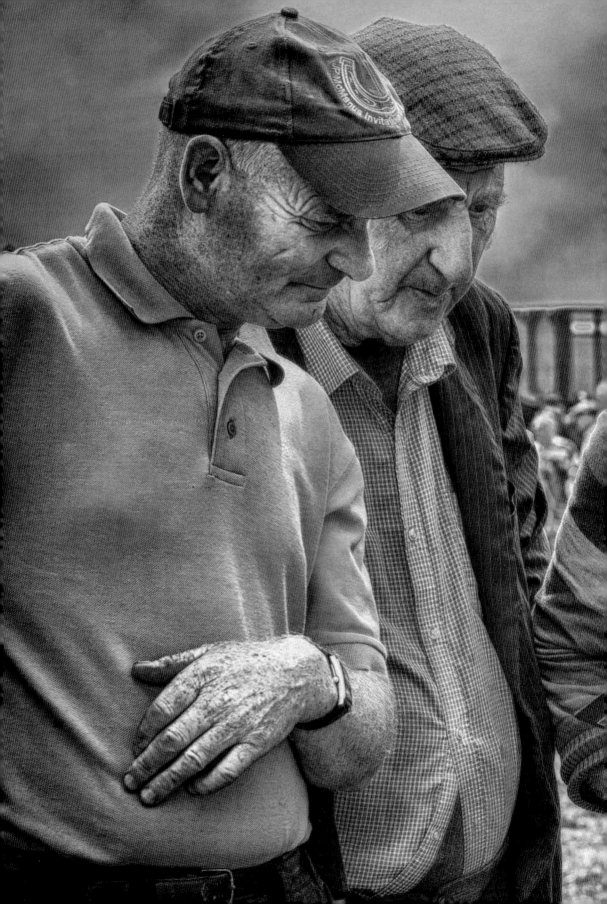

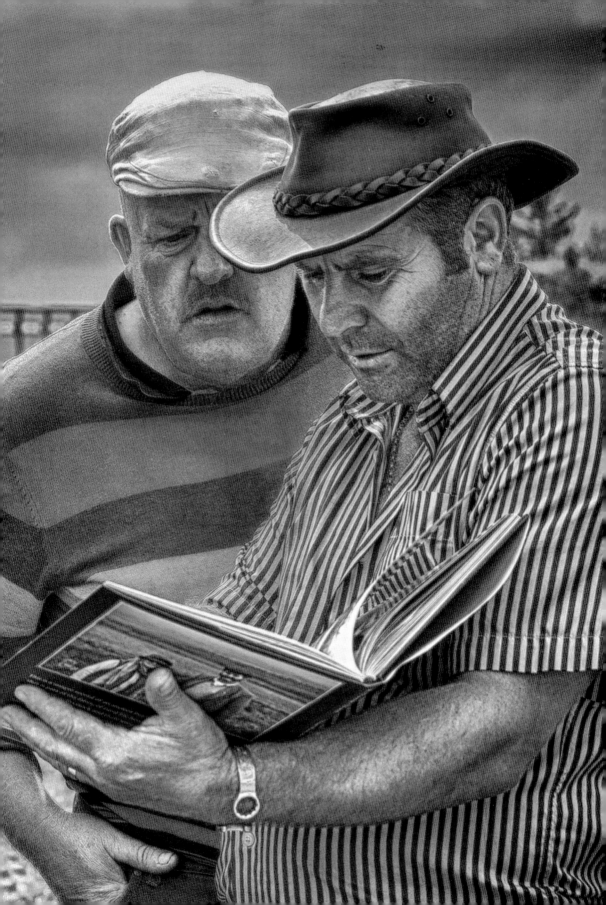

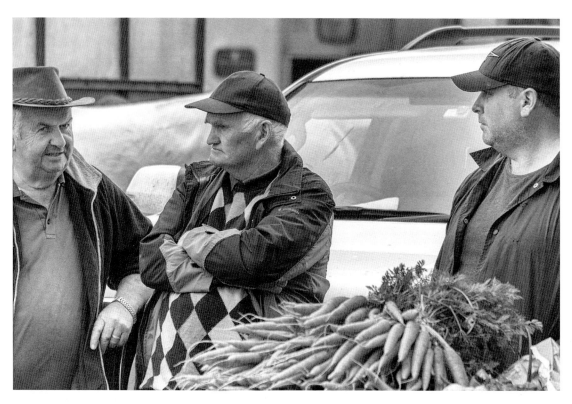

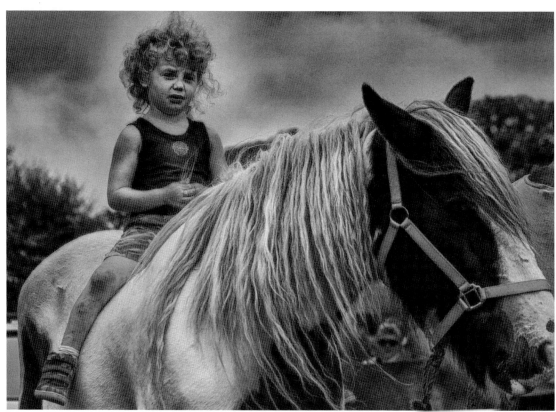

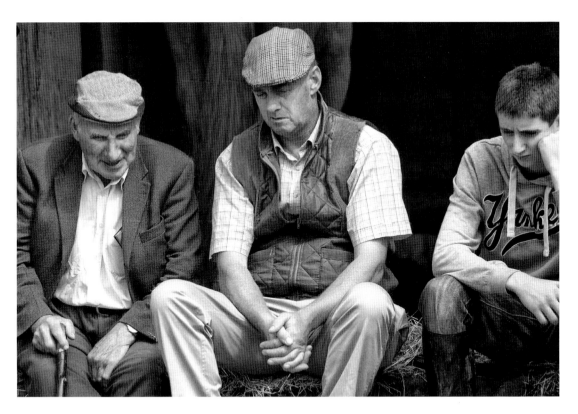

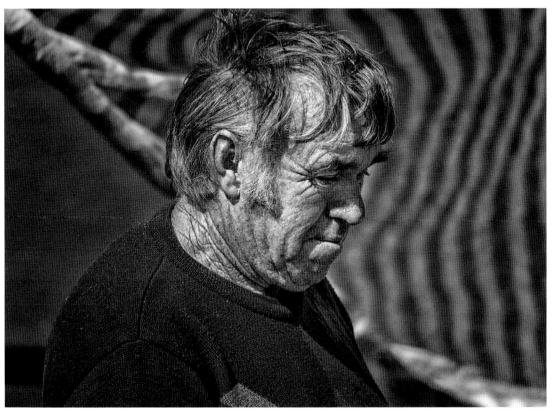

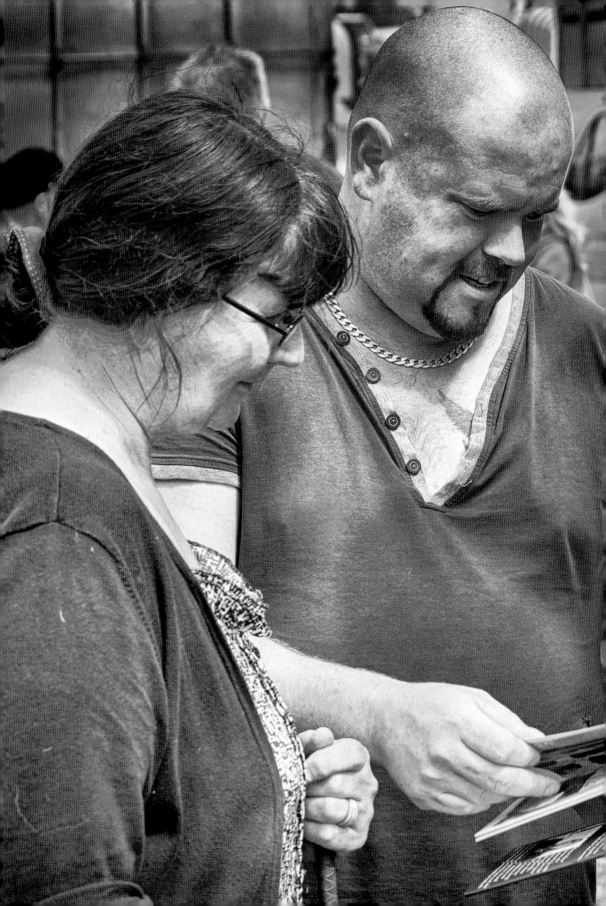

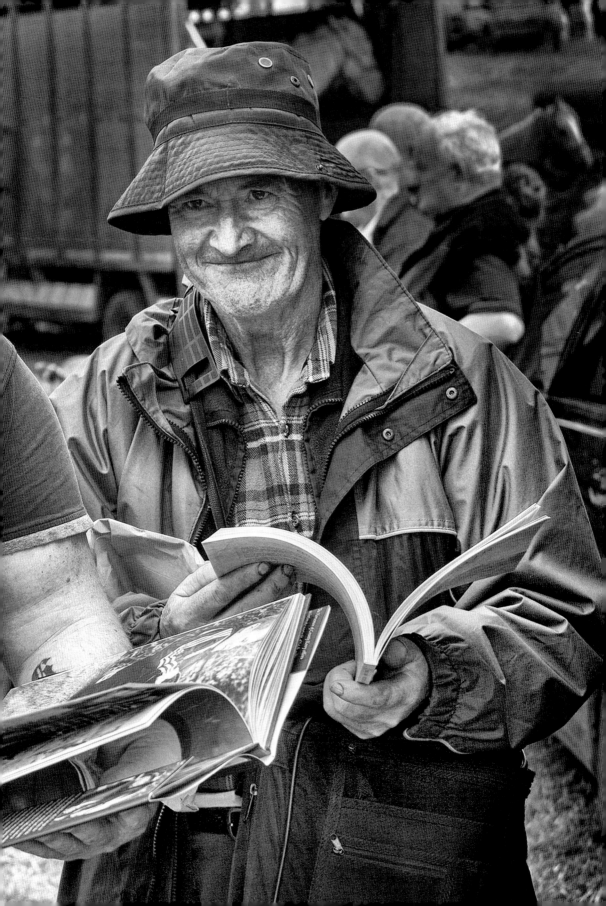

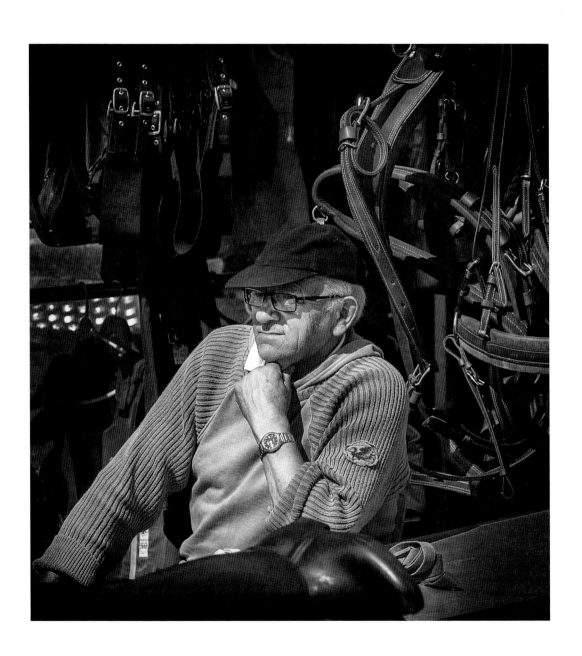

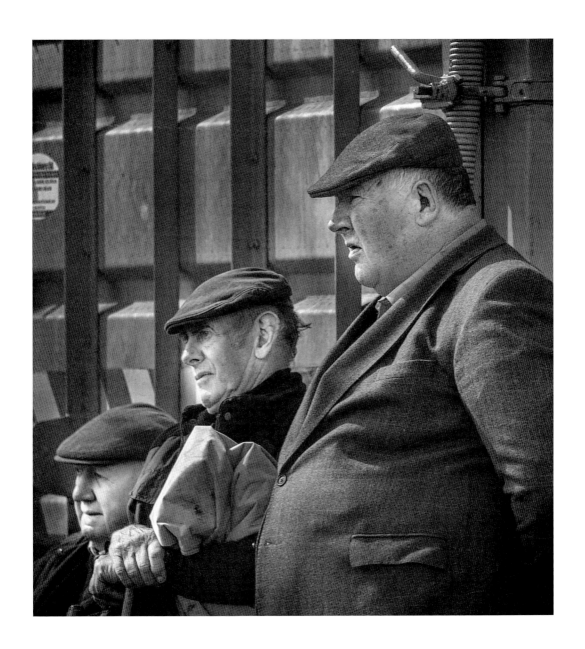

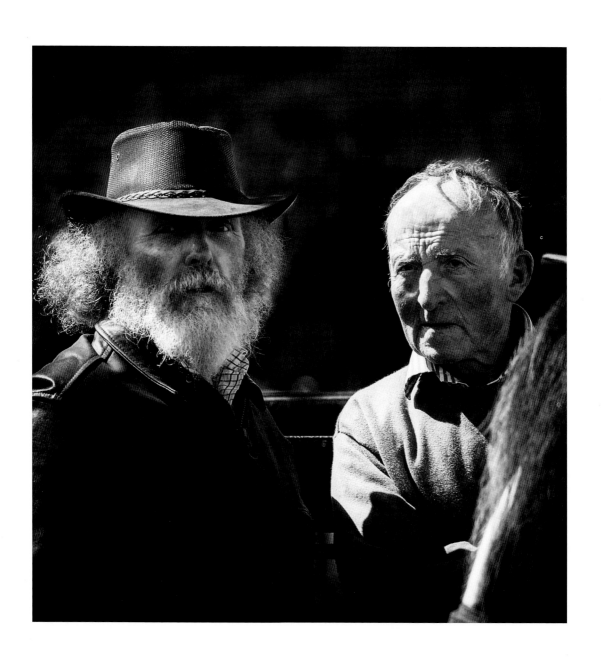

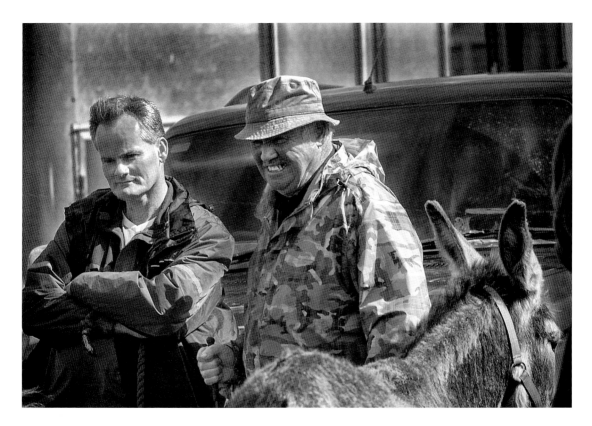

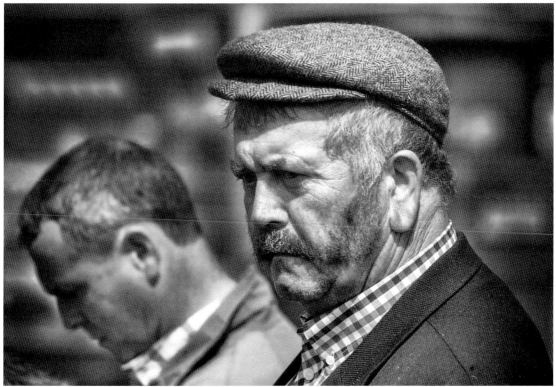

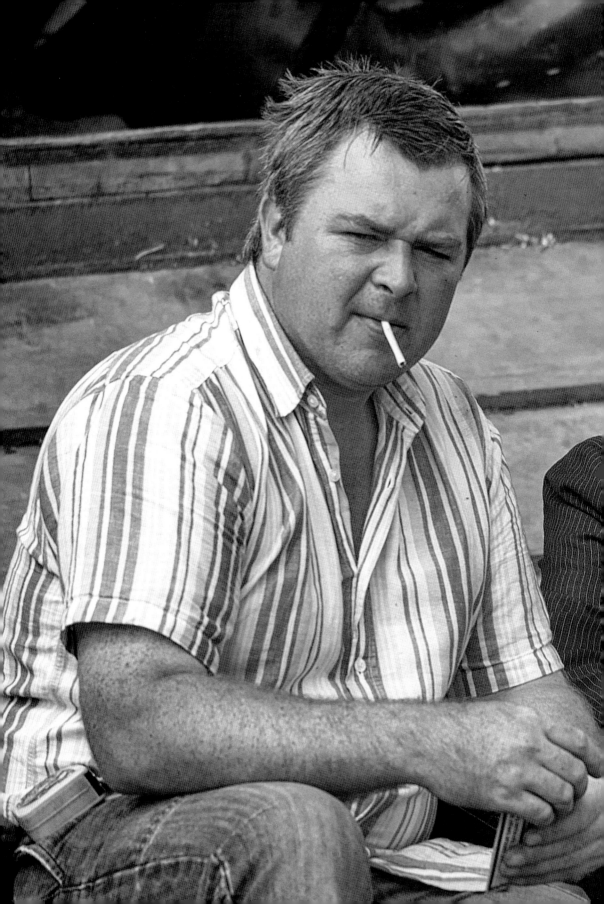

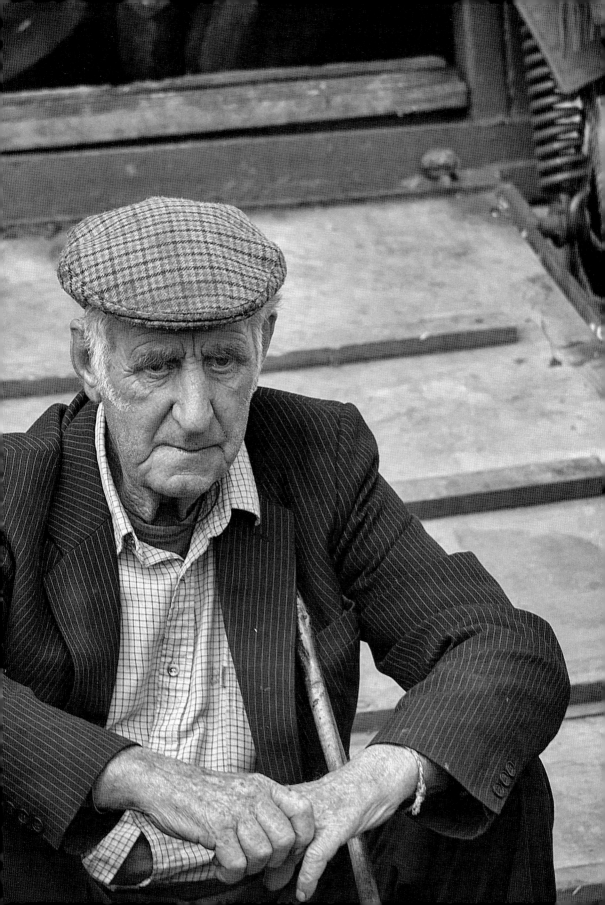

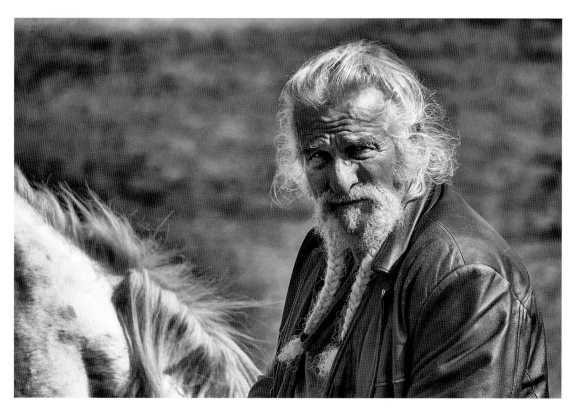

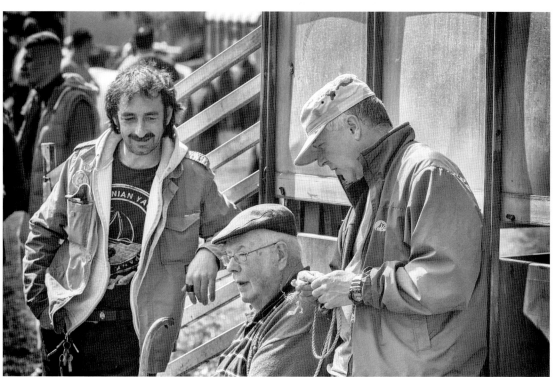

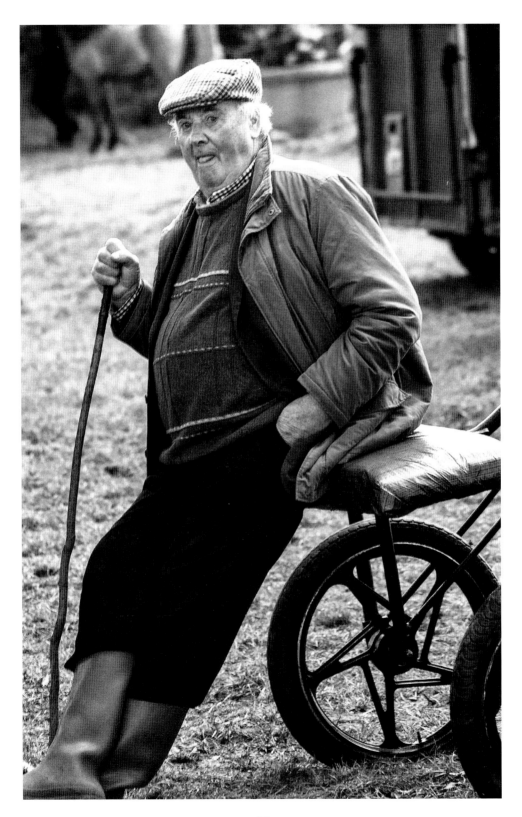

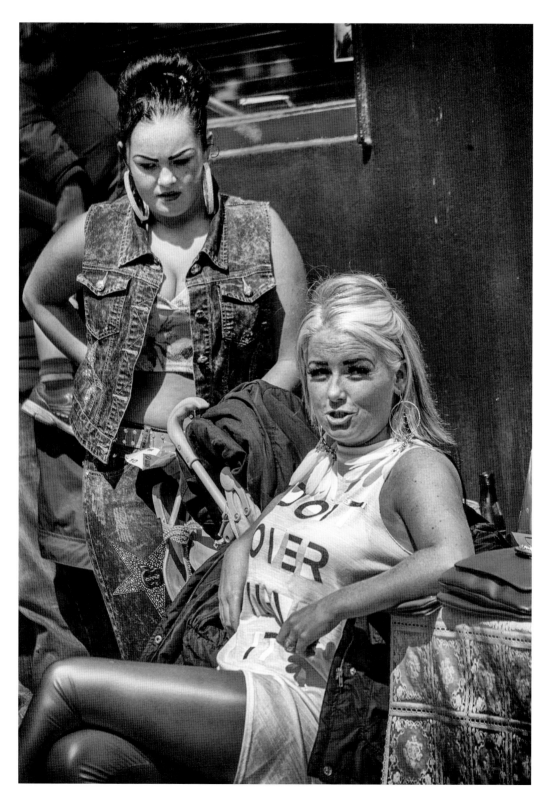

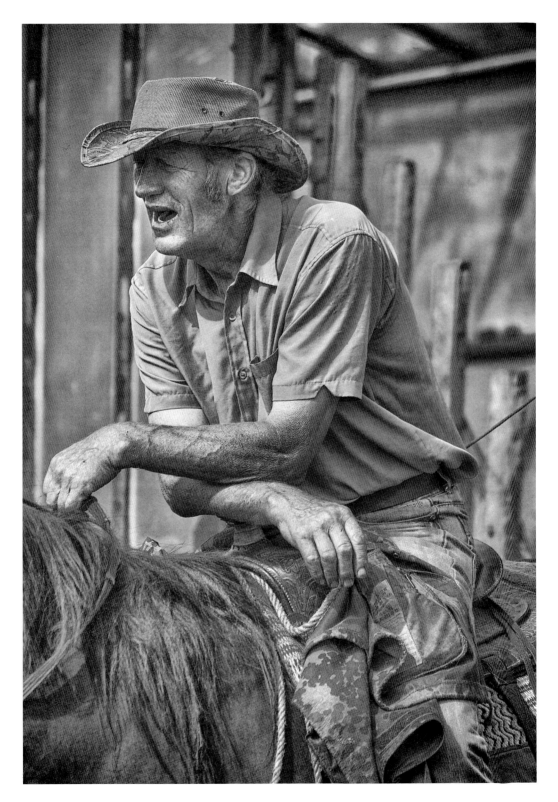

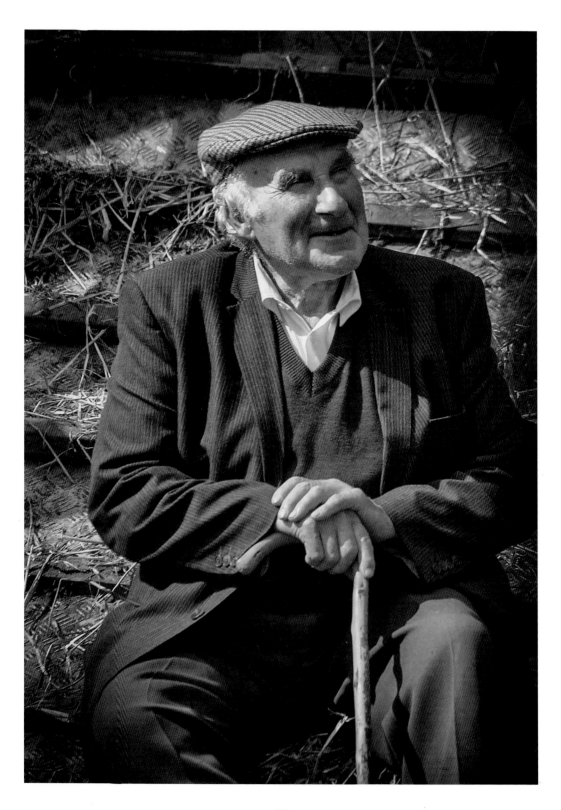

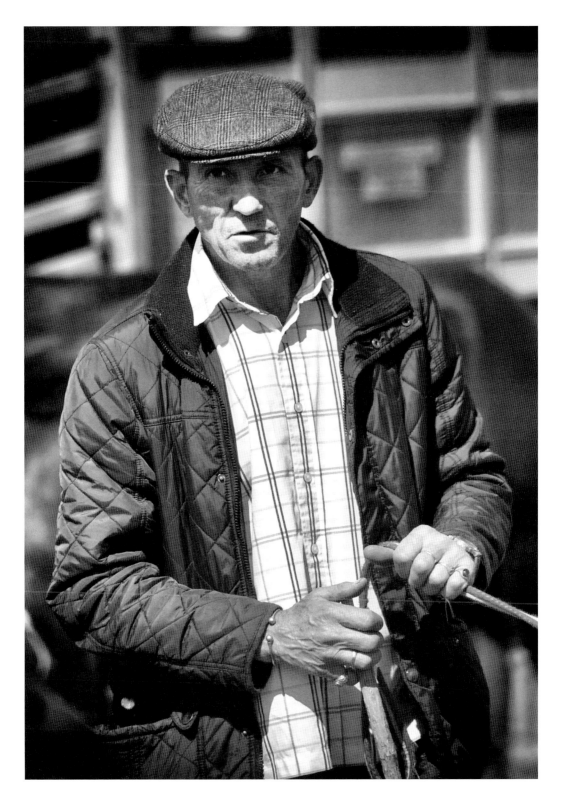

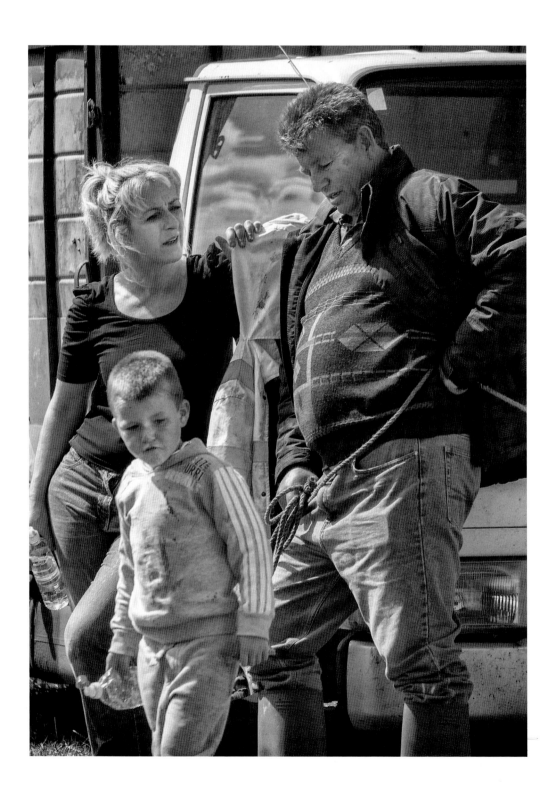

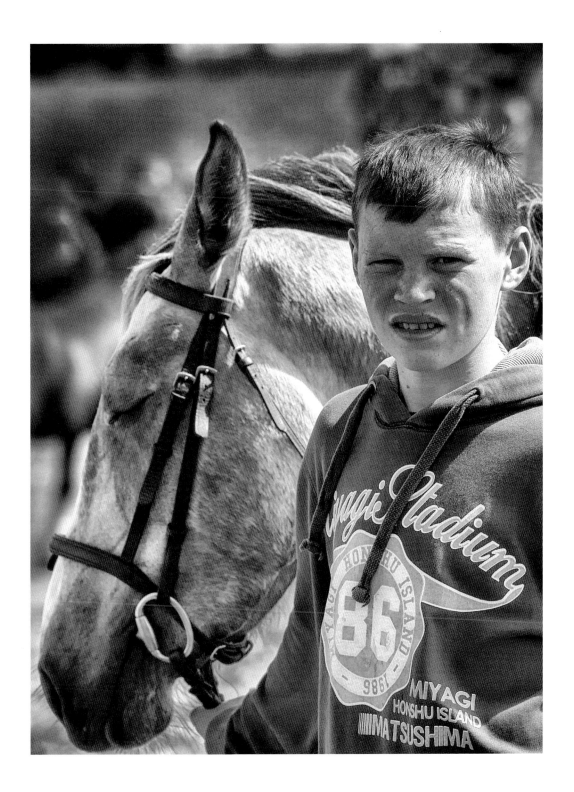

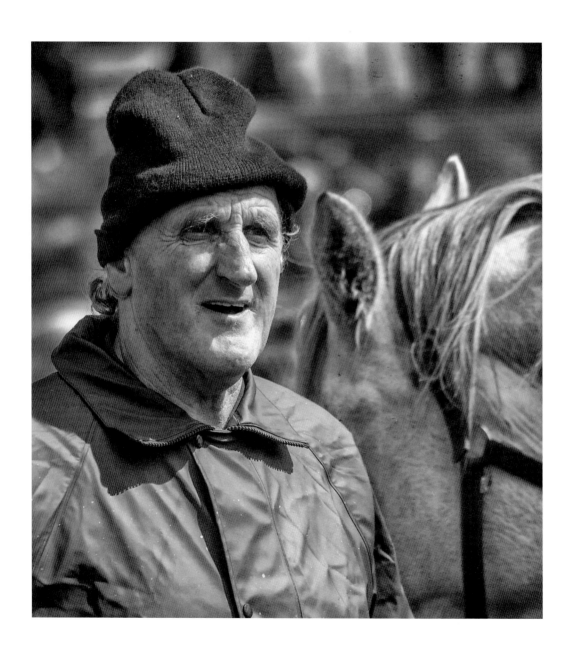

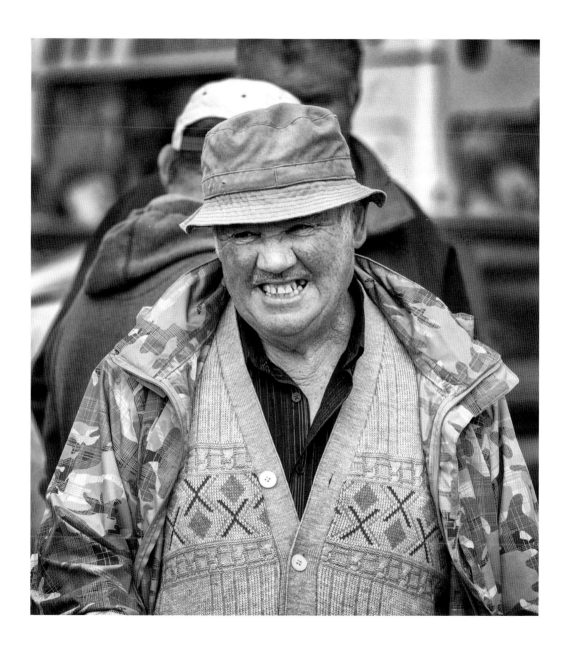

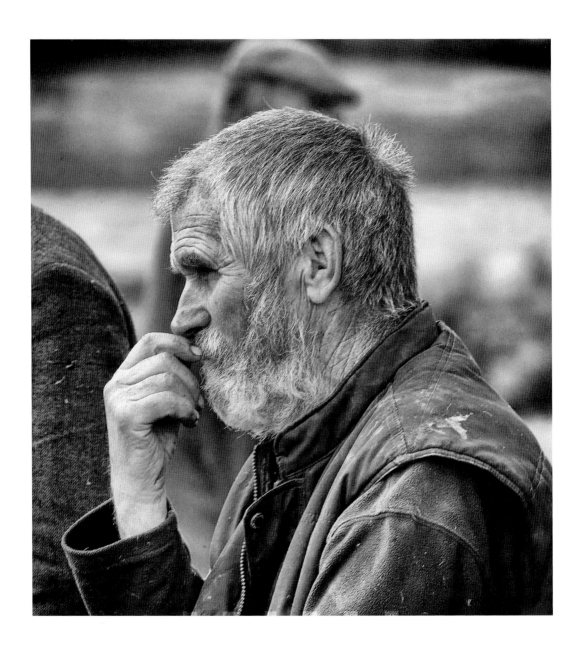

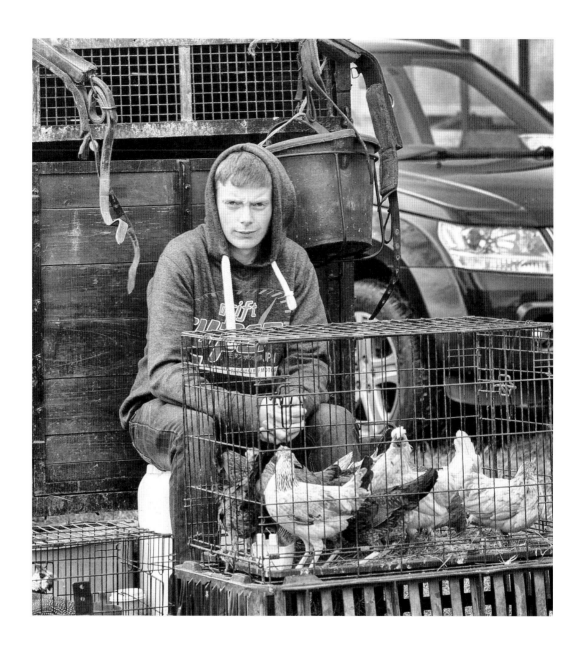

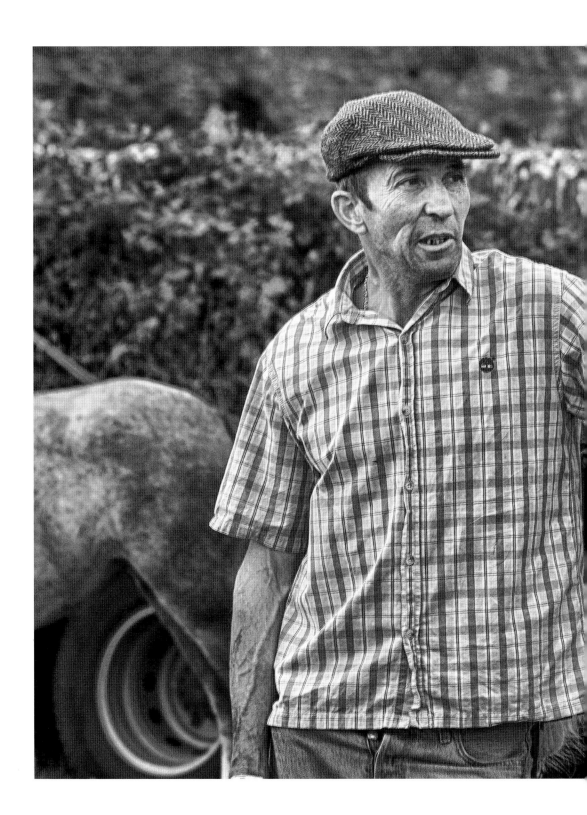

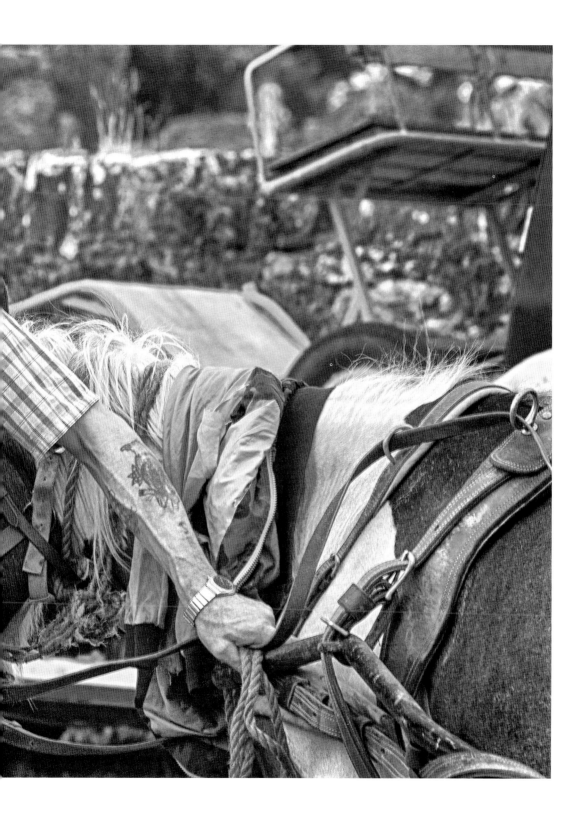

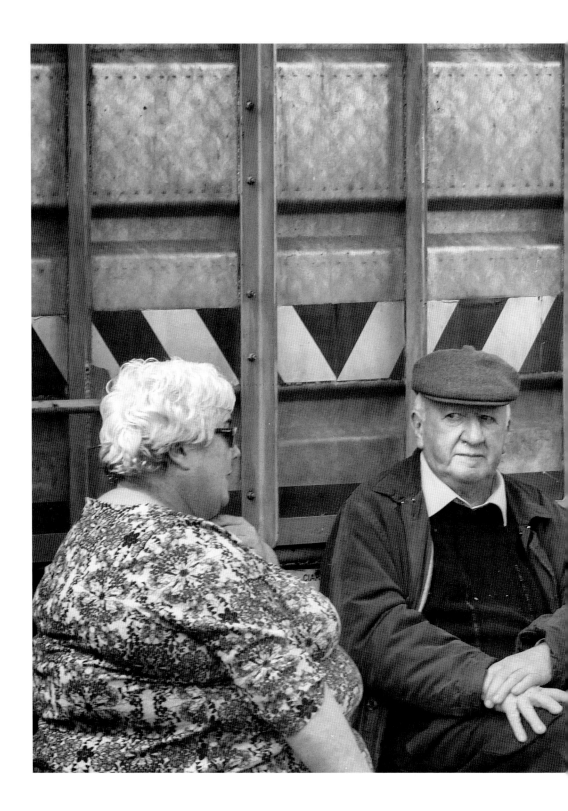

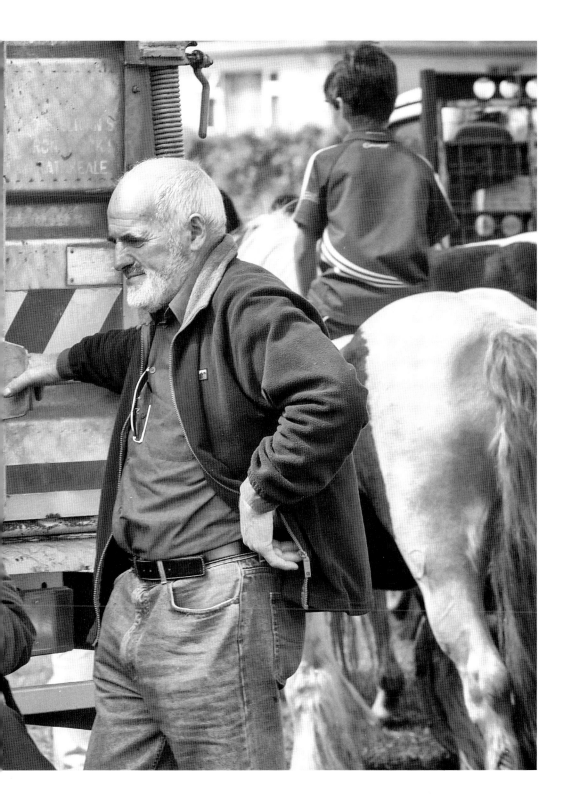

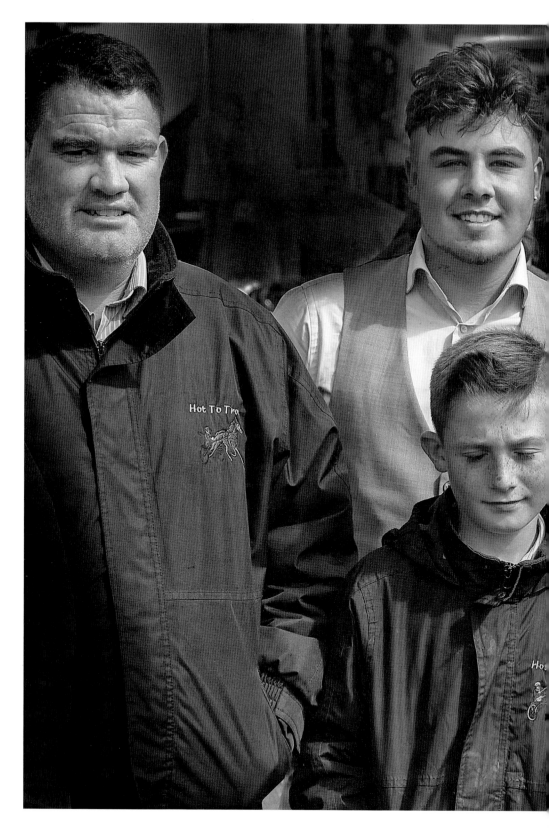

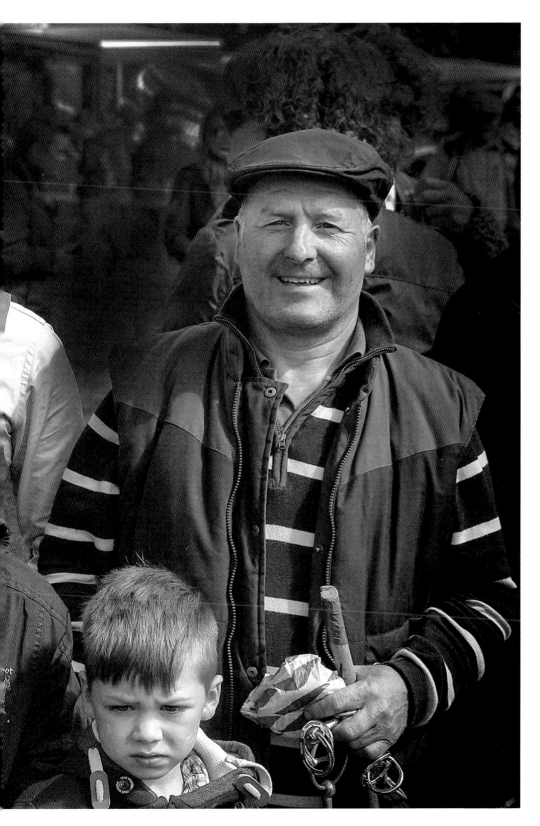

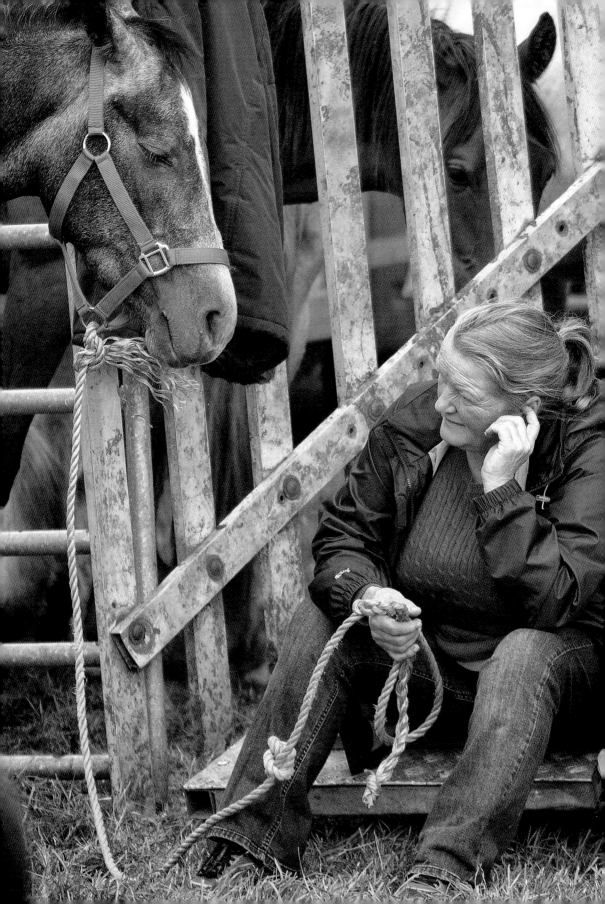

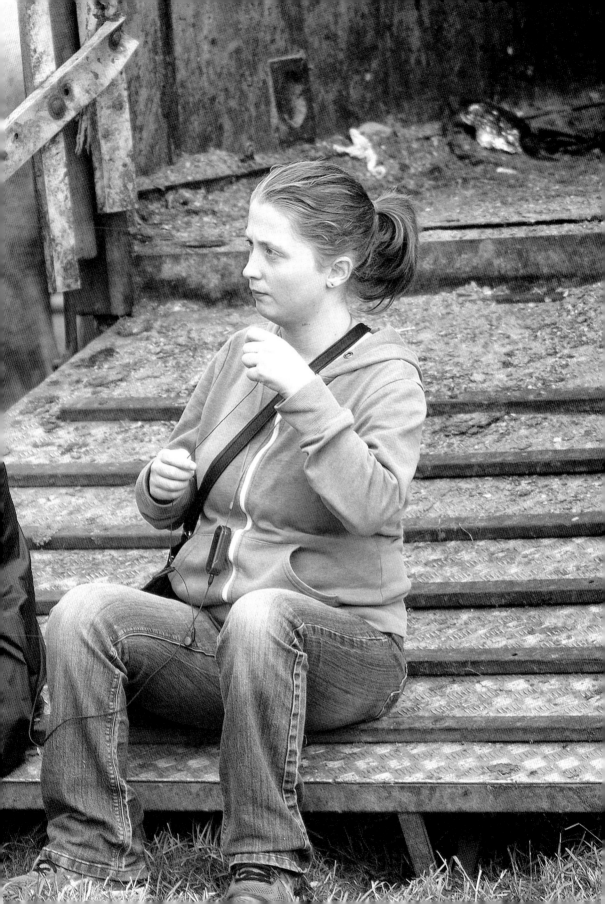

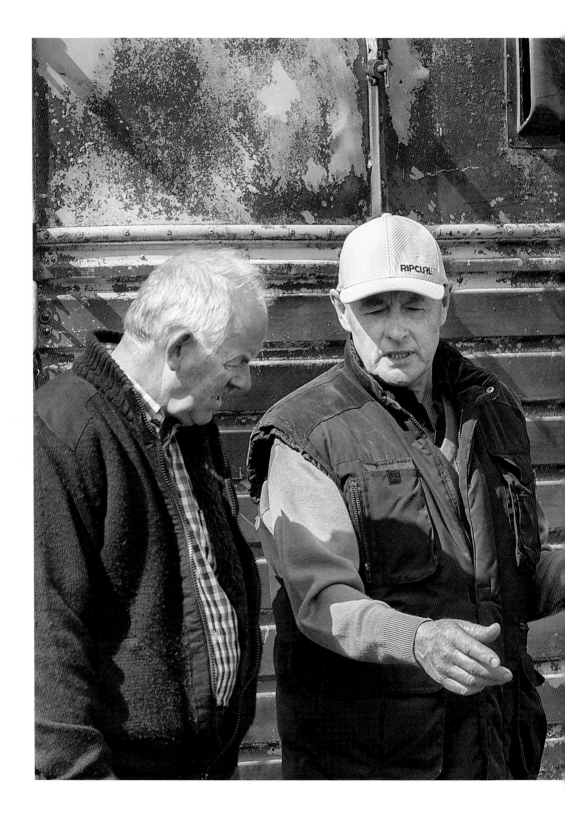

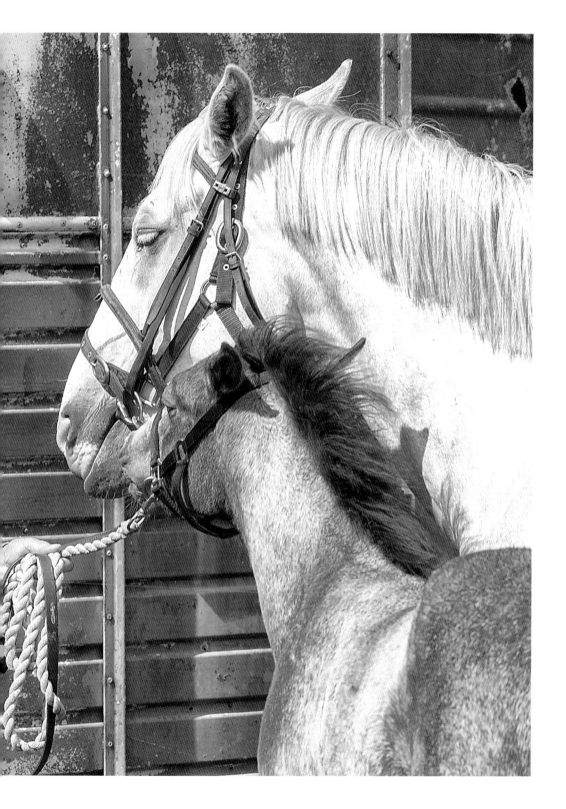

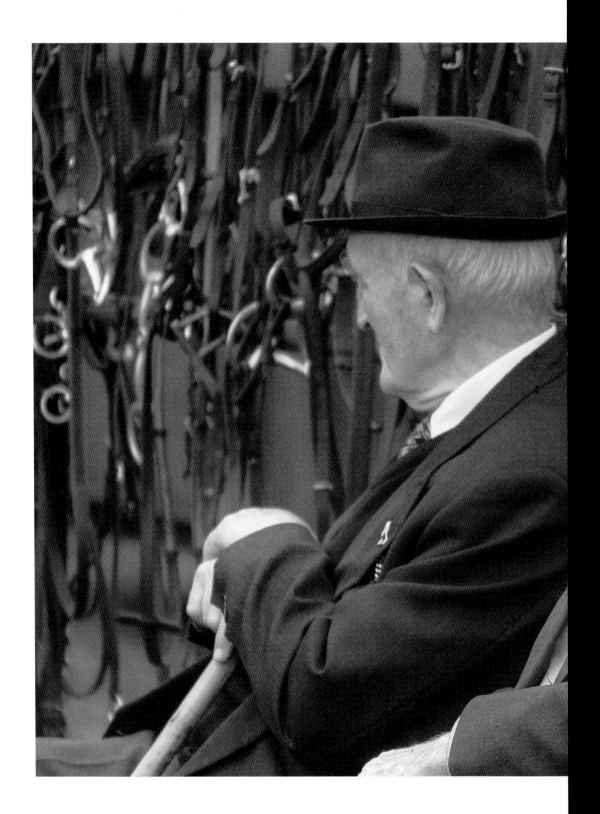

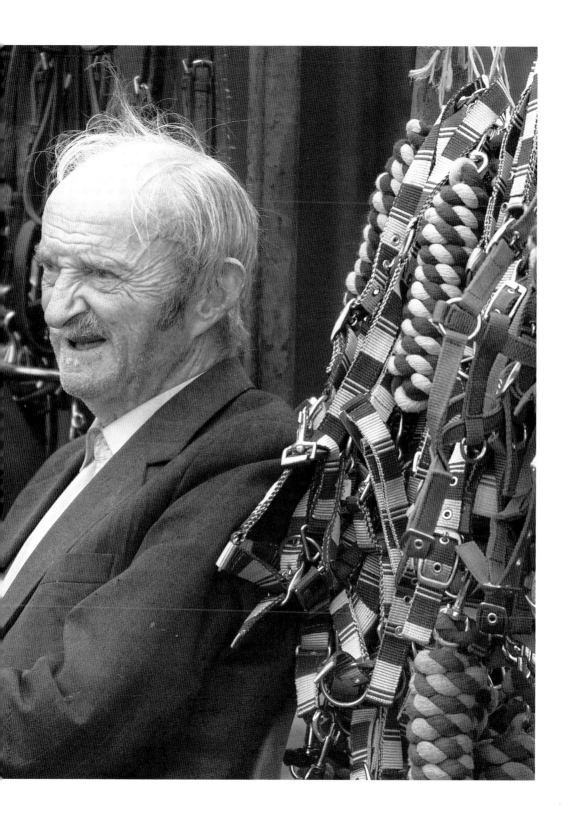

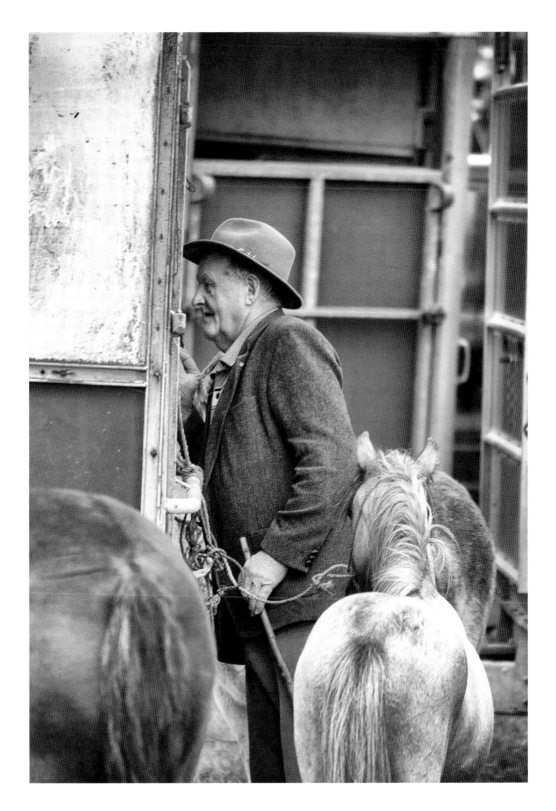

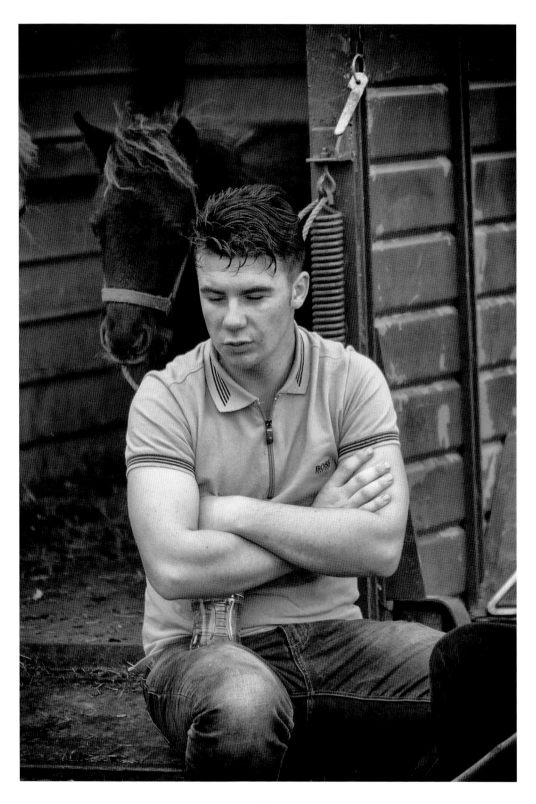

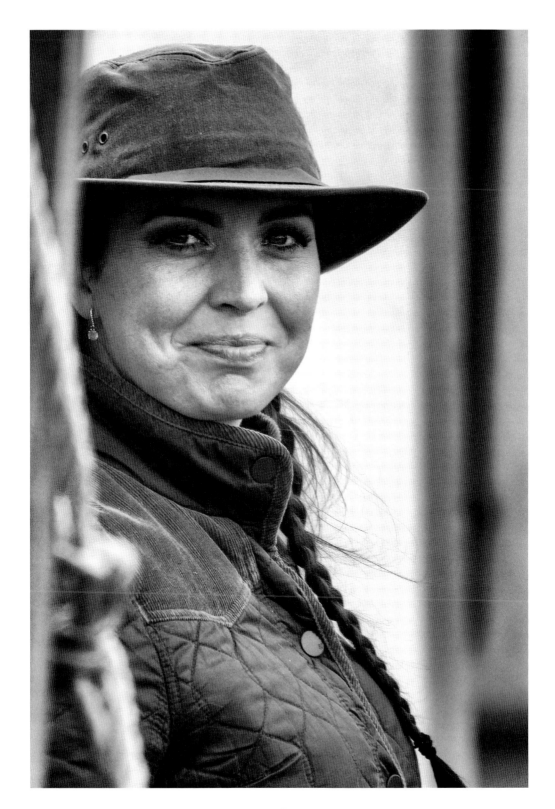

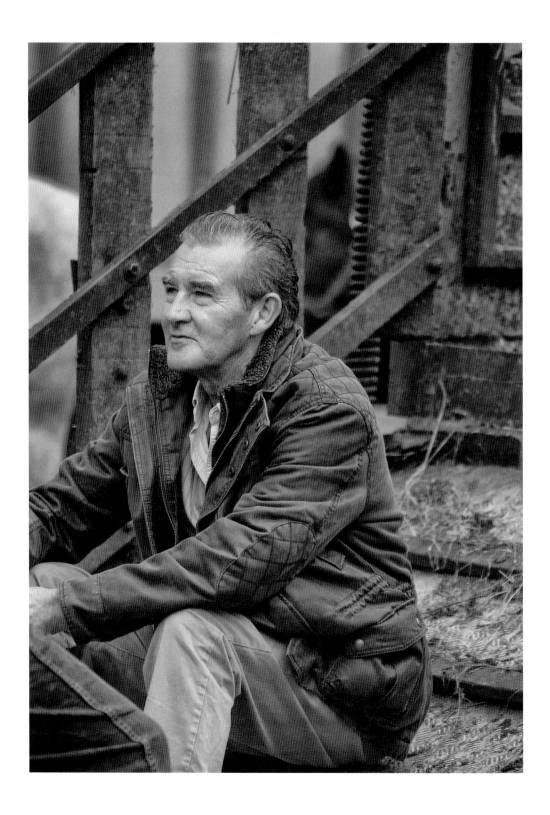

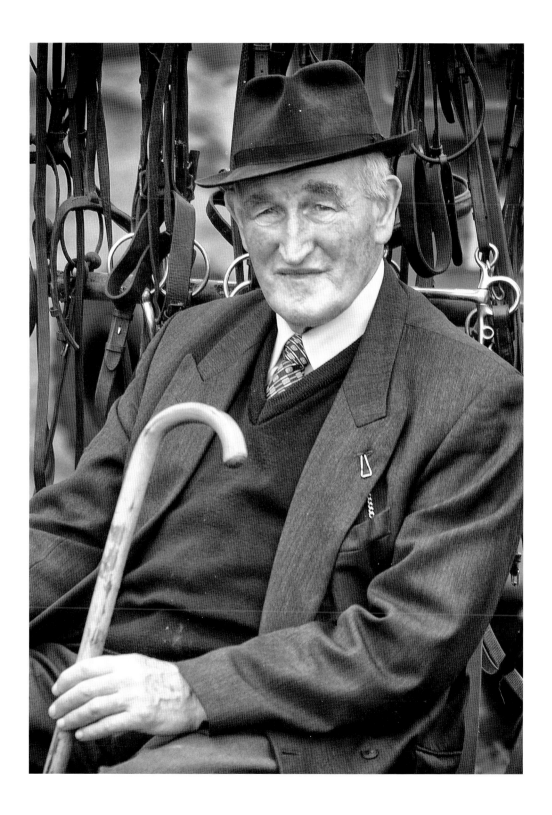

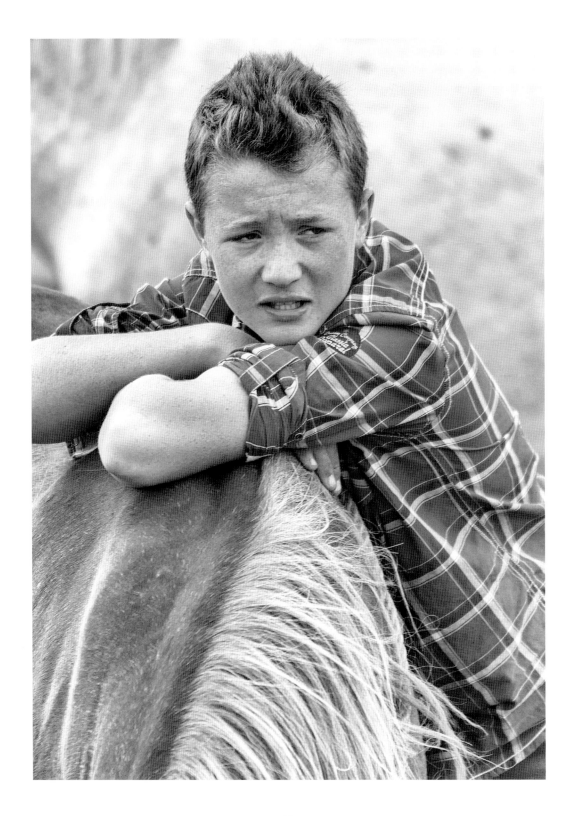

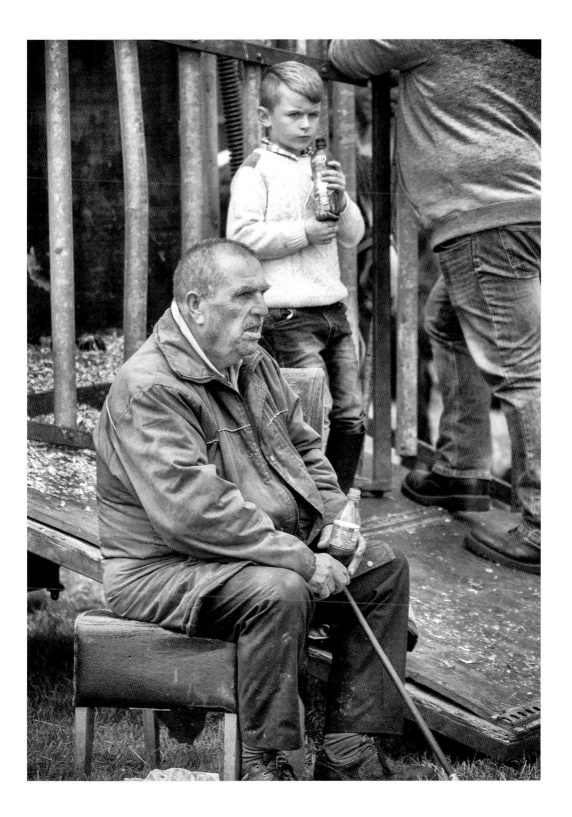

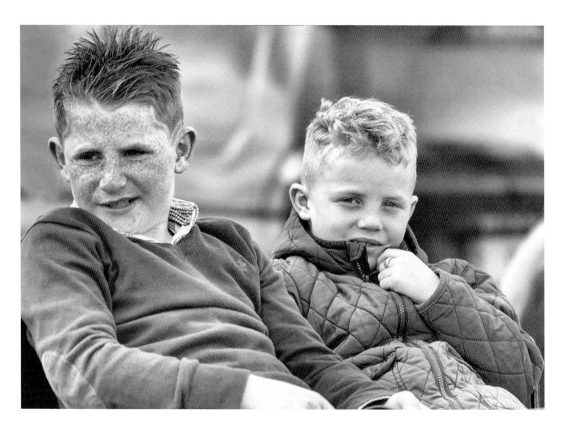

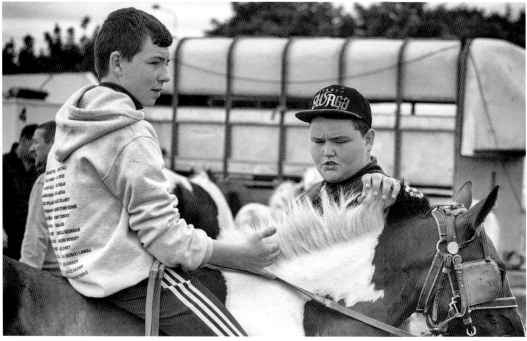

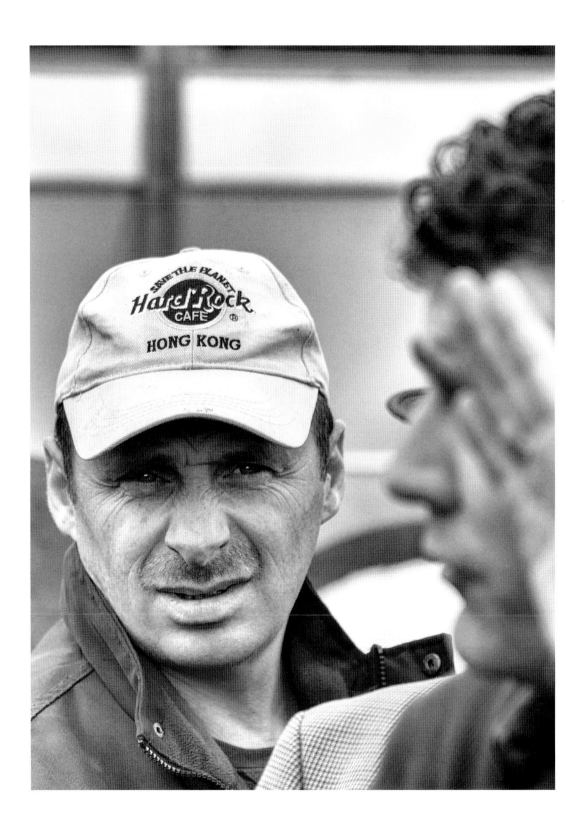

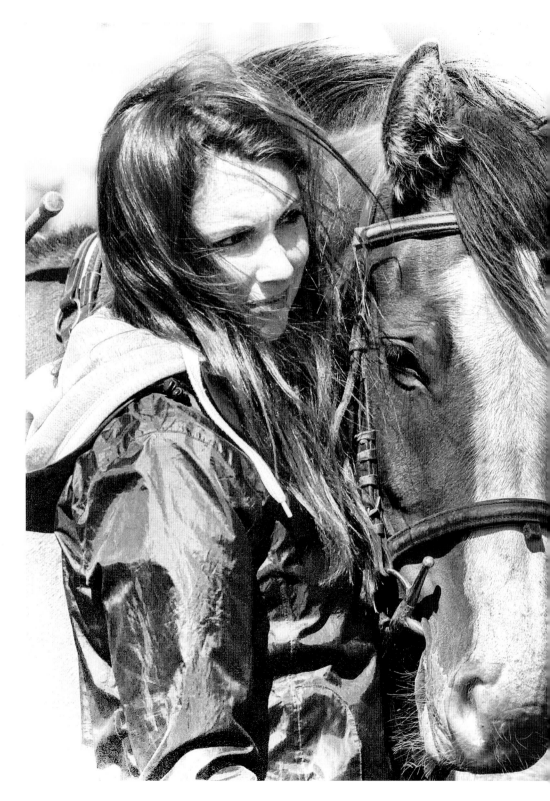

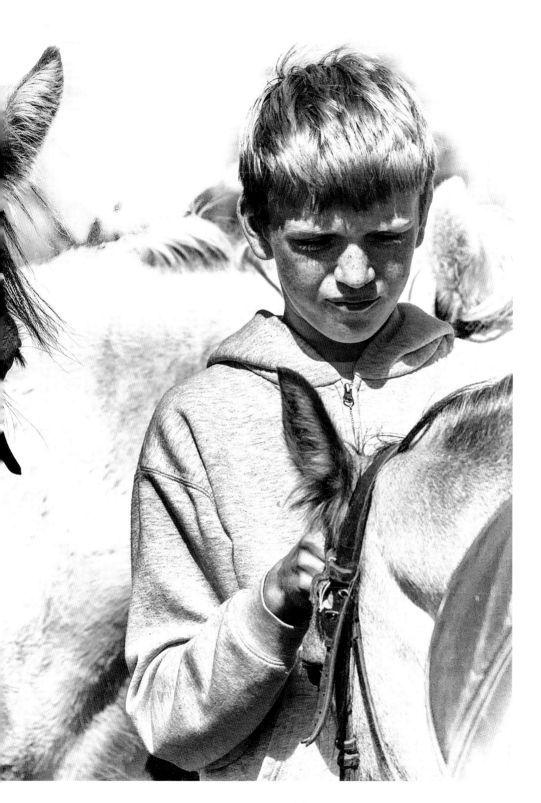

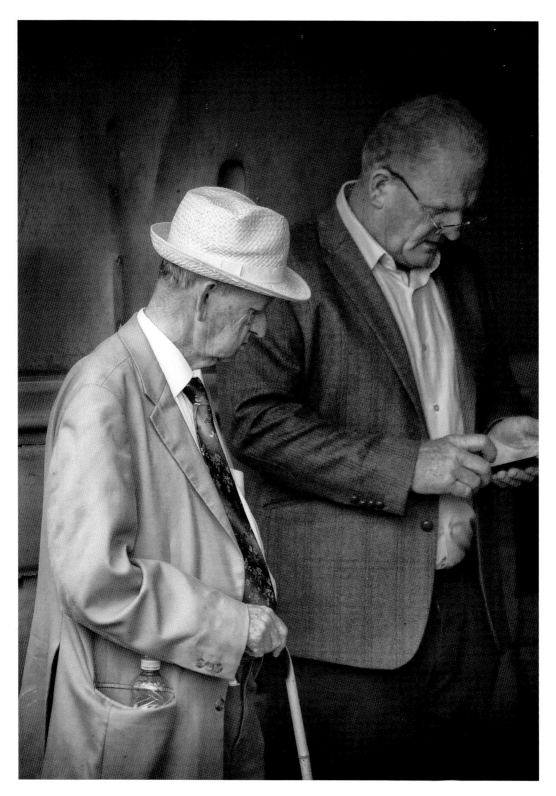

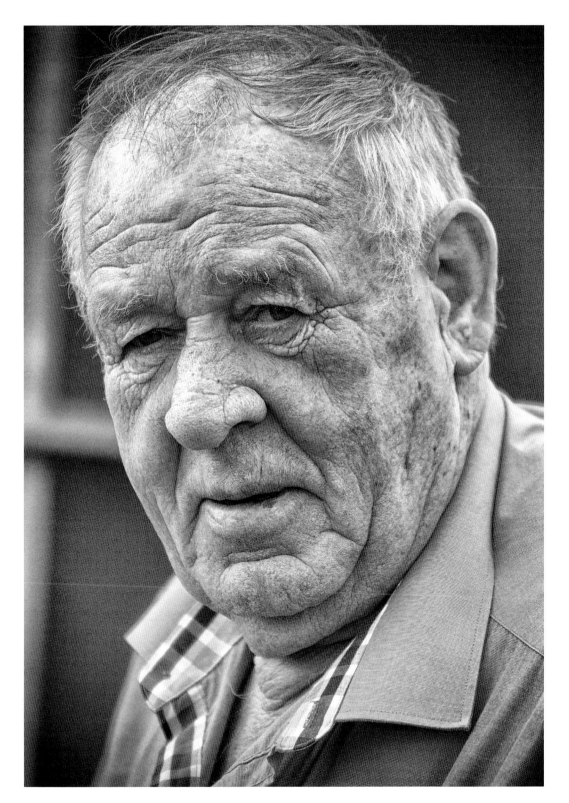

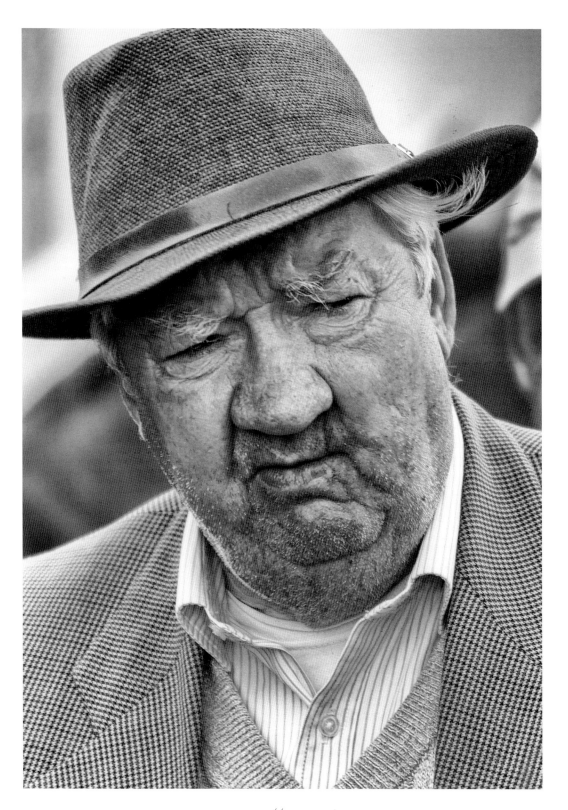

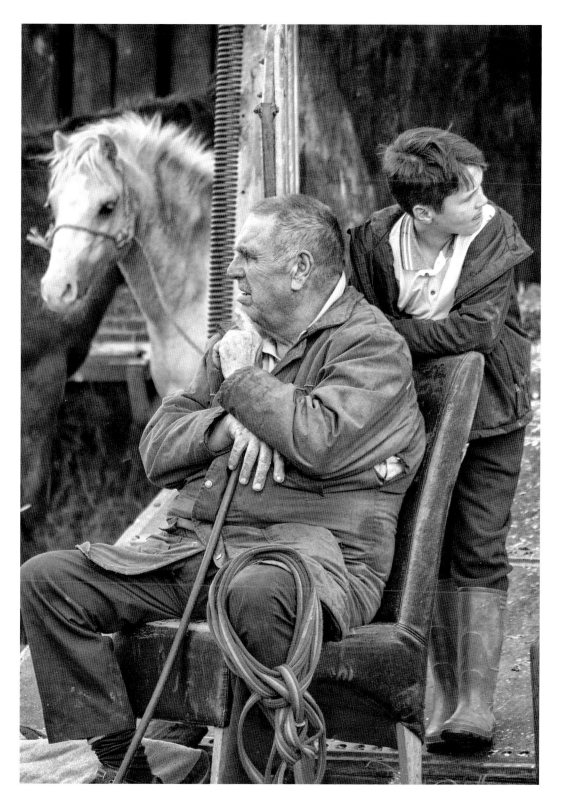

Innishannon Steam & Vintage Rally

I first visited the Innishannon Steam & Vintage Rally – then known as the Upton Steam Rally – in the late 1980s and was immediately captivated by the atmosphere and photographic potential of the event. The rally has been running since 1969, primarily with the aim of raising funds for charity.

In 1997 it became known as the Innishannon Steam & Vintage Rally and in the intervening years it has become the largest event of its kind in the country, now boasting over 1,500 exhibits each year, comprising steam engines, vintage tractors, military vehicles, fire engines, trucks and various other machinery.

Add to this music, open-air dancing, pets' corner, sheep dog trials, a funfair and tug-of-war competitions and you begin to get a flavour of why the event draws thousands of visitors each year.

The rally is held over the June Bank Holiday weekend on a thirty-eight-acre site one mile from the village. It now has two main objectives:

- To promote steam and vintage heritage at a national level.
- To raise much-needed funds for the Irish Cancer Society.

It has been hugely successful on both fronts.

The array of faces, young and old, to be captured are a delight for any street photographer and the addition of coal dust, axle grease and candy floss just adds to the atmosphere of the wonderful candid portraits that can be captured there.

To wander the site, especially on a sunny Sunday afternoon, is to witness a microcosm of rural Ireland spanning fifty years or more and covering several generations, from babies in prams to octogenarians in their Sunday best and straw hats.

Over the years at Innishannon I have photographed everyone from leather-

clad bikers, farmers and tug-of-war competitors to children covered in ice cream, and have never returned home disappointed from my day's labours.

I like to wander among the lovingly restored vintage cars first, shooting candids of the proud owners, eager to engage with any stranger who stops to admire their pride and joy. I then move on to the main arena, where men and women in dirty overalls, their faces covered in soot and grease, tenderly minister to their traction engines, buffing up brass until it gleams in the sunlight and always finding something else to adjust or tweak with a spanner.

The various demonstrations of traditional threshing, timber-cutting and rock-breaking have given me many great photographs over the years. When I've exhausted all photographic potential from these, I train my lens on the thousands of spectators getting on with their day out, who are usually so engrossed in proceedings that they are oblivious to the fact that they are being photographed.

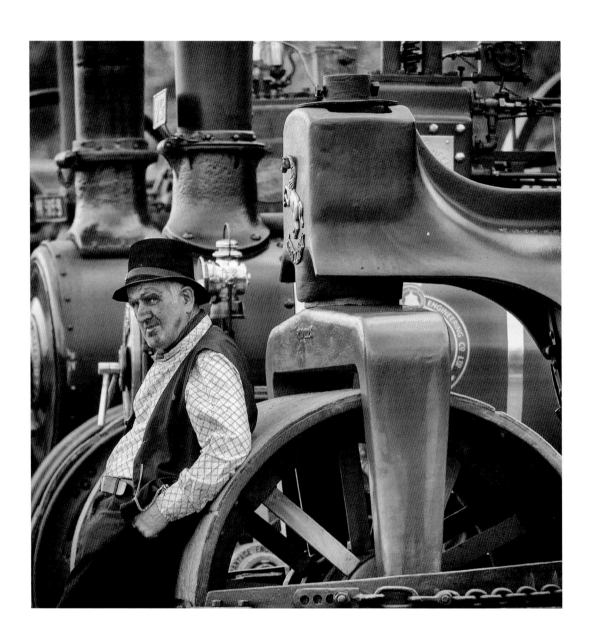

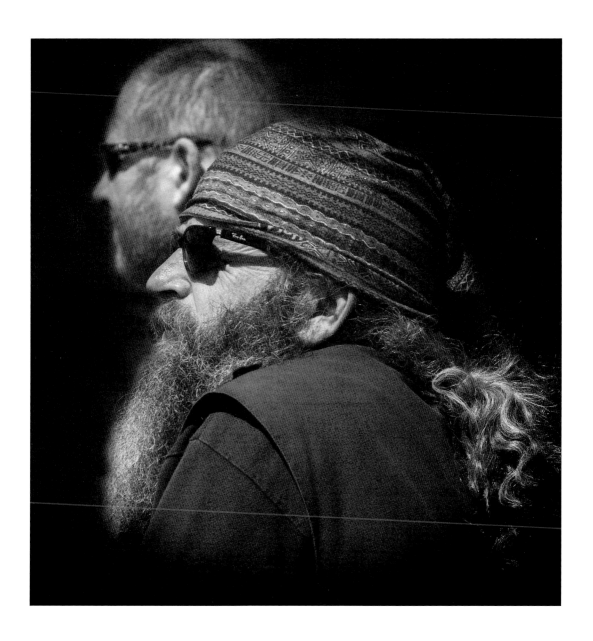

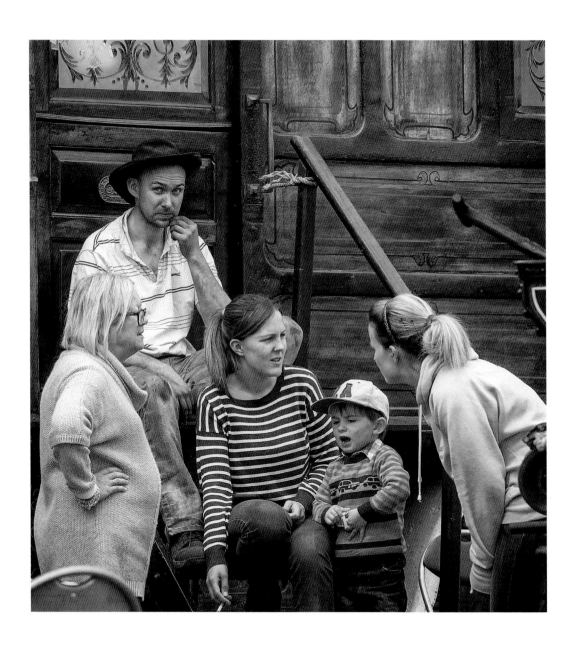

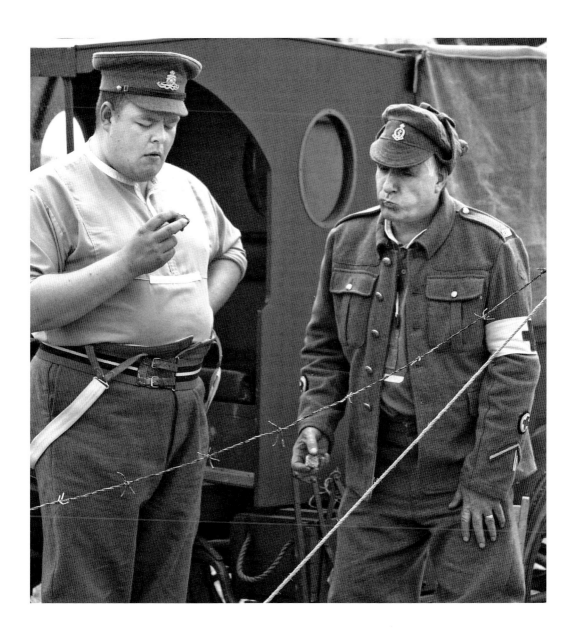

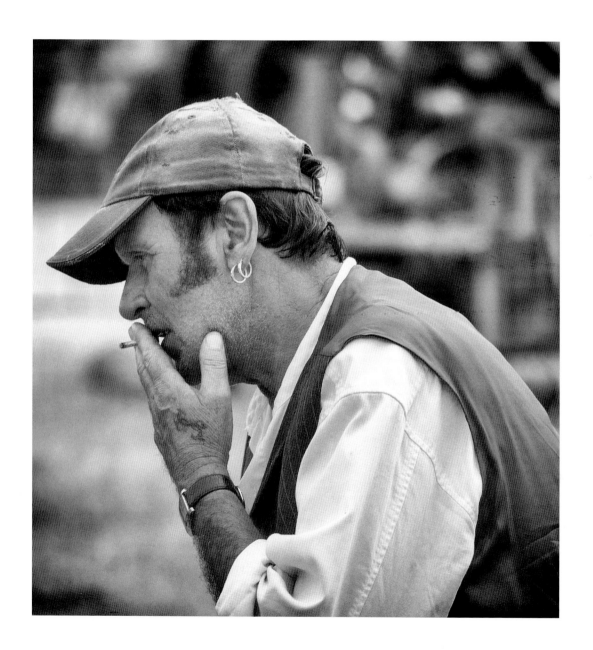

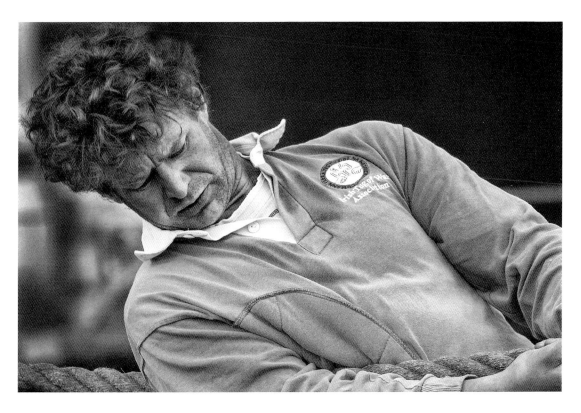

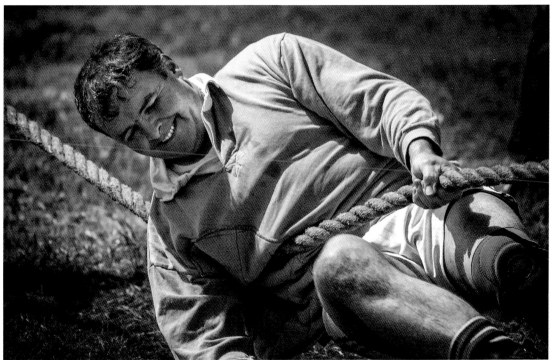

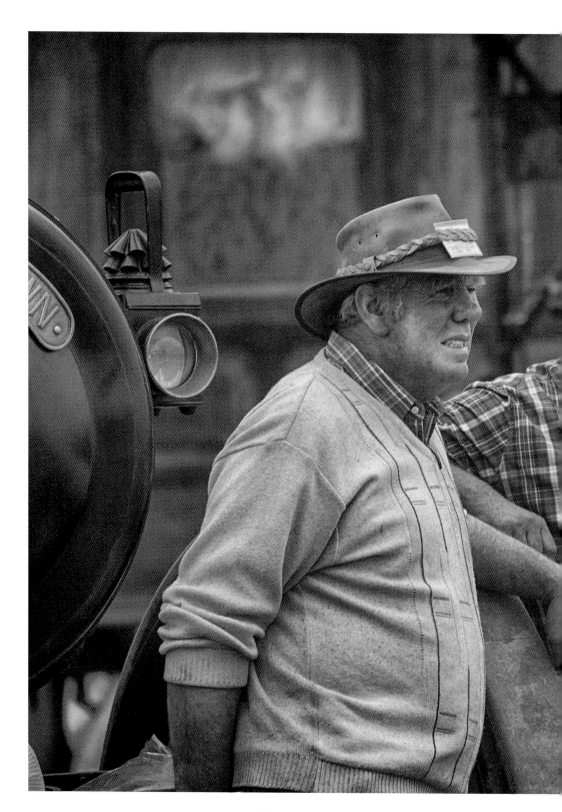

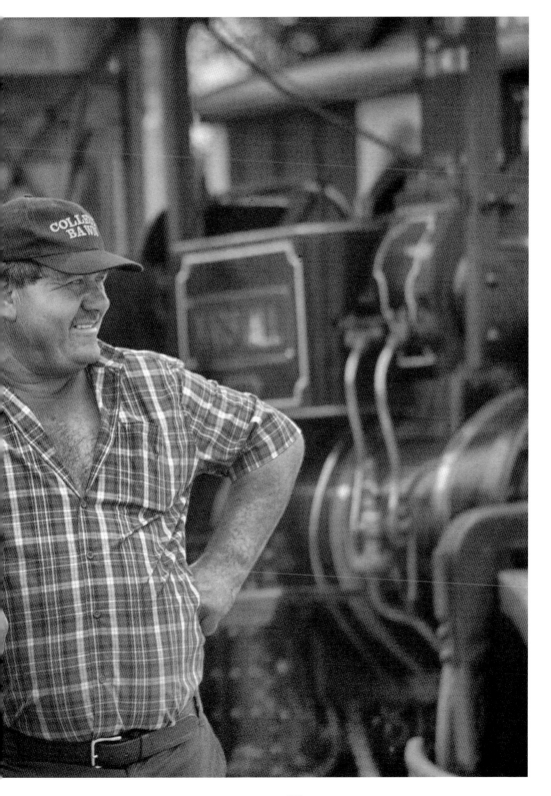

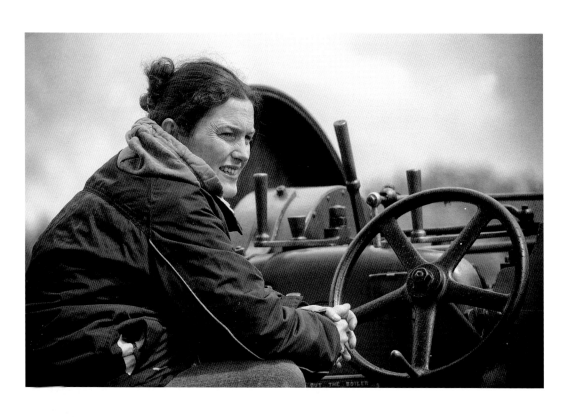

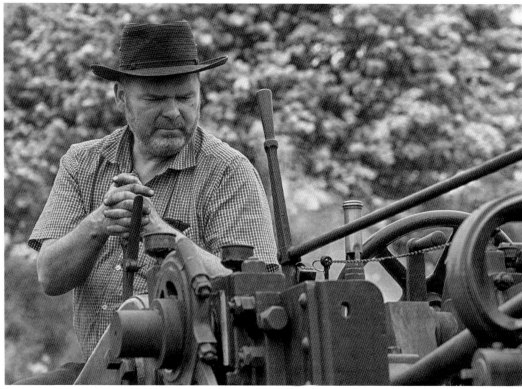

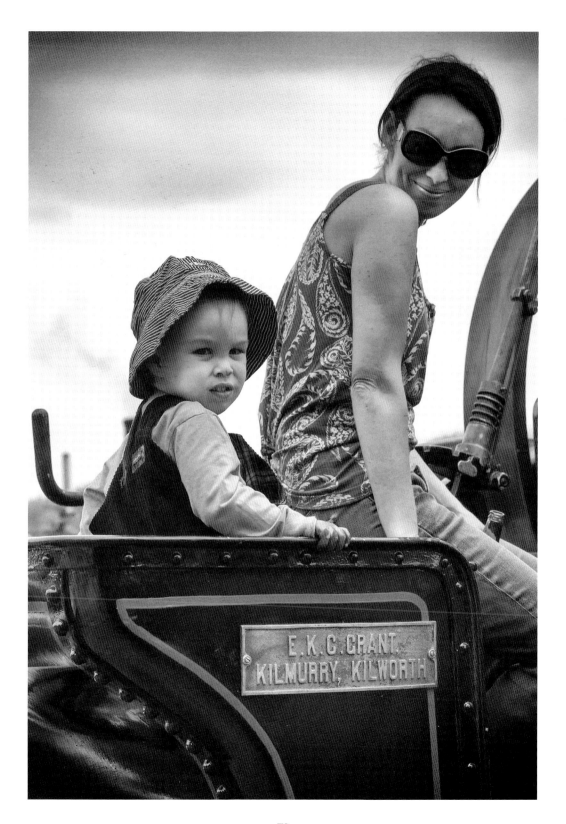

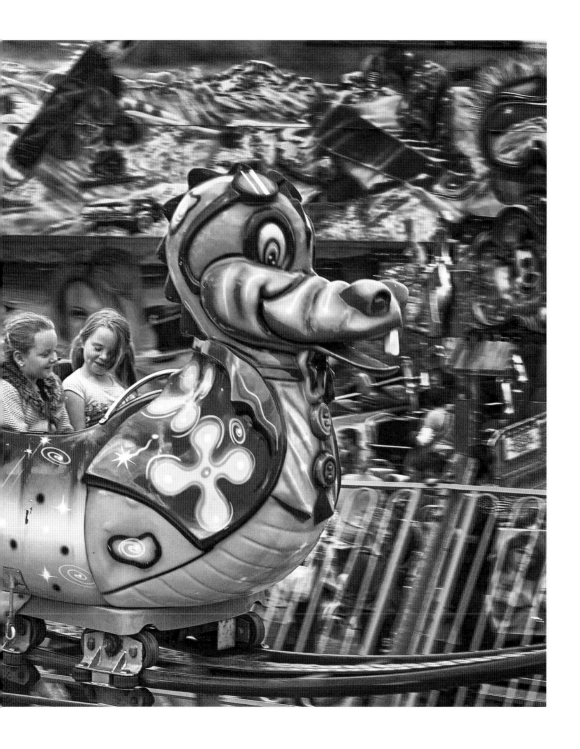

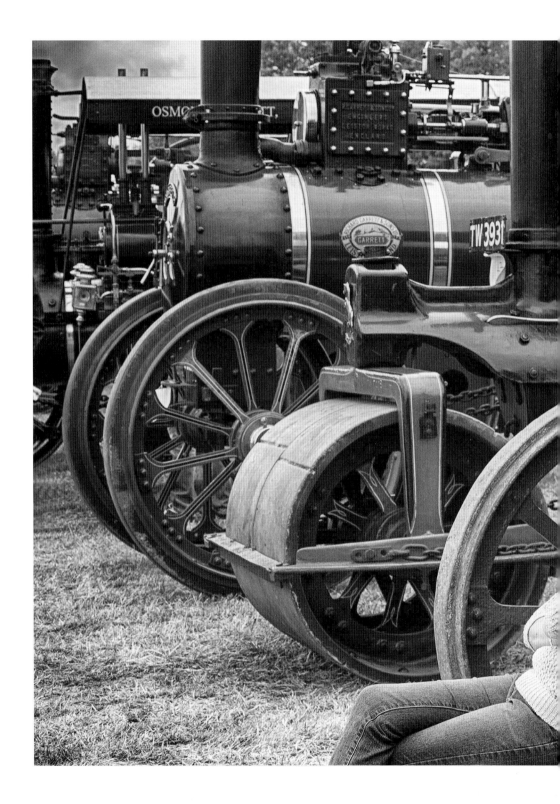

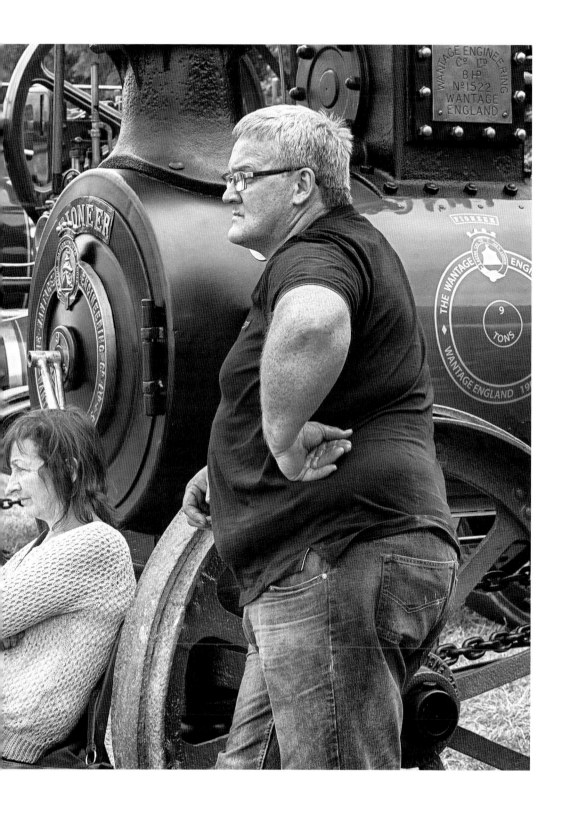

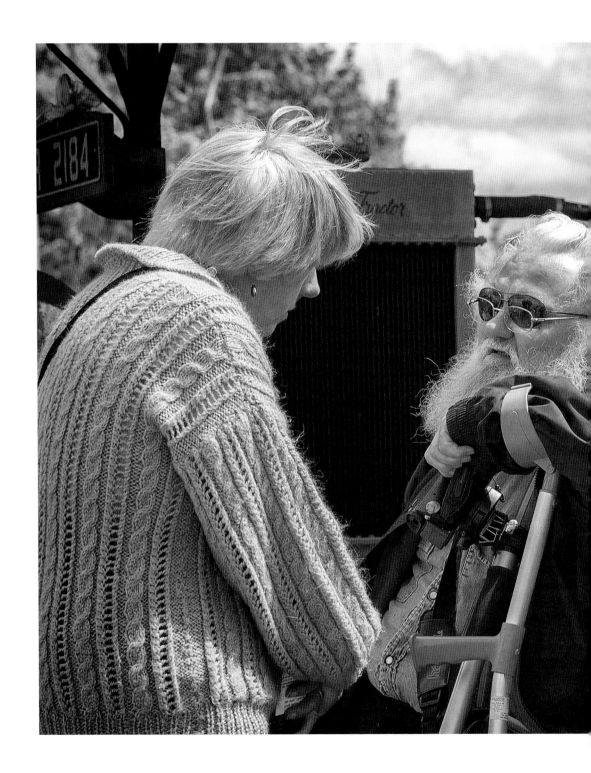

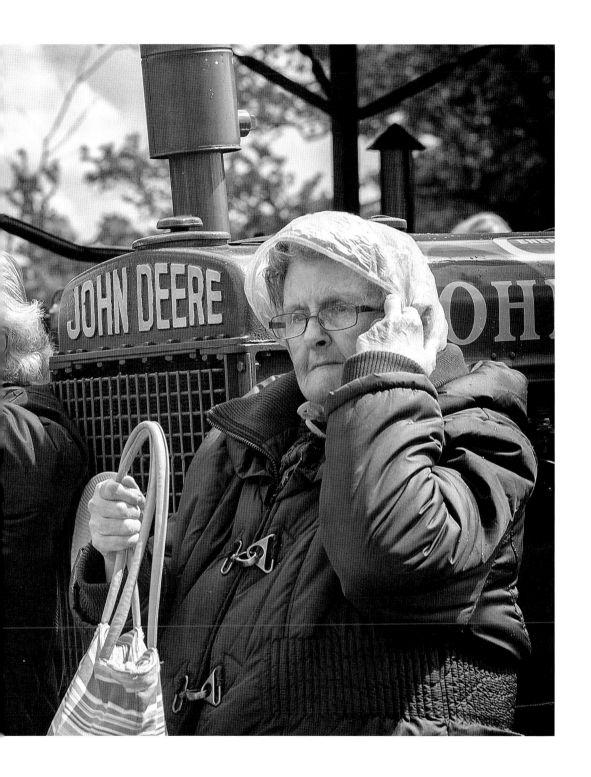

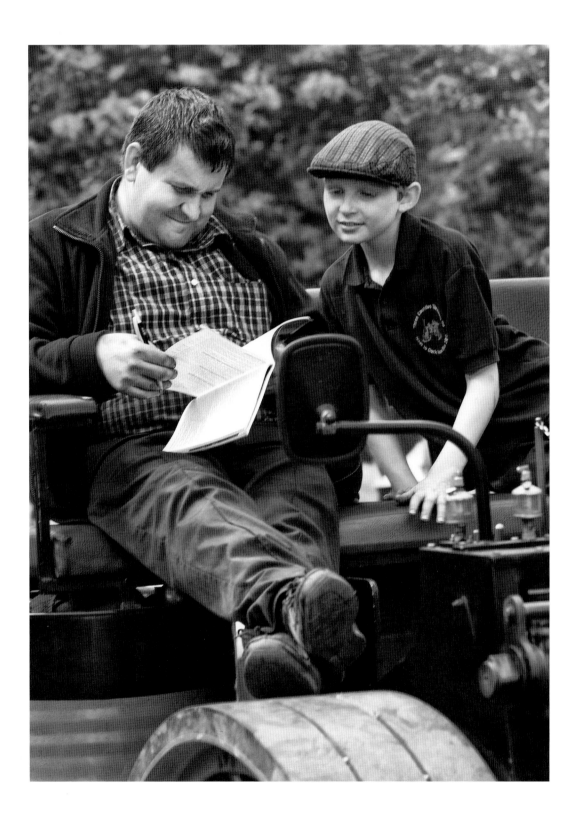

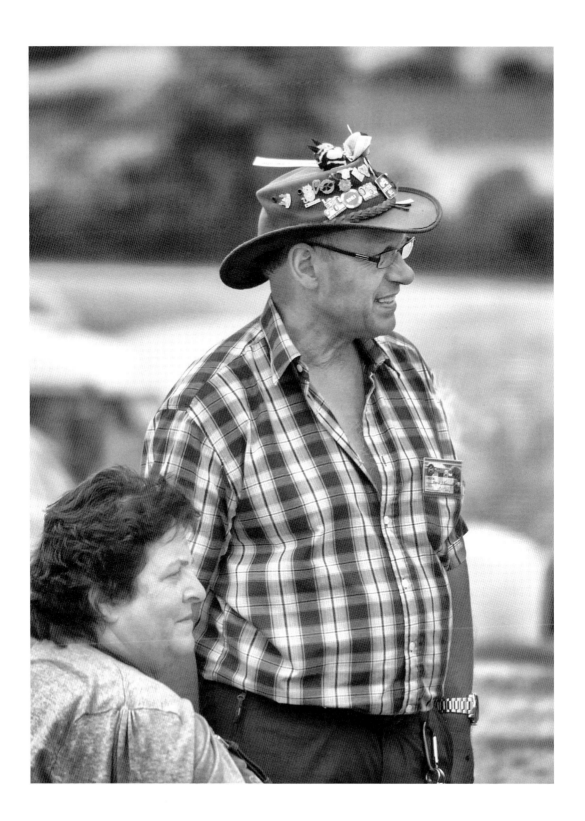

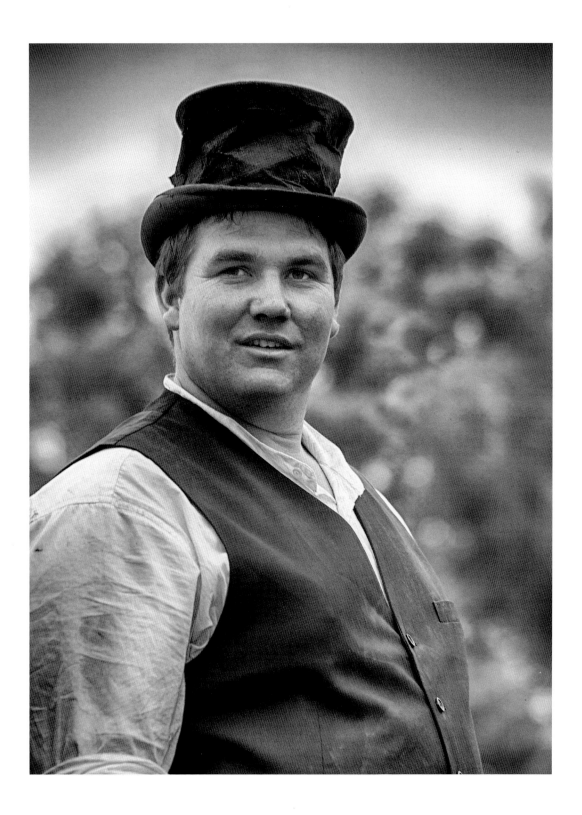

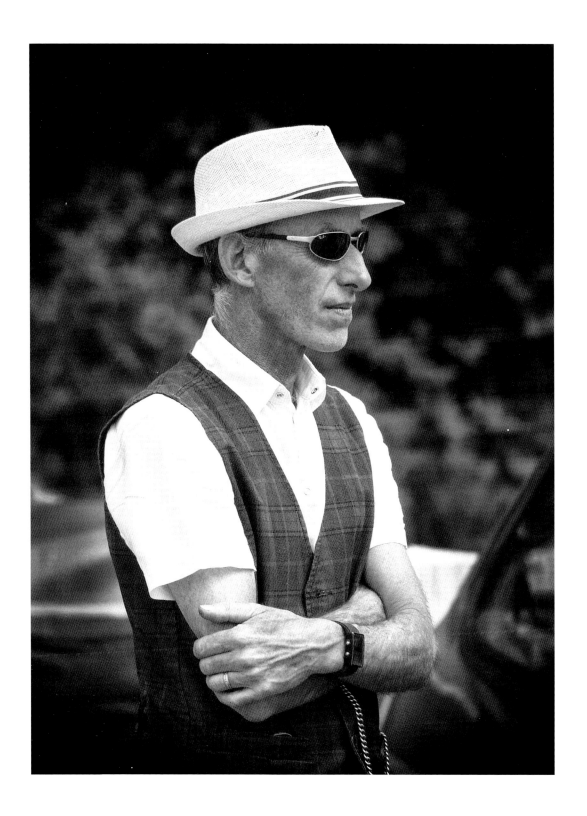

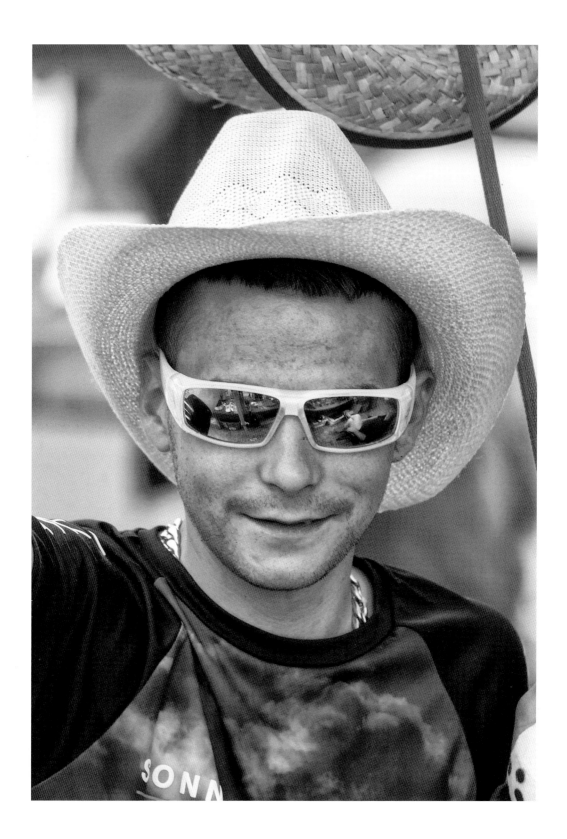

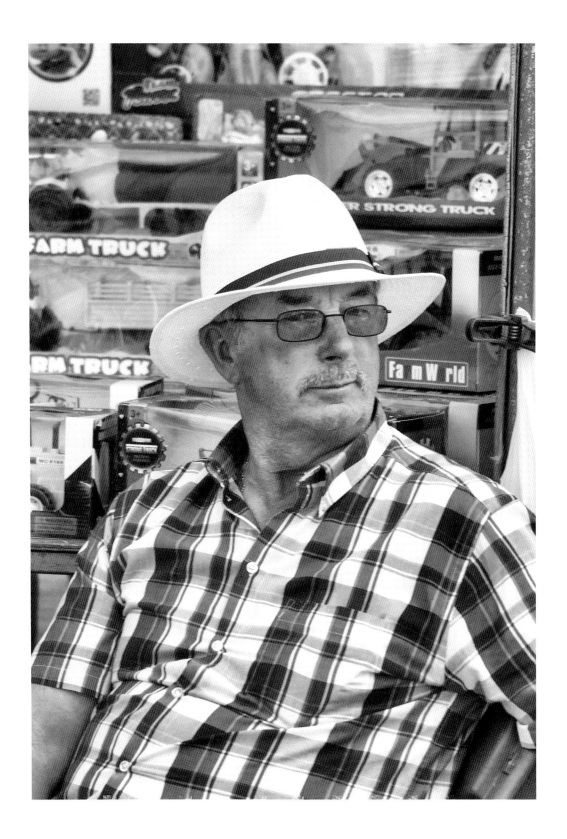

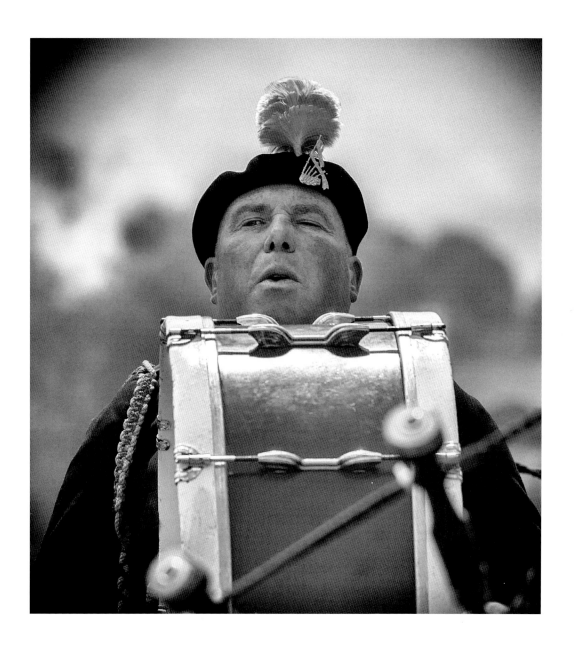

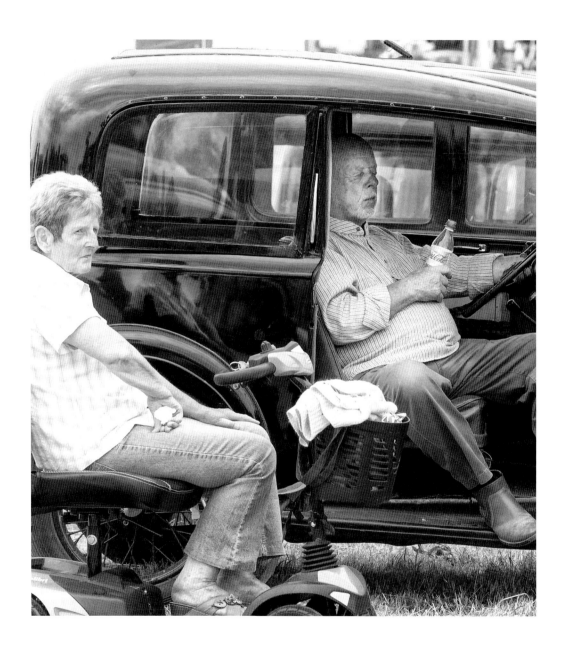

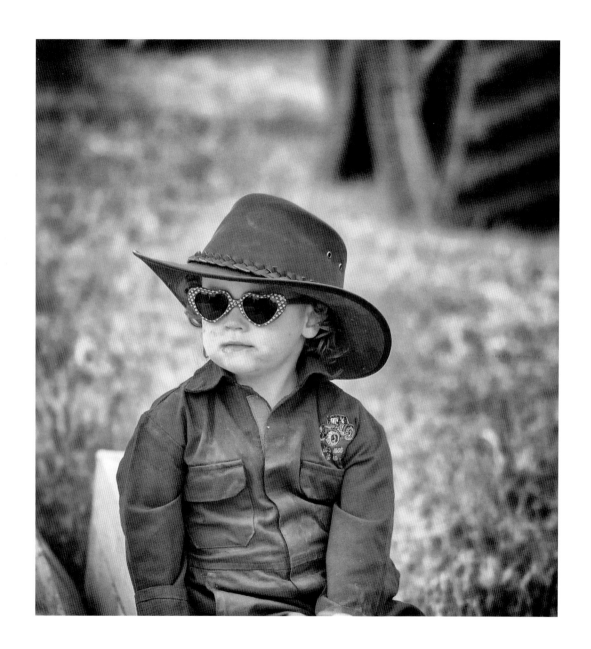

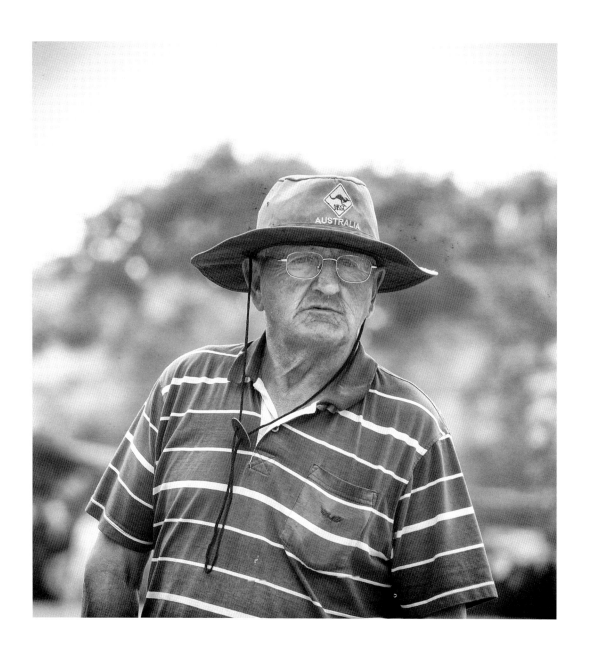

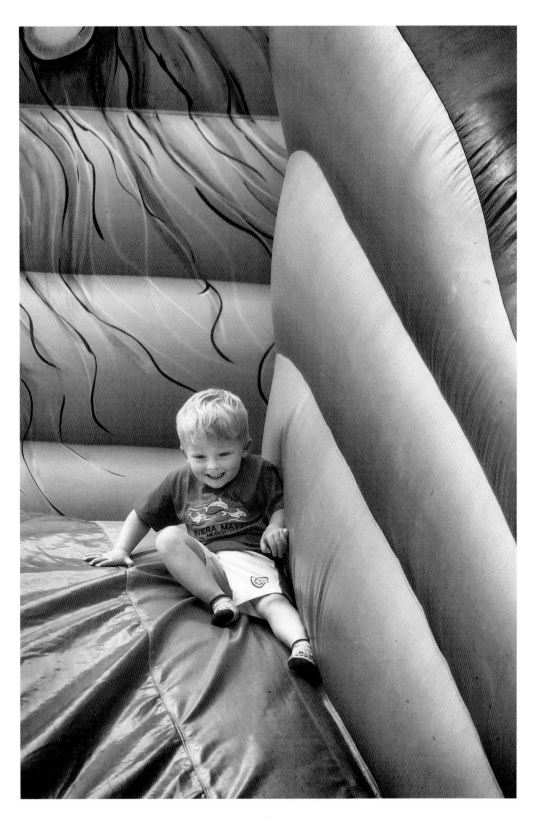

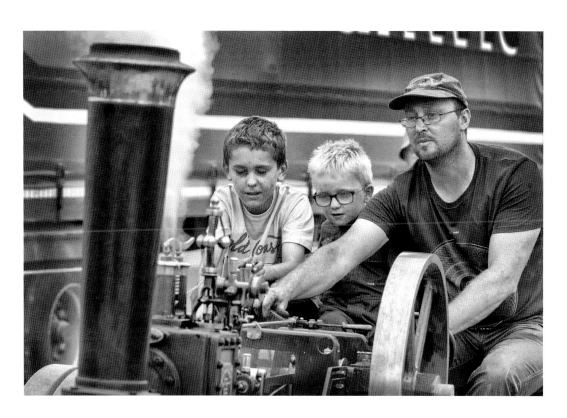

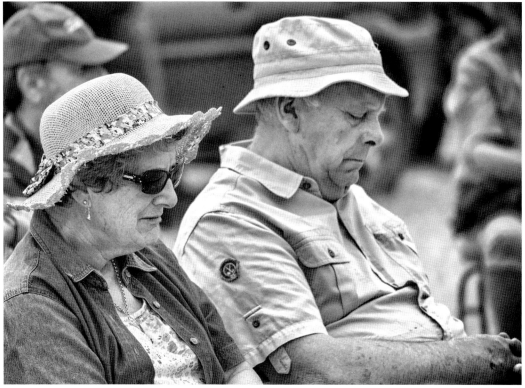

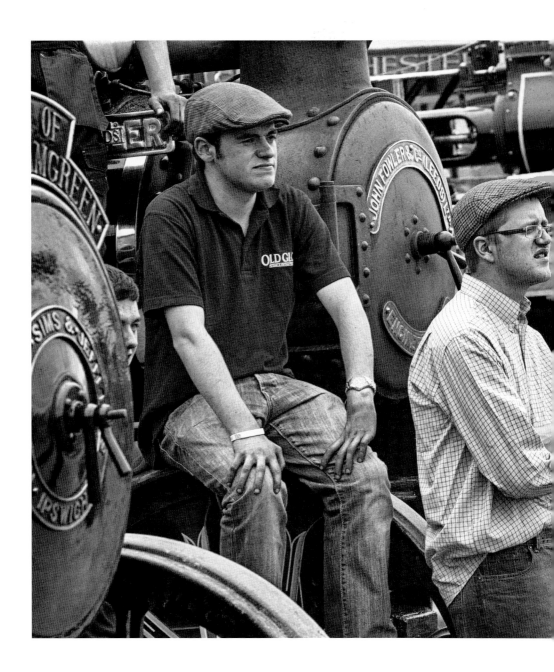

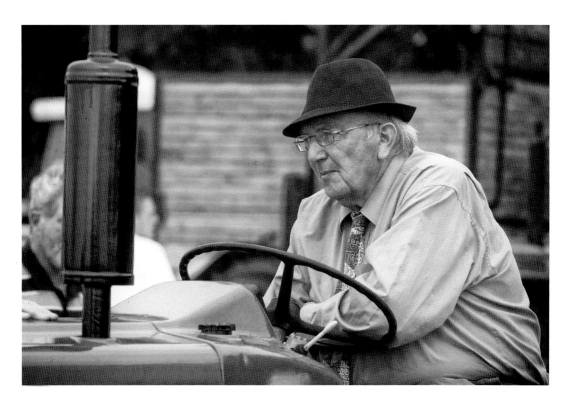

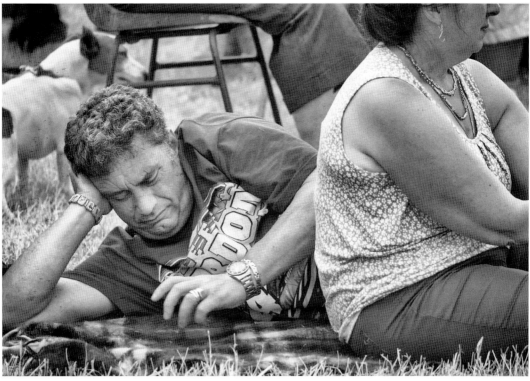

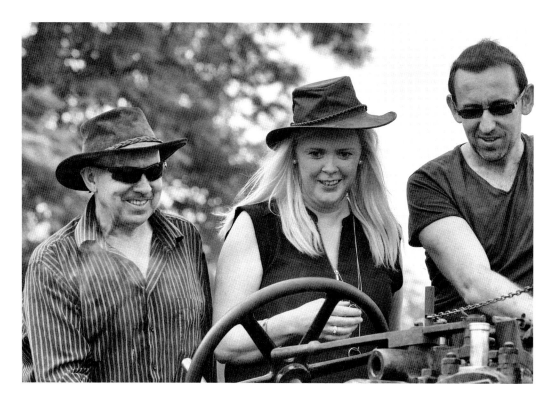

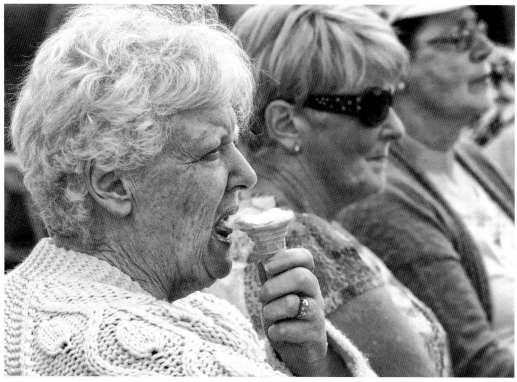

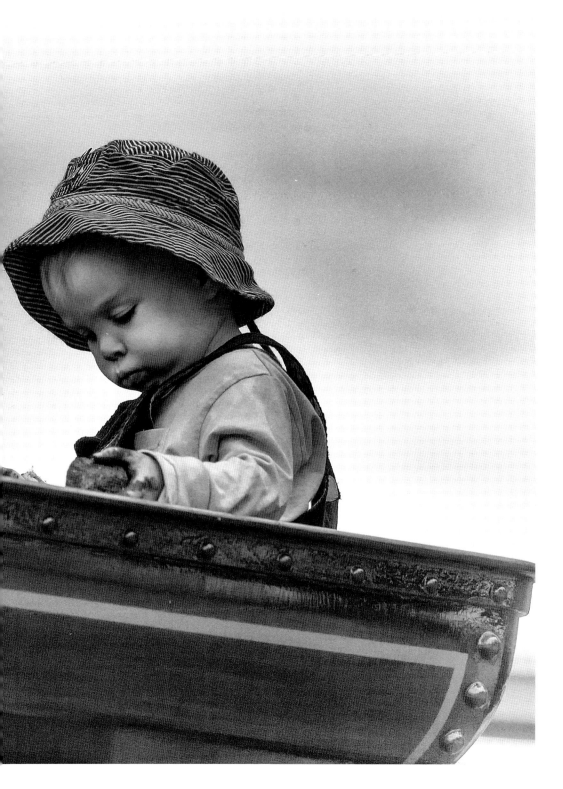

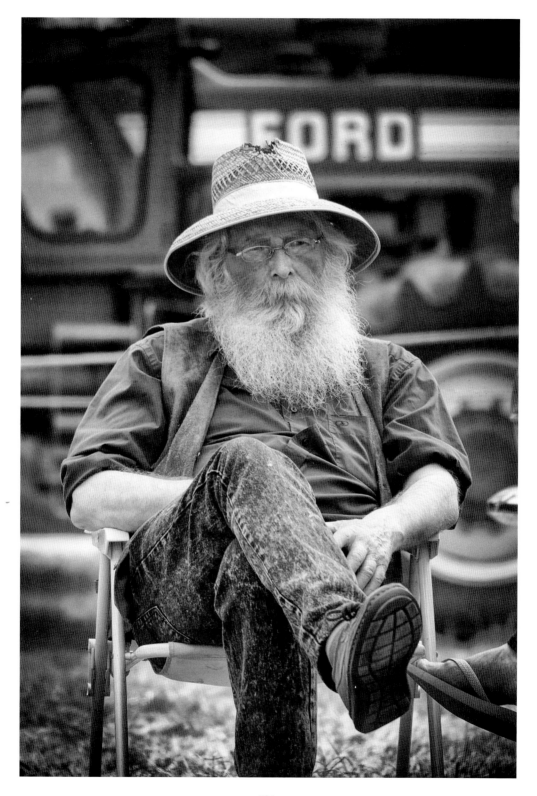

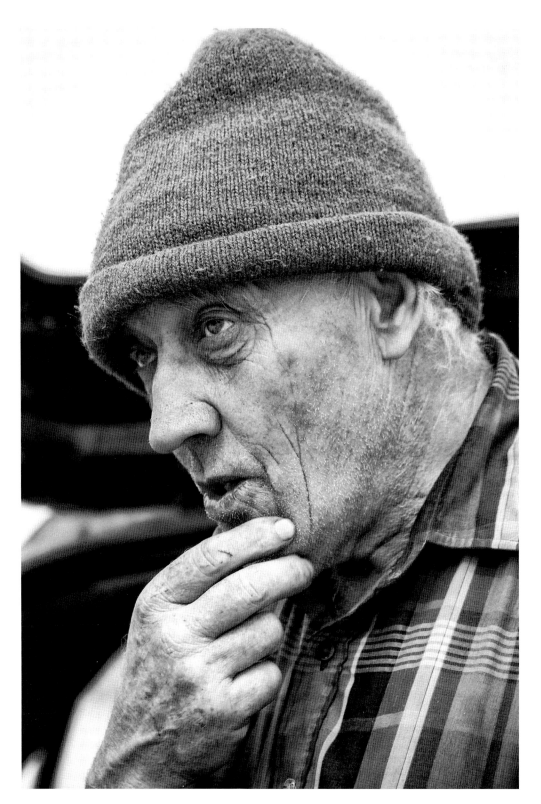

Cork Jazz Festival

The first ever Cork Jazz Festival took place in 1978 and in the intervening years it has become by far the biggest event of its kind in Ireland. It attracts thousands of music fans and hundreds of musicians to the city over the October Bank Holiday weekend each year.

The festival was the brainchild of Jim Mountjoy, who, in 1978, was the marketing manager at the Metropole Hotel on MacCurtain Street. At the time, he saw the festival as a way of filling his hotel rooms for the long weekend, particularly given that a planned bridge convention scheduled to take place in the hotel that weekend had been cancelled at the last minute.

In the following years, Mountjoy and the newly founded jazz committee also introduced a jazz pub trail around the city, with live bands playing to packed audiences. A specially laid-on 'jazz train' from Dublin also opened up the festival to fans countrywide.

Average visitor numbers have exceeded 40,000 in recent years and the list of past performers reads like a who's who of the great jazz musicians of the twentieth century. These include Ella Fitzgerald, Buddy Rich, Oscar Peterson, Dizzy Gillespie, Cleo Laine, Chick Corea and many more too numerous to mention.

The festival features many open-air gigs and this makes for a great atmosphere on the city's streets. In 2015 I wandered the streets with my camera, trying to capture some interesting portraits as the musicians left the confines of the indoor venues to preach their jazz gospel to the masses.

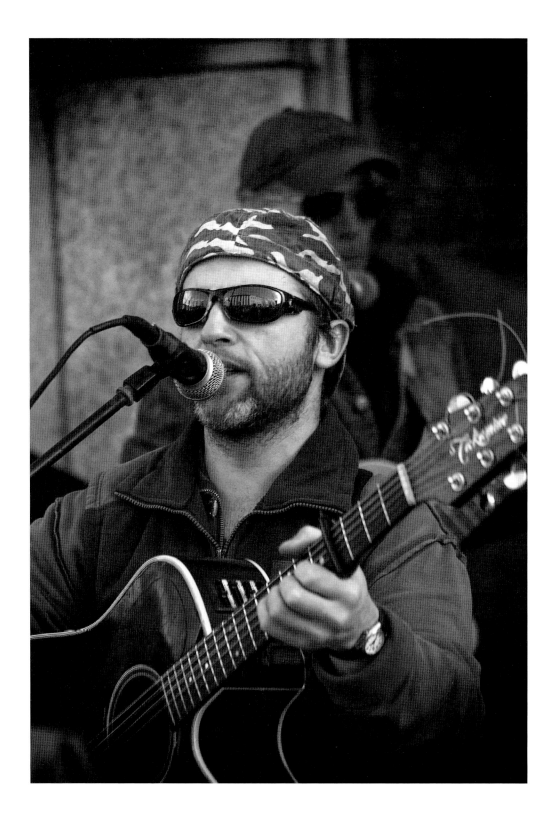

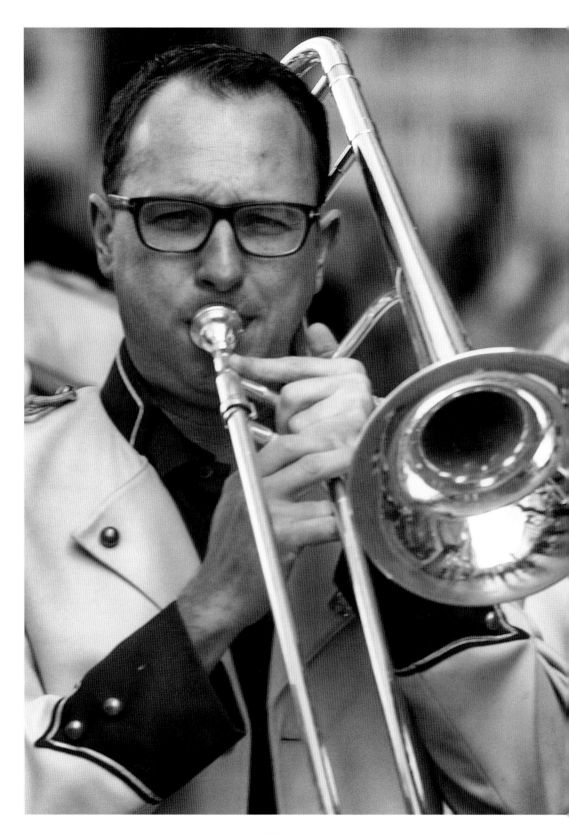

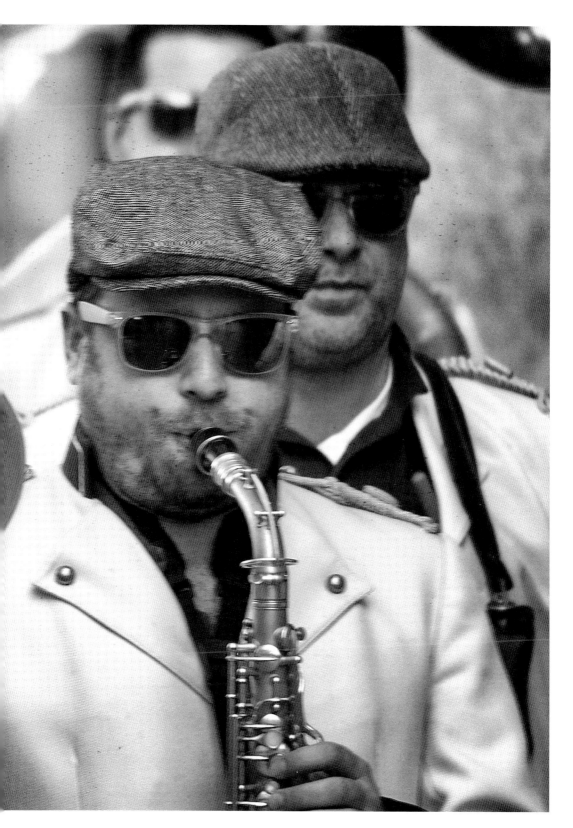

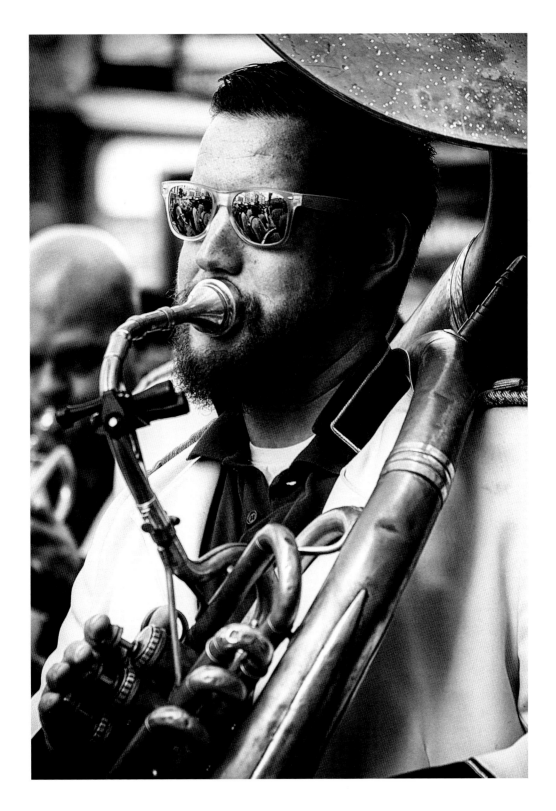

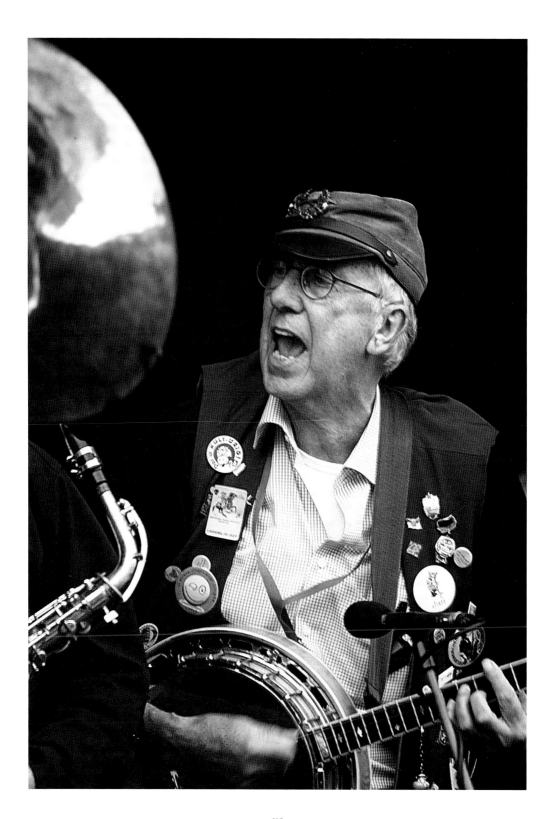

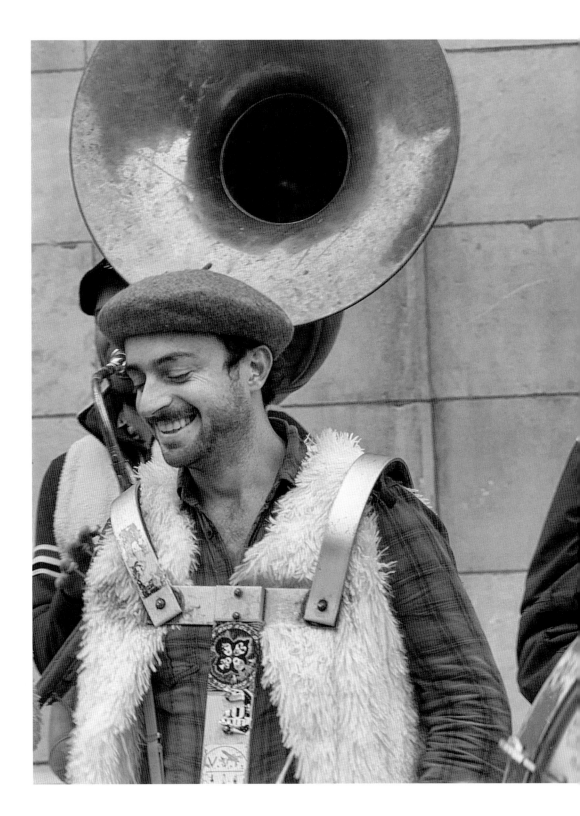

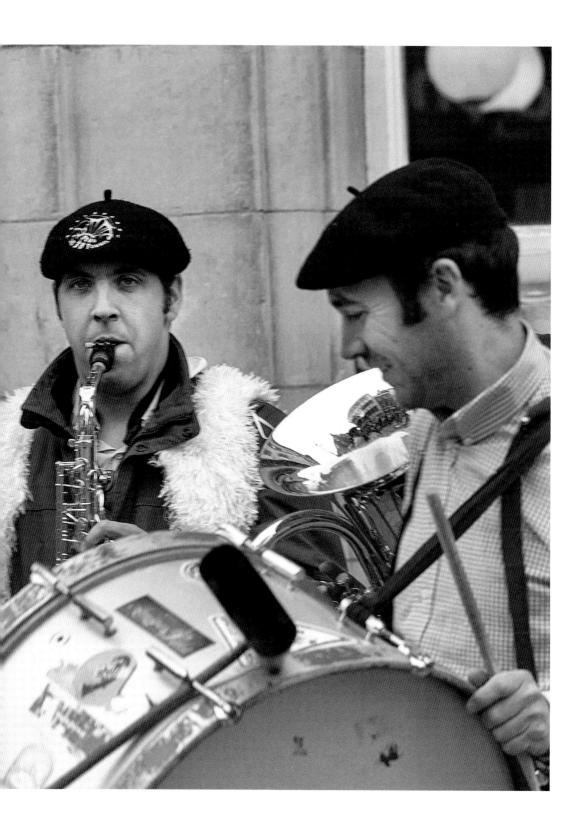

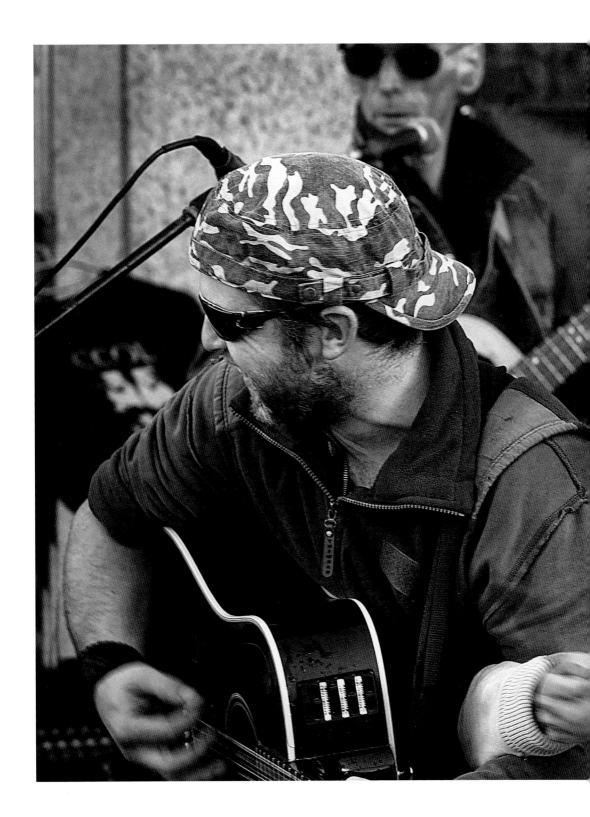

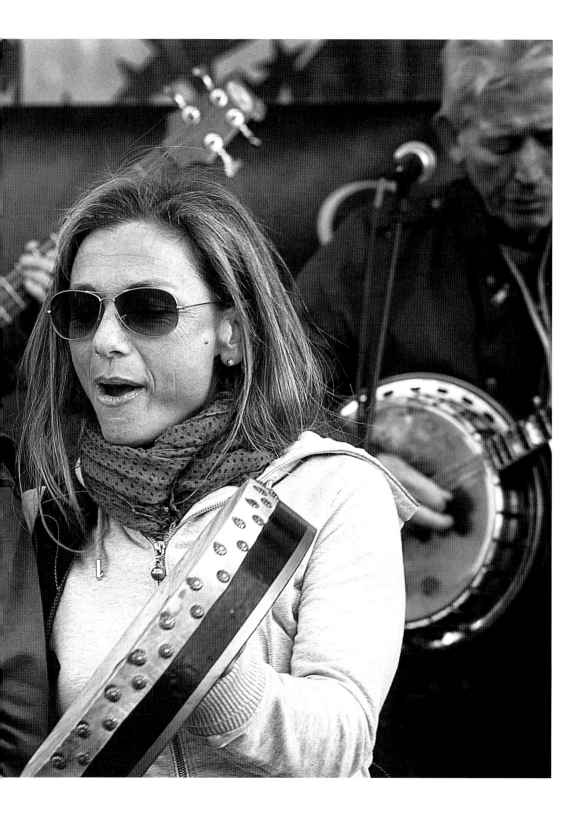

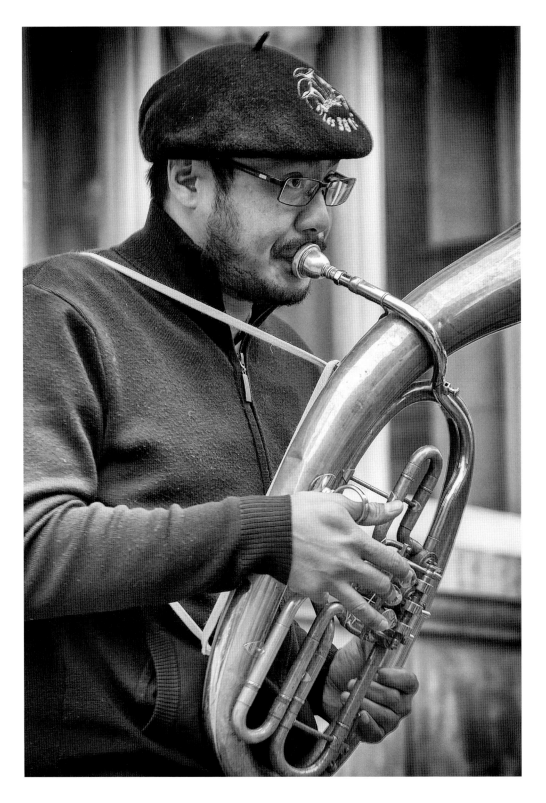

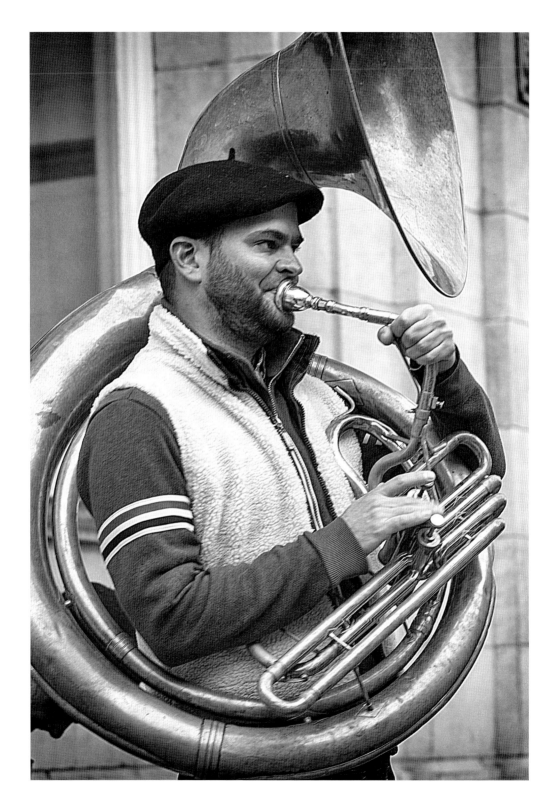

Cahirmee Horse Fair

My recent penchant for the photography of all things equine took me to the renowned Cahirmee Horse Fair in Buttevant in July 2015.

Buttevant is a town in north Co. Cork, situated on the main road from Cork to Limerick. It reportedly takes its name from the motto of the Anglo-Norman de Barry family, who arrived there in the late-twelfth/early-thirteenth century and built Buttevant Castle, the remains of which still stand on the outskirts of the town. Their motto was *Boutez en avant*, roughly meaning 'push forward'.

The Cahirmee Horse Fair has a strong history, dating back, some say, to the time of King Brian Boru (although most Irish fairs lay claim to being the oldest fair in Ireland). There is some data on record, however, to suggest that Napoleon's horse 'Marengo' was bought at the fair from a Kerryman named O'Connor. The fair is also reputed to have supplied many horses for his armies. It is also recorded that it supplied the Duke of Wellington's horse at the Battle of Waterloo, an Irish black named 'Copenhagen'.

Before 1914 Cahirmee was considered to be arguably the greatest horse fair in the British Isles. The fair was originally held in the Fair Field at Cahirmee, some two miles from the town, but it moved into the town centre in 1921 and has been held there every year since.

The fair is held on 12 July each year except when this date falls on a Sunday – the fair then moves to the following day so that the bank is open for lodgements and withdrawals (depending on whether one is buying or selling).

There is no organising committee and the fair is not advertised, yet it draws thousands to the town each year and is a great social occasion for the surrounding area. In the days preceding the fair, an eclectic mix of horse-dealers, traveller-folk, stall-holders and various interested onlookers begin to arrive, thronging the entire main street to witness events and do business.

Traditional cobs, children's ponies, hunters, donkeys and a myriad of hens, chickens, turkeys, ferrets and puppies then change hands for sums large and small.

Fair day is unlike any other day in the town and it also smells a lot different due to the 'deposits' of many of the animals on the main street. A pair of stout boots or wellingtons is advisable for the intending visitor!

An aside to the main fair are the stalls belonging to the casual traders that line both sides of the road into the town and sell everything from second-hand power tools to Stetson hats and secret magic potions that are guaranteed to cure any ailment, whether human or equine.

There is always a great, friendly atmosphere at Cahirmee Fair and a motley collection of 'characters' that you would struggle to find at any other fair in the country.

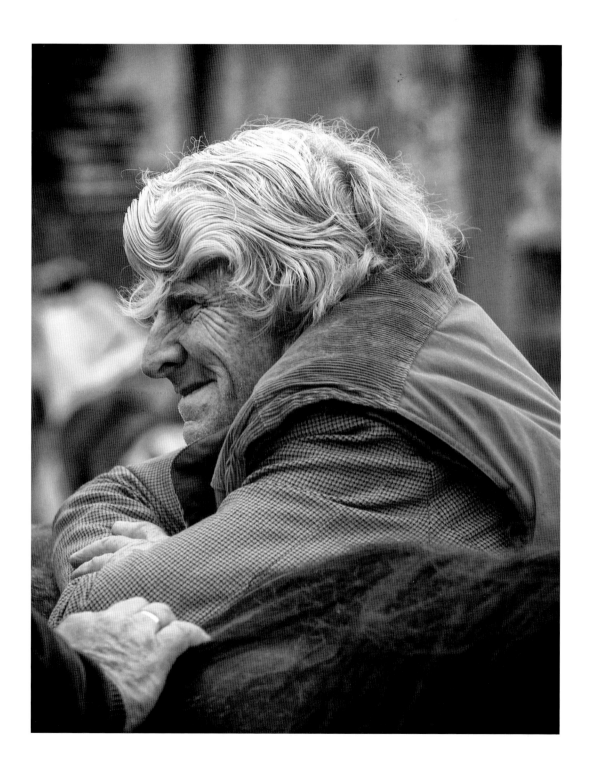

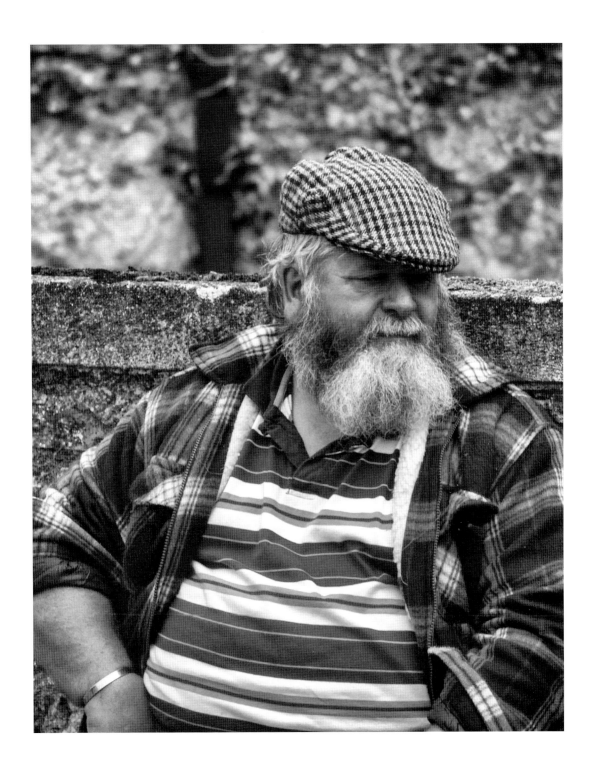

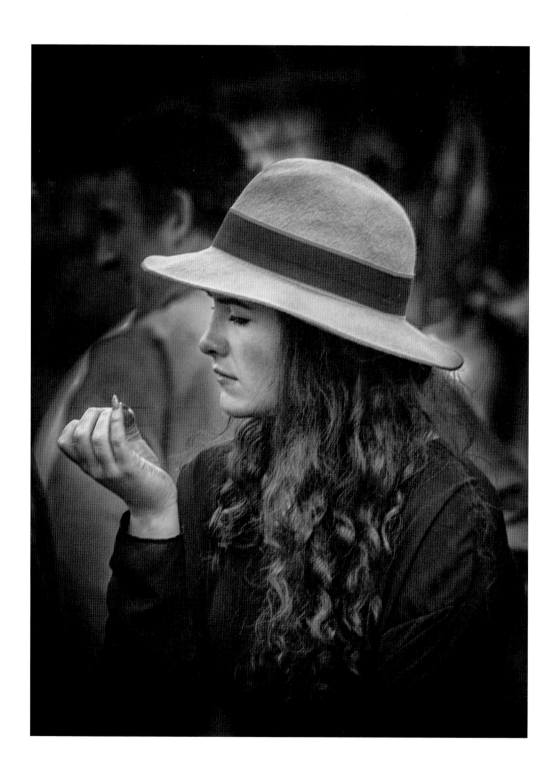

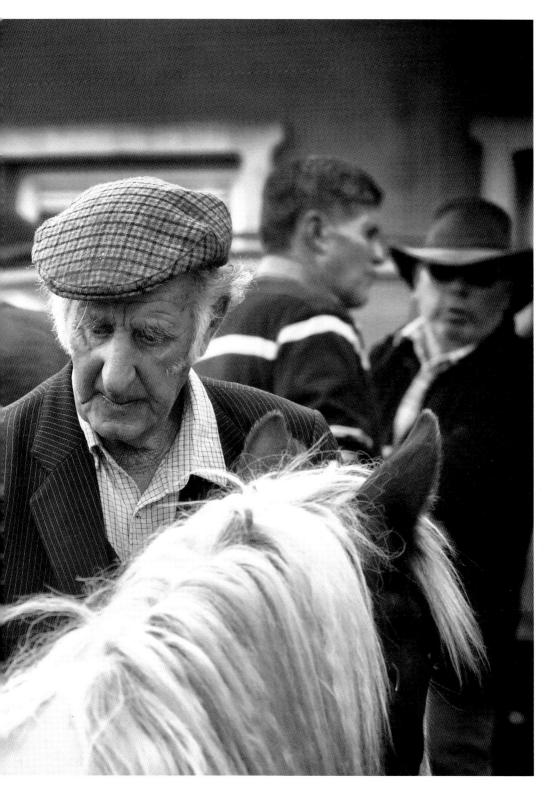

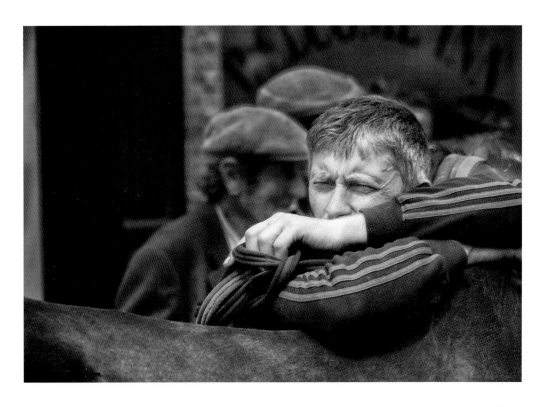

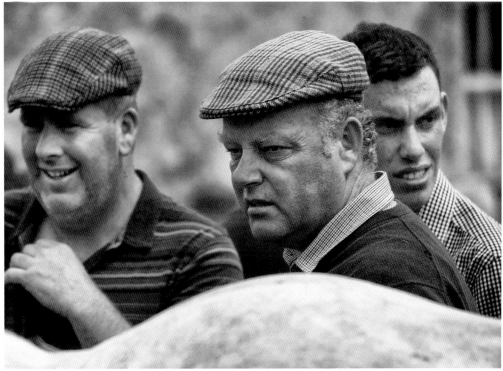

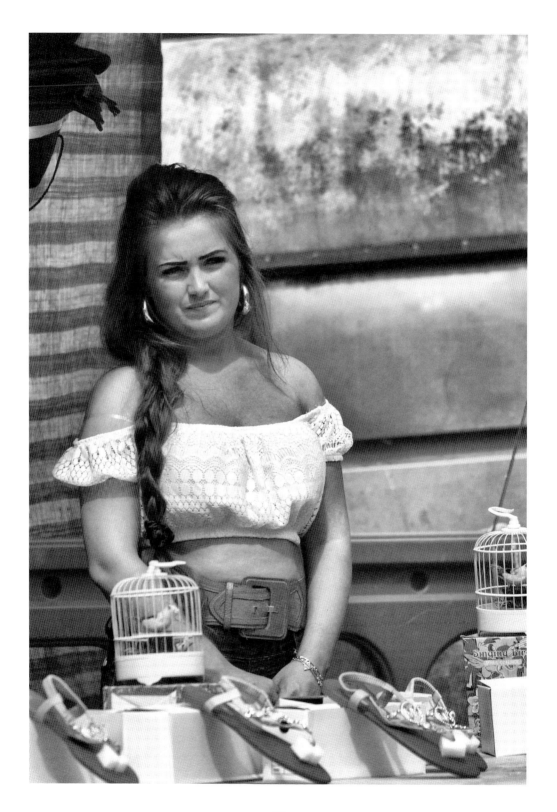

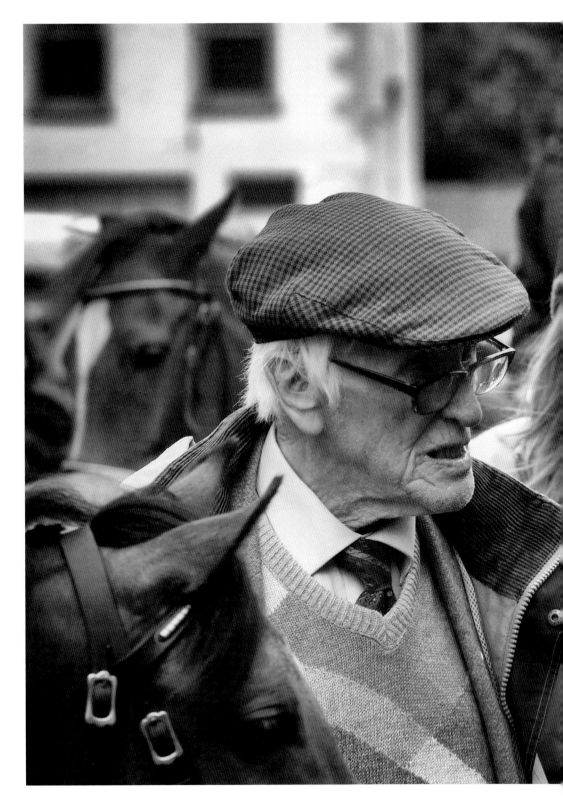

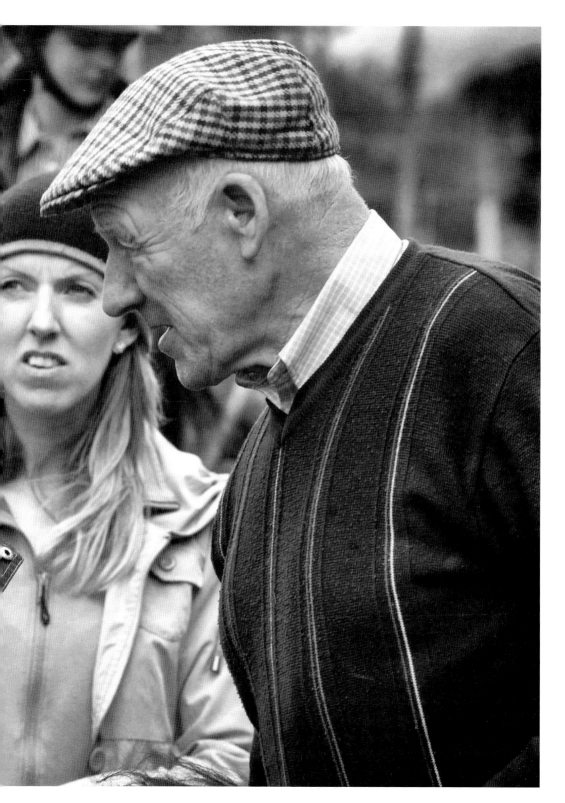

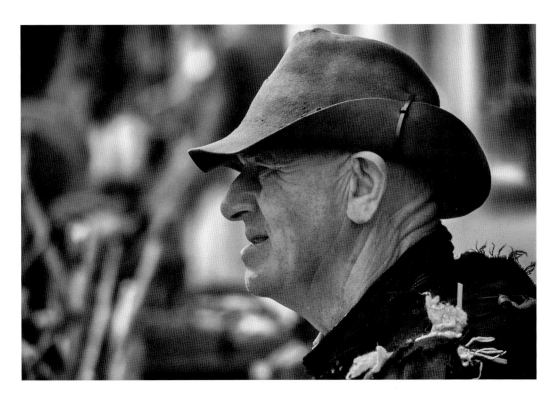

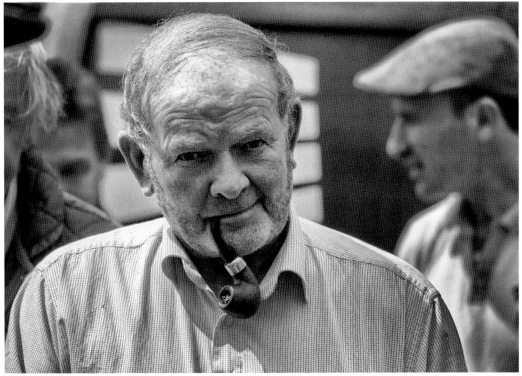

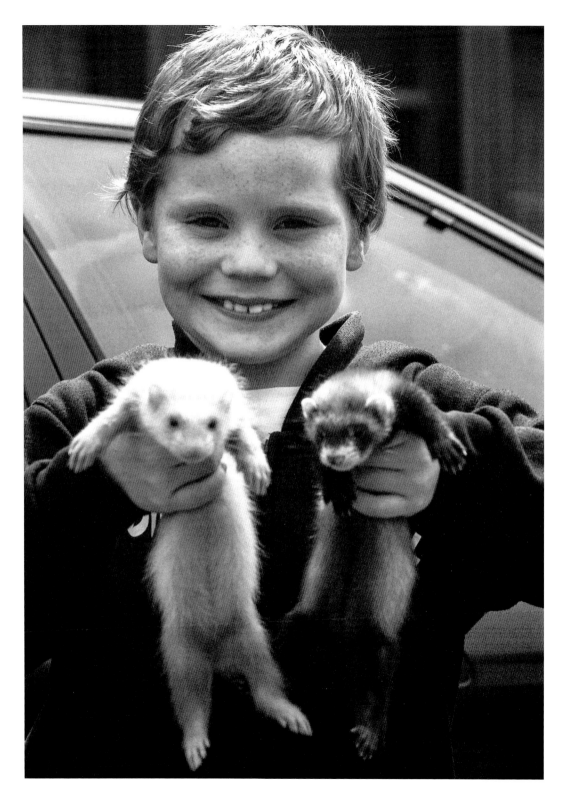

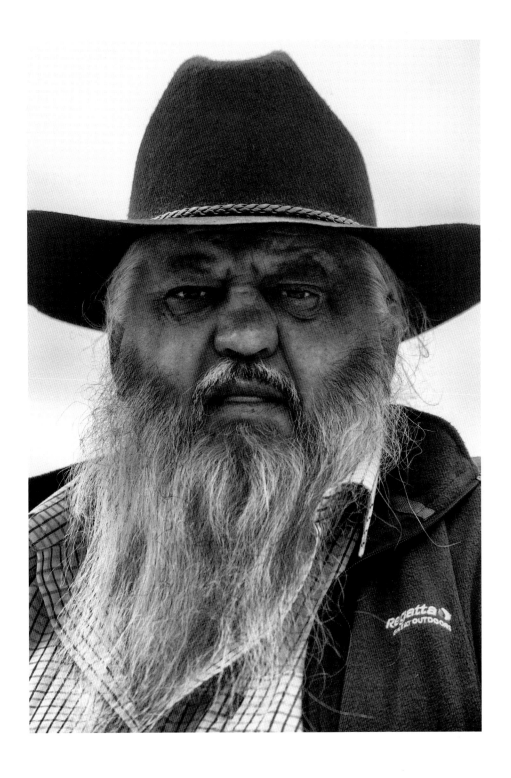

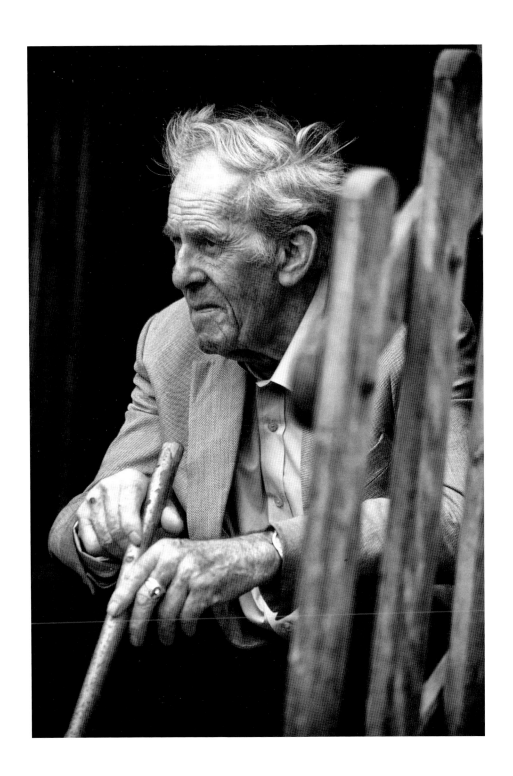

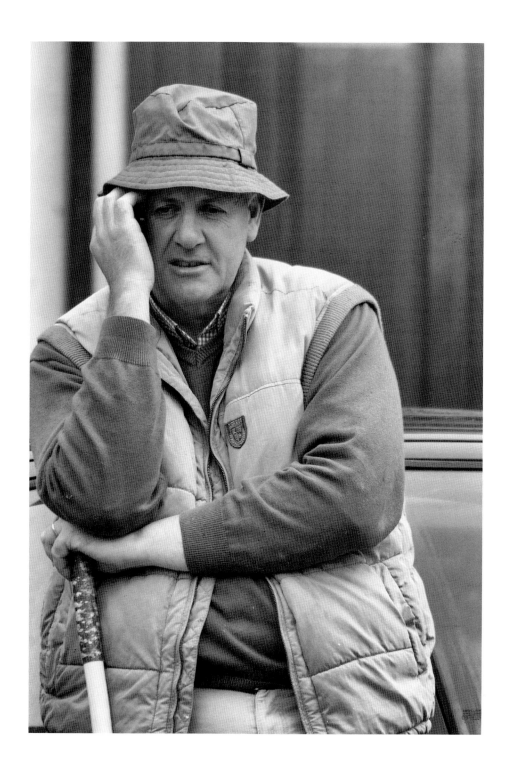

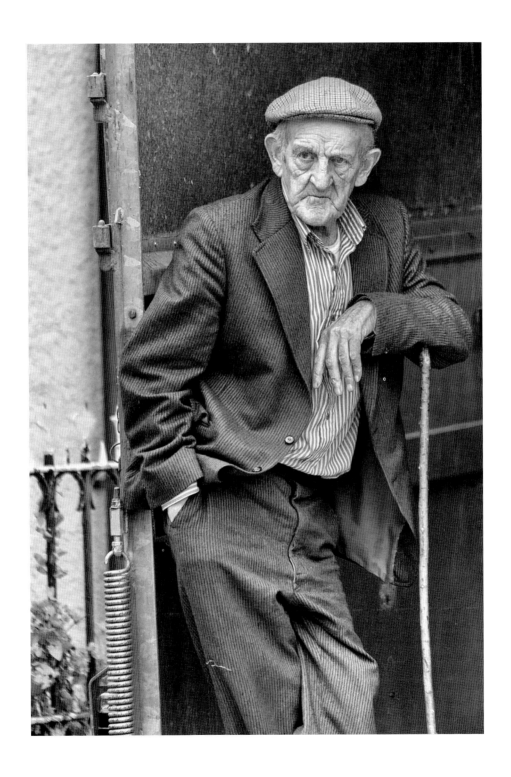

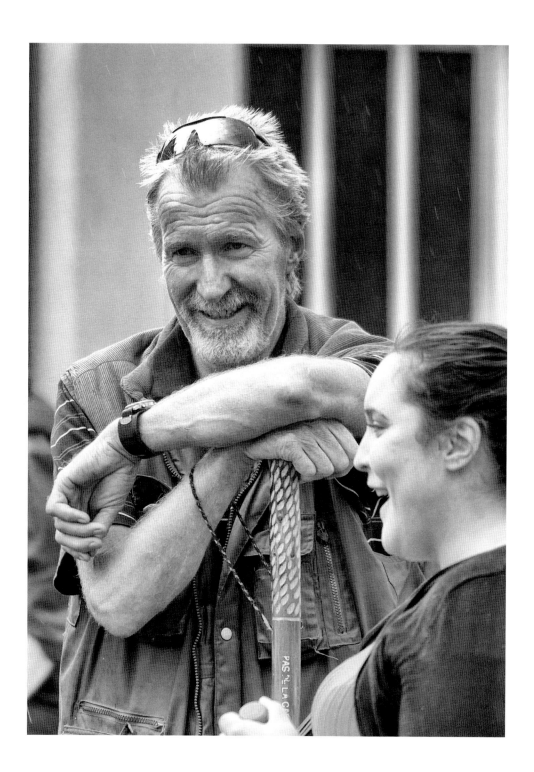

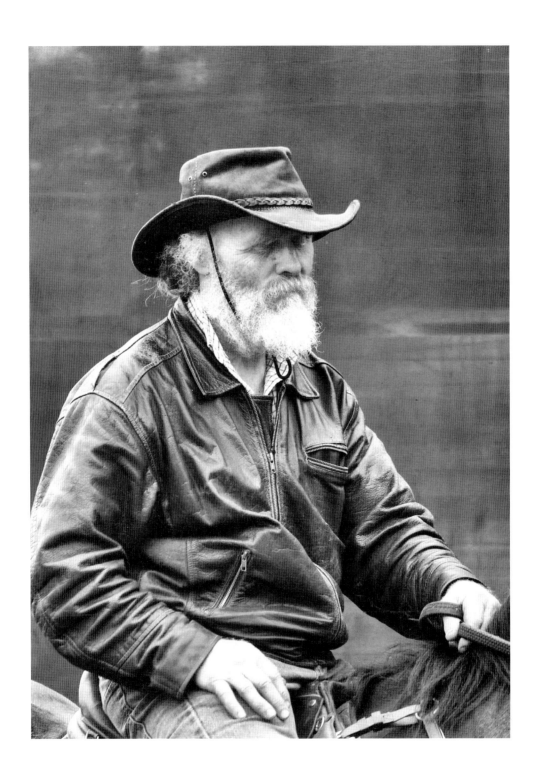

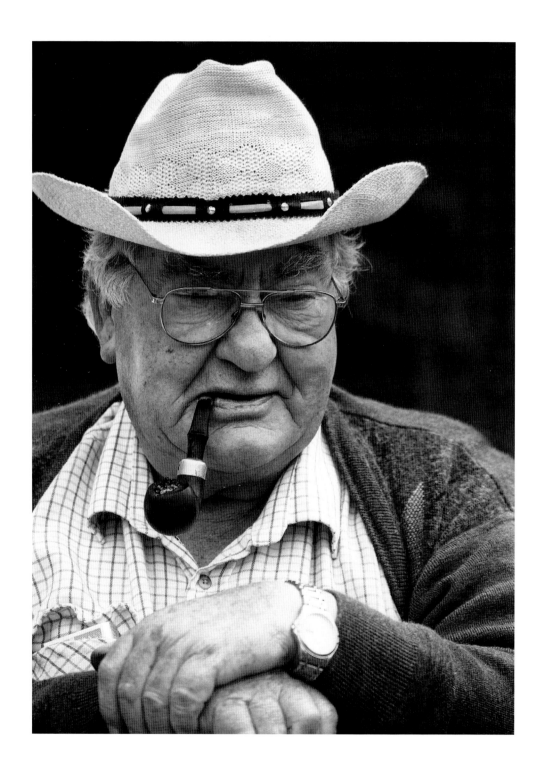

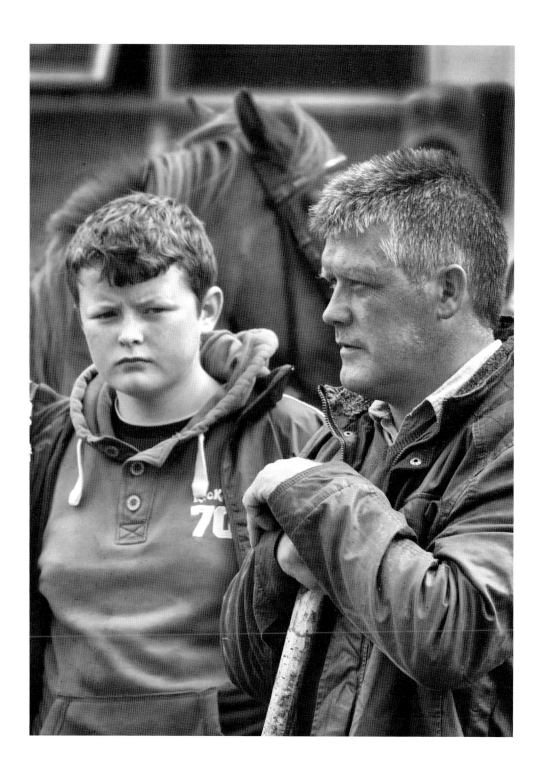

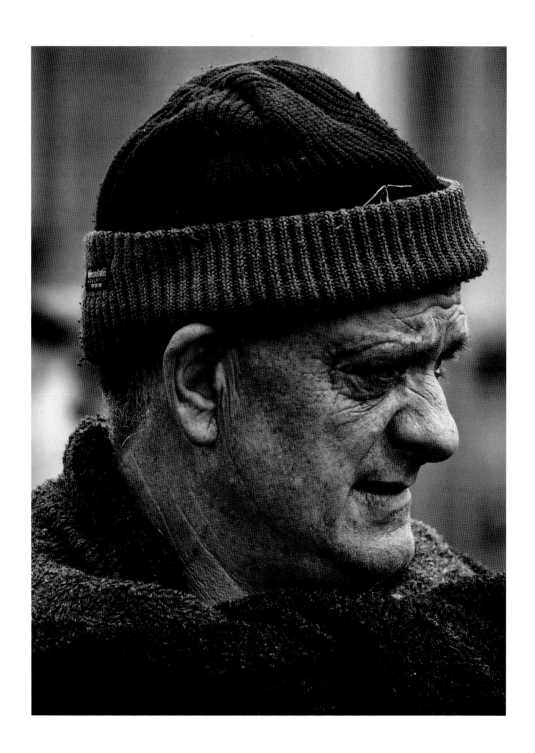

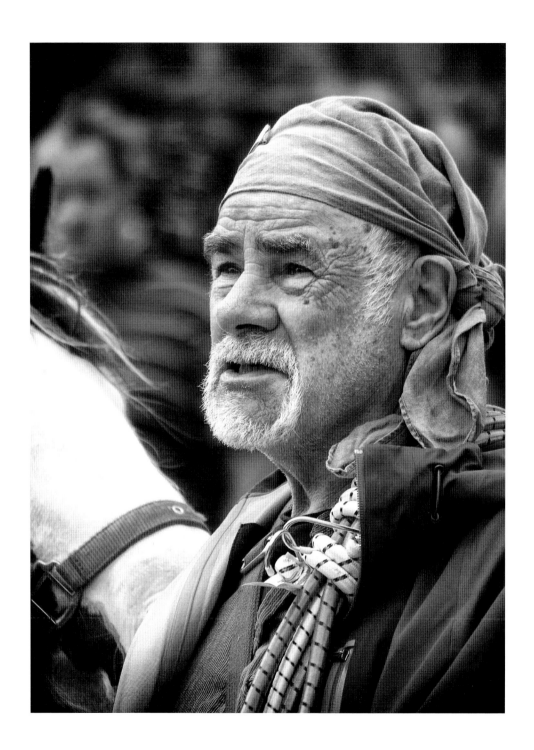

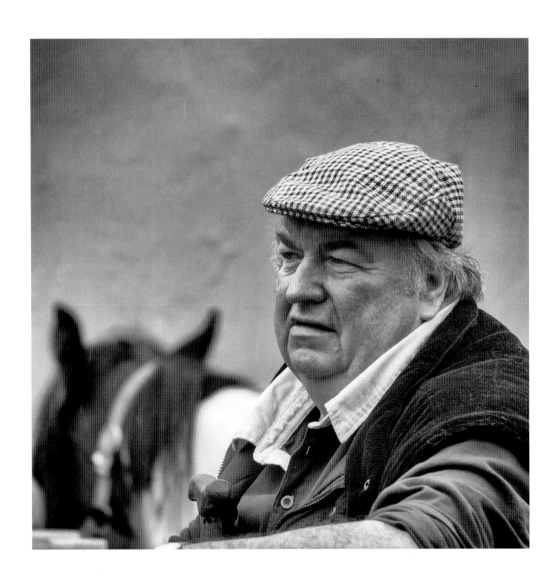

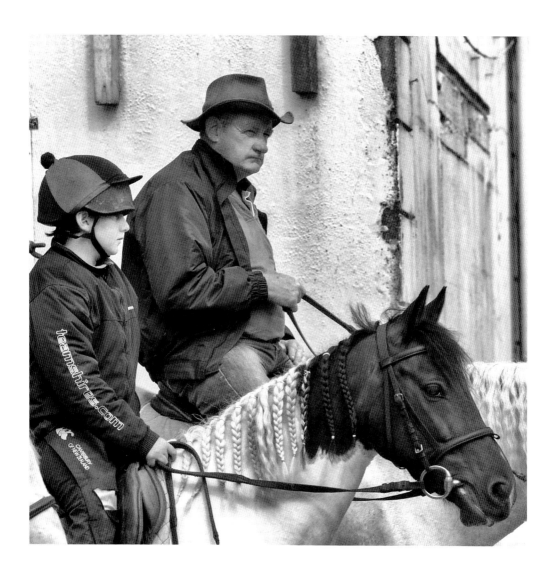

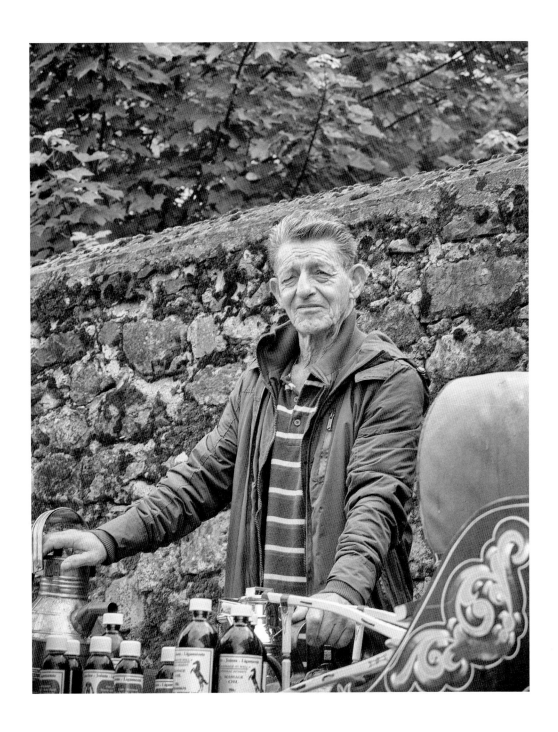

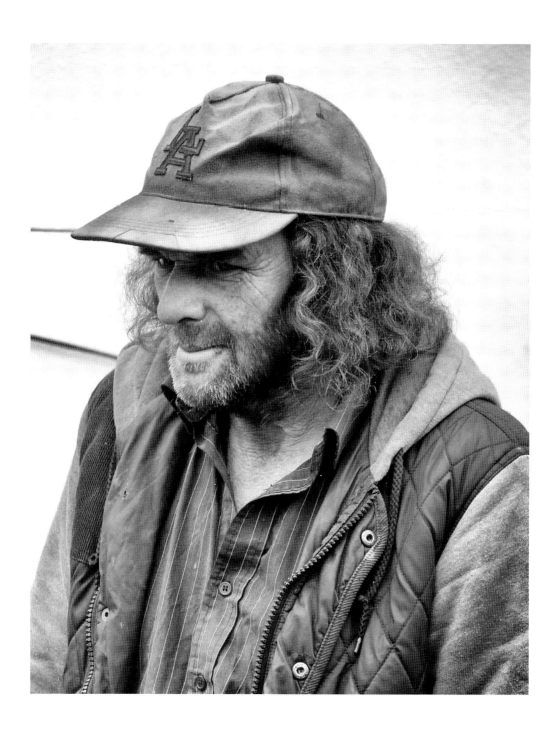

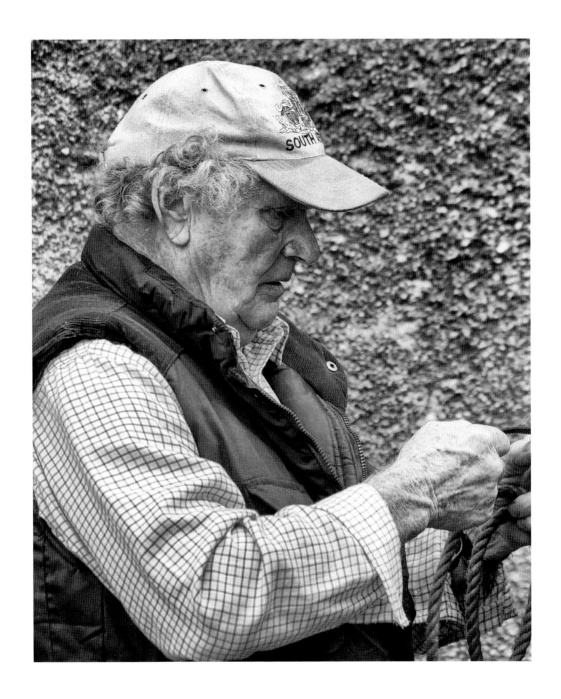

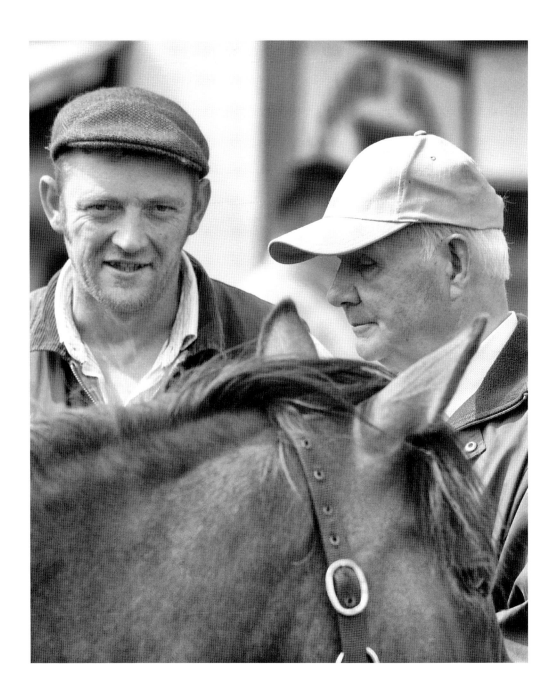

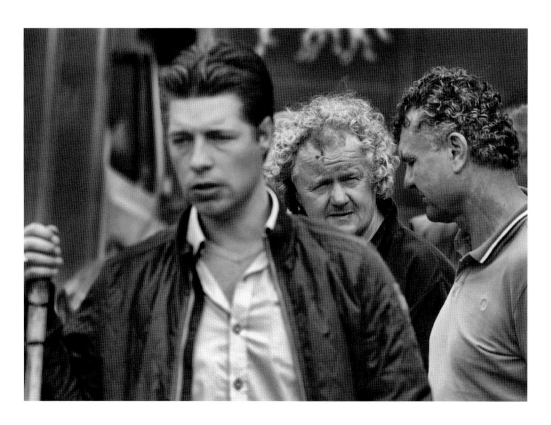

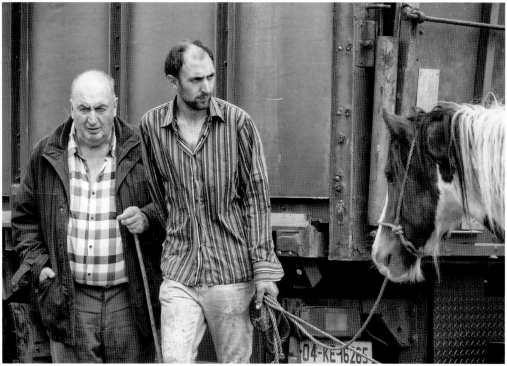

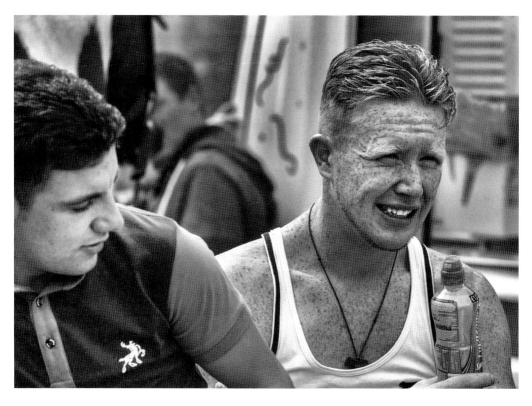

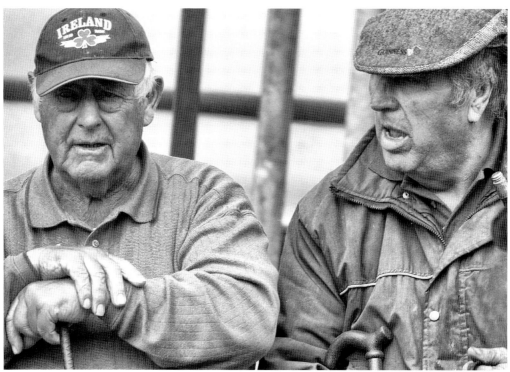

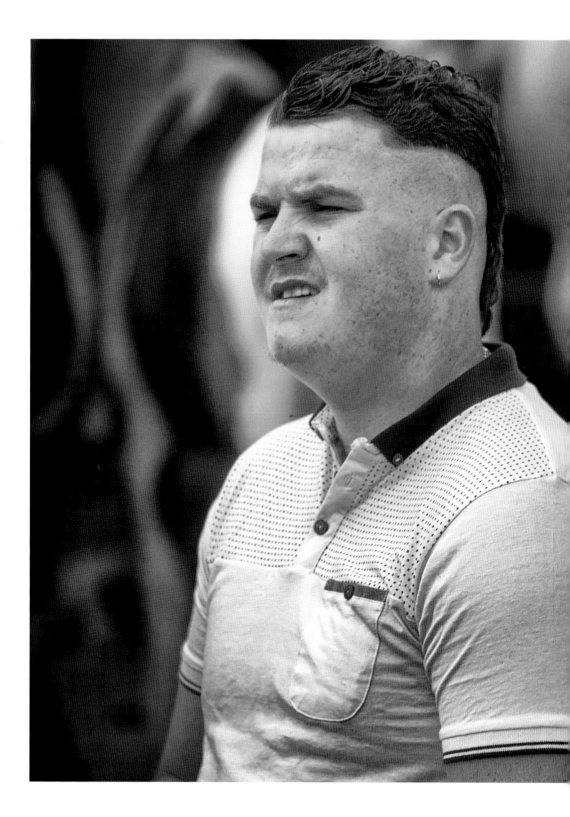

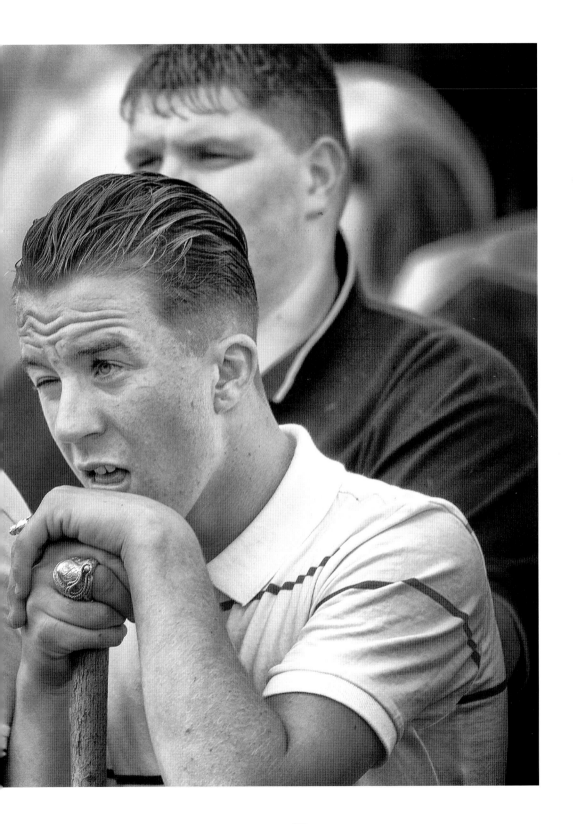

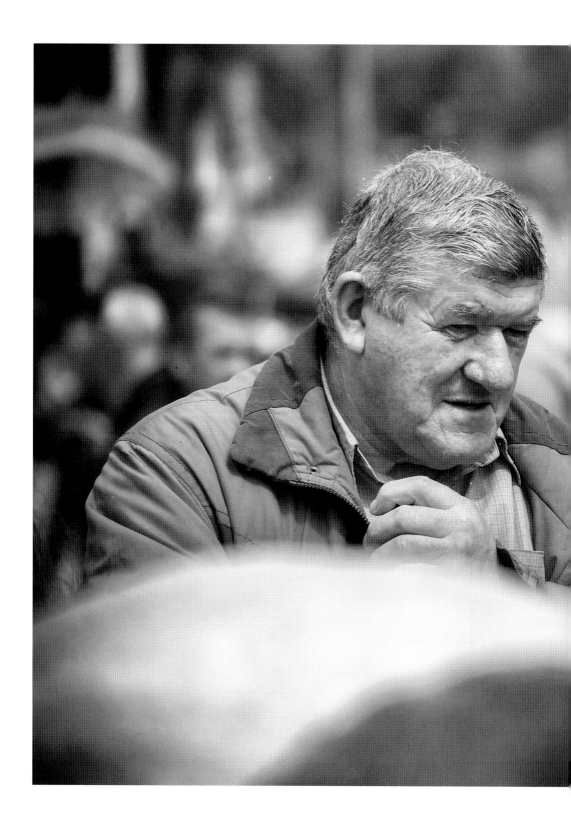

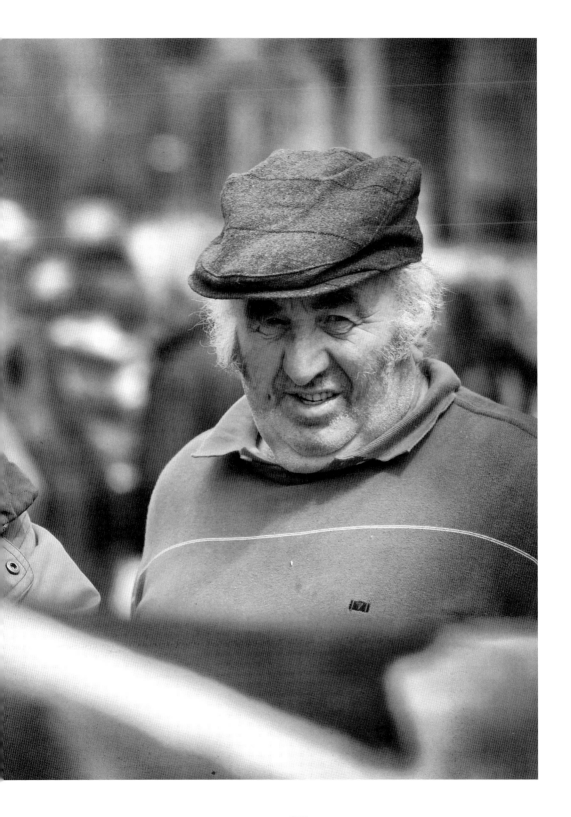

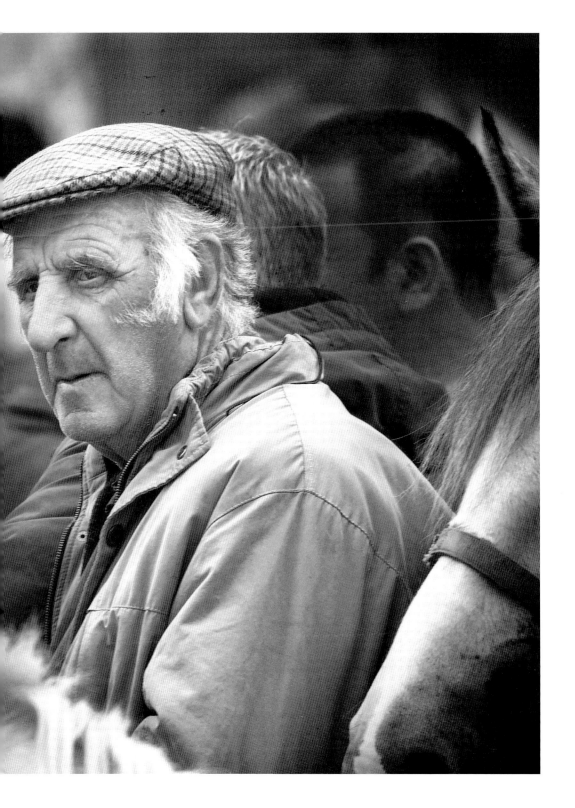

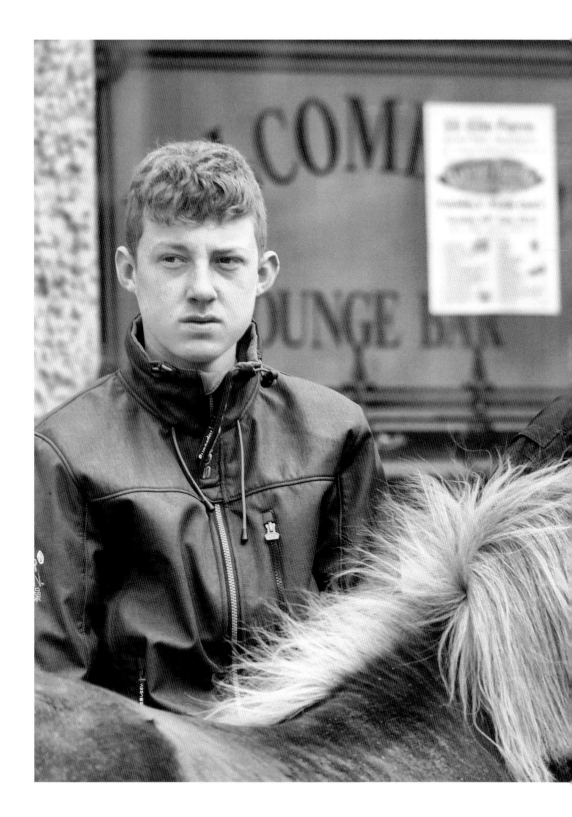

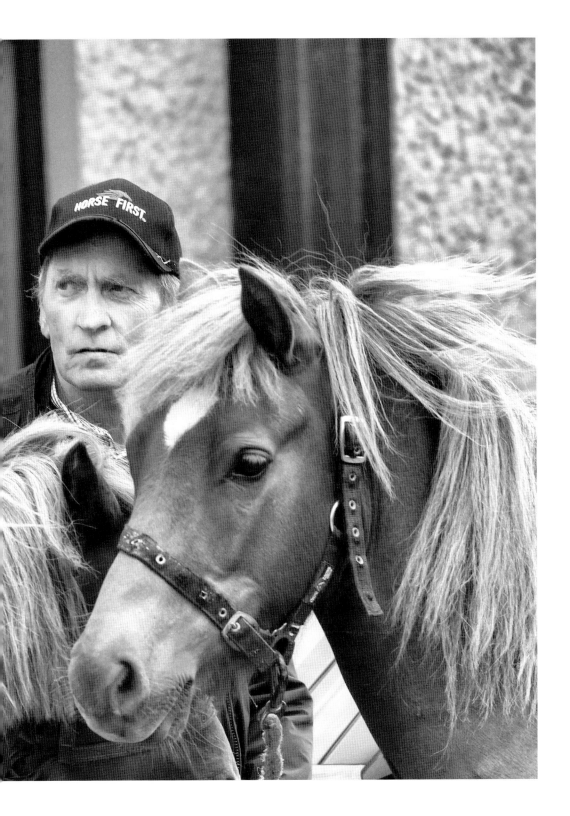

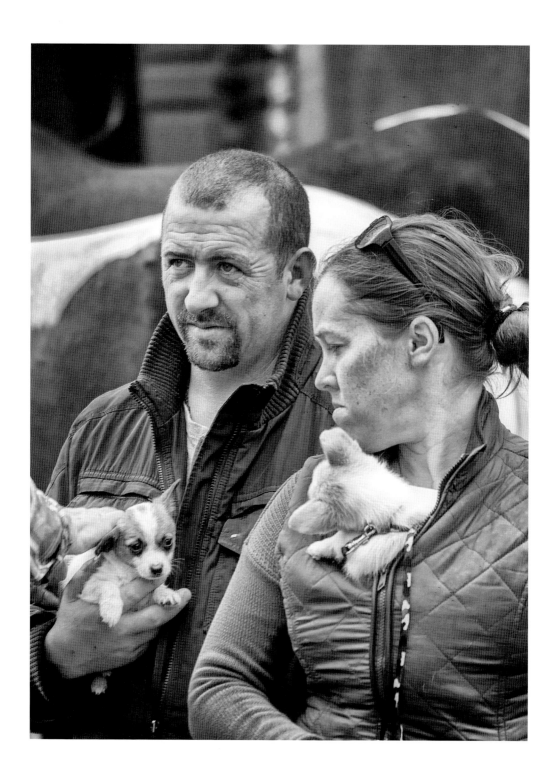

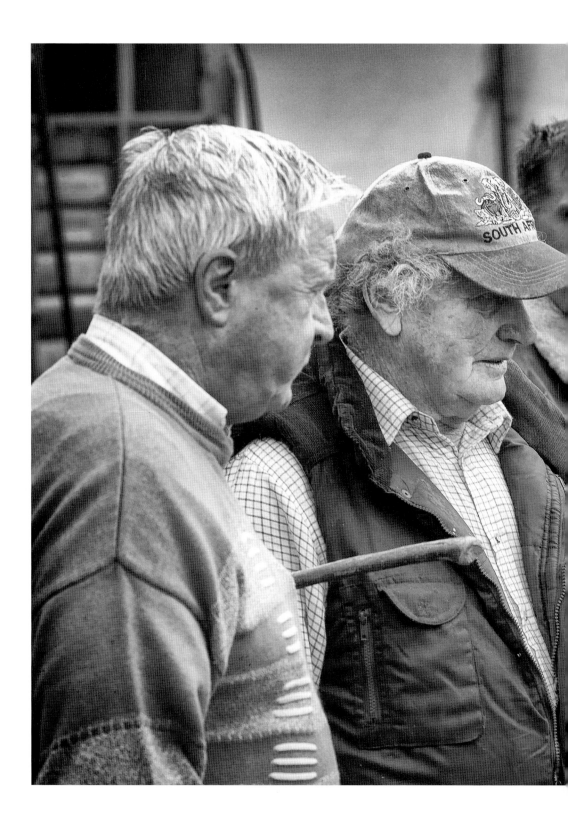

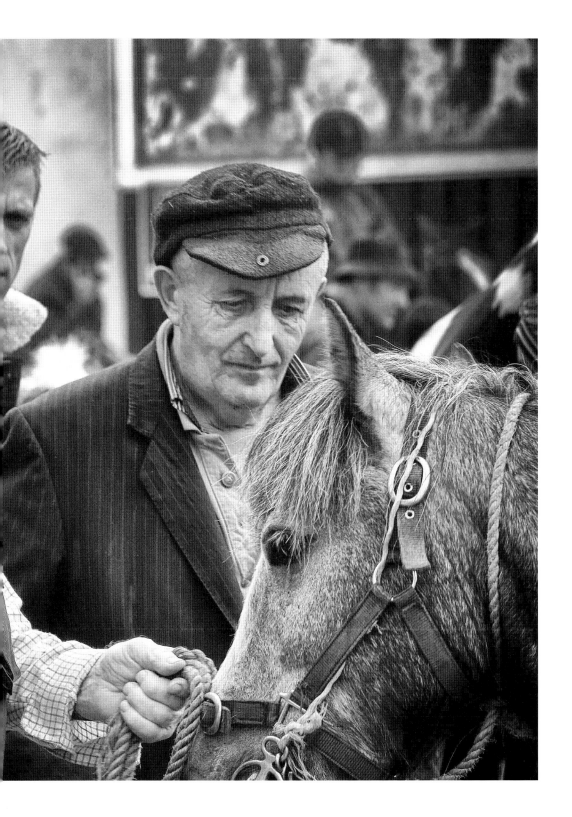

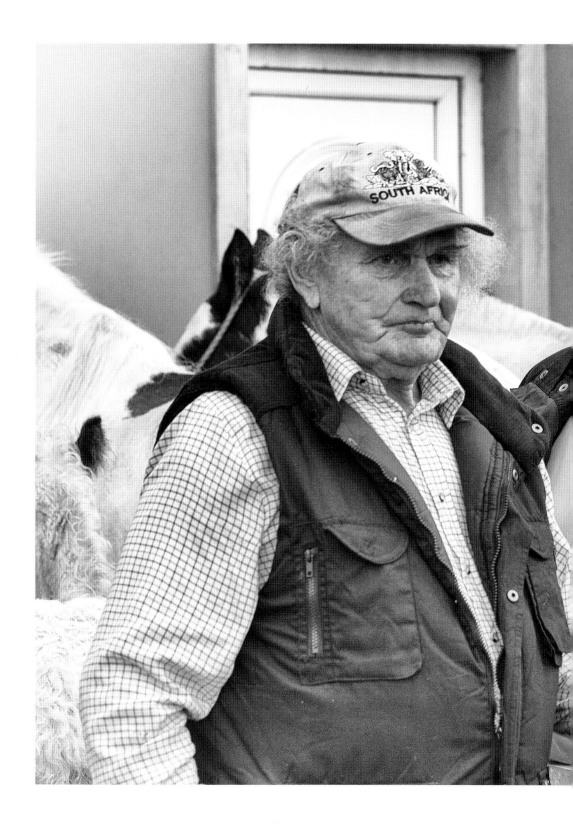

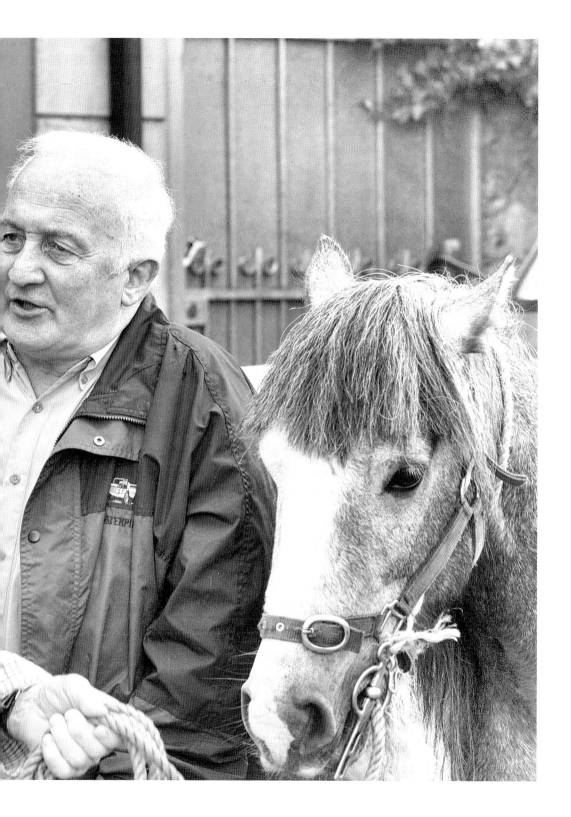

St Patrick's Day

17 March is the day that the whole world goes green and becomes Irish to celebrate our patron saint. Those from the older generation wear the shamrock on their lapels, while the young prefer to paint their faces and wear leprechaun hats and beards as they party the day away. It is estimated that over five million pints of Guinness are consumed worldwide daily, but on St Patrick's Day that number rises to thirteen million.

The story of St Patrick, for anyone who doesn't know it, goes something along the following lines. He is said by most to have spent his early years in Britain, where he was captured by Irish pirates and brought to Ireland to work as a slave. He was forced to tend to animals for six years before eventually escaping and returning home to his family. He later became a cleric and returned to convert his captors.

The dates of his life cannot be fixed but it is thought that he was active as a missionary in Ireland during the fifth century. He became Bishop of Armagh and Primate of All Ireland and many regard him as the bringer of Christianity to the island.

Legend has it that he banished the snakes from Ireland after they attacked him during a forty-day fast that he was undertaking. He is also said to have used the shamrock (a three-leafed plant) to teach the doctrine of the Holy Trinity.

I remember, as a young boy growing up in 'Catholic Ireland', that it was obligatory to abstain from something (usually sweets) during the forty-day season of Lent from Ash Wednesday to Easter Sunday. St Patrick's Day falls within that period, but was generally considered to be a day off from our Lenten abstinence, so it gave us a welcome break where we could gorge on sweets, chocolate and crisps.

The following photographs were shot as candid images at traditional St Patrick's Day parades around the south of Ireland over the last few years.

Most of the subjects were participants in the proceedings, although some were spectators in the crowd, oblivious to my lens.

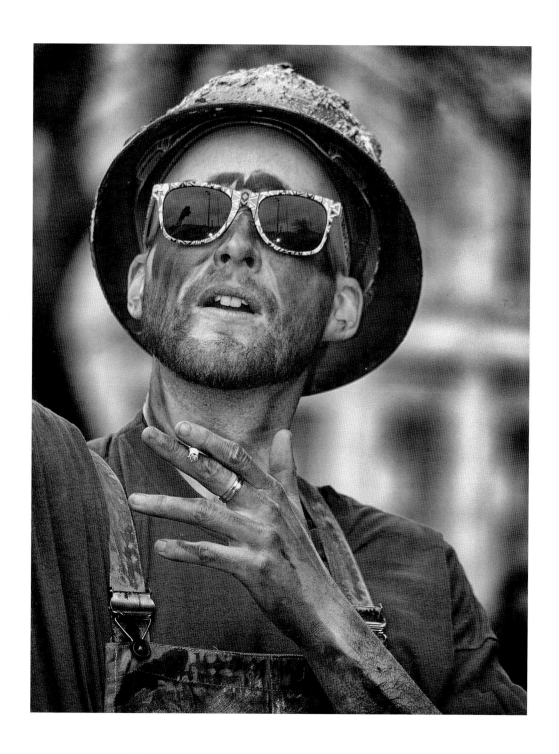

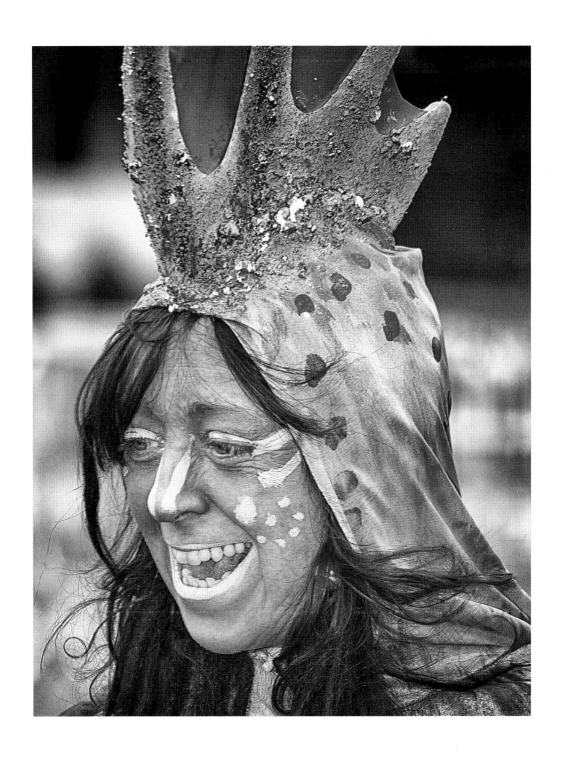

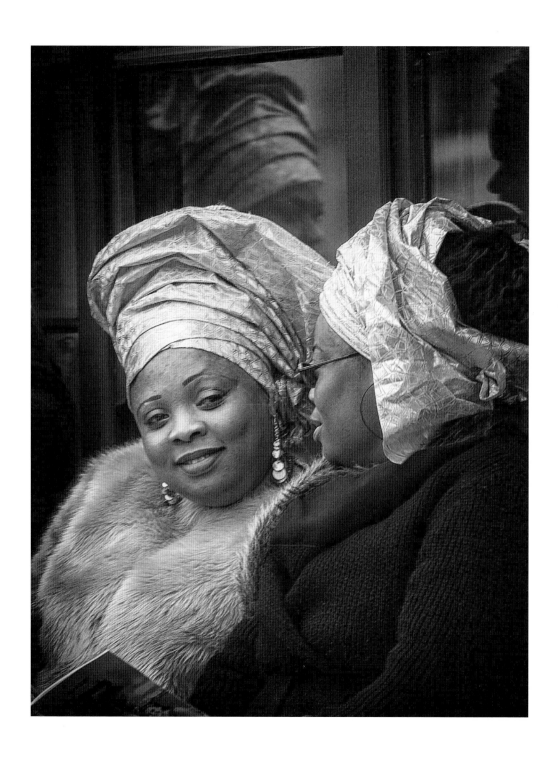

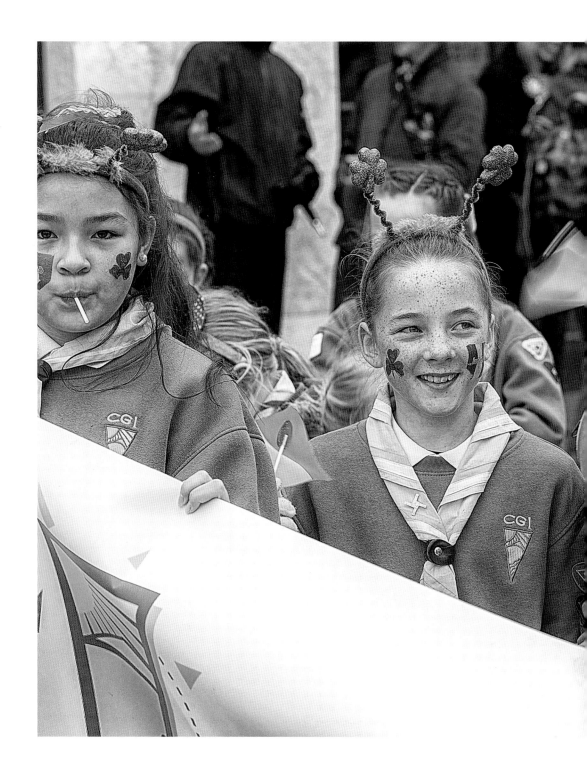

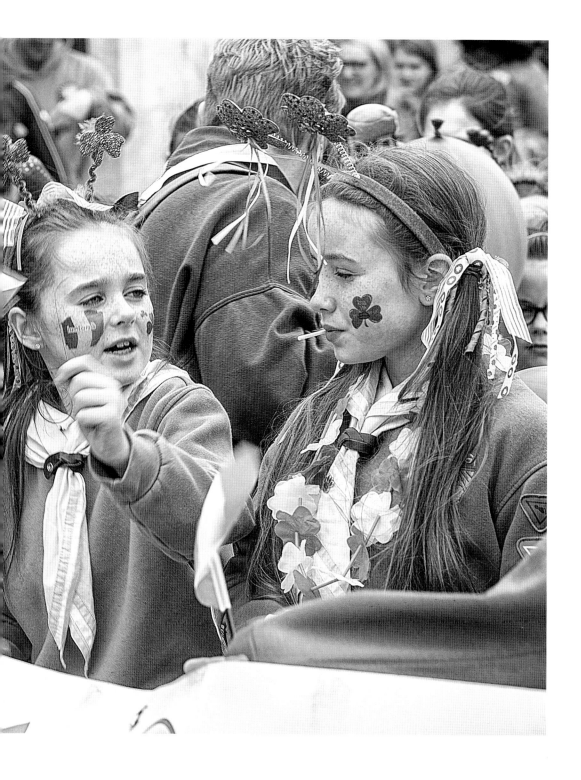

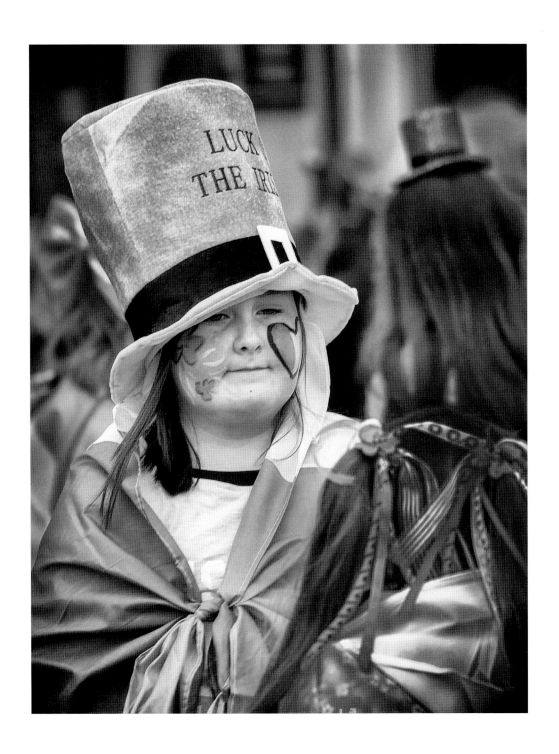

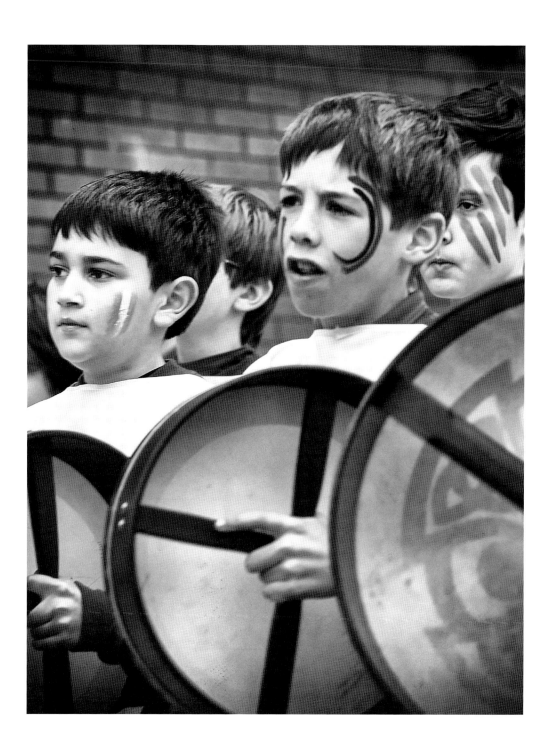

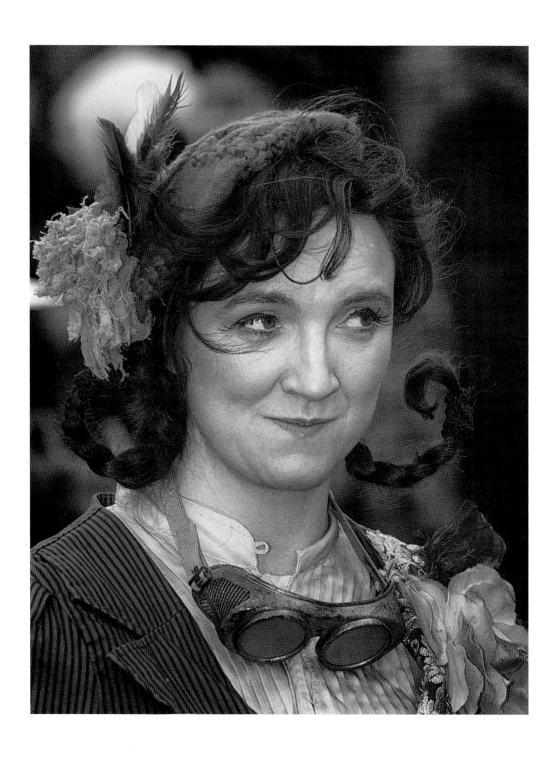

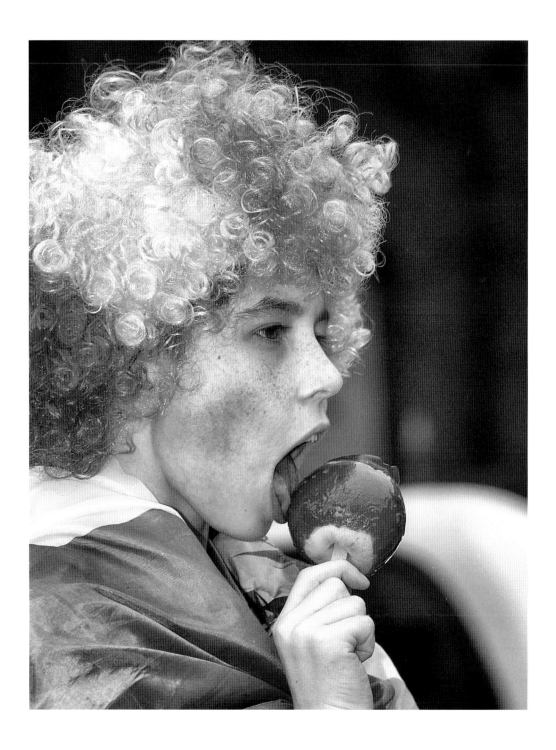

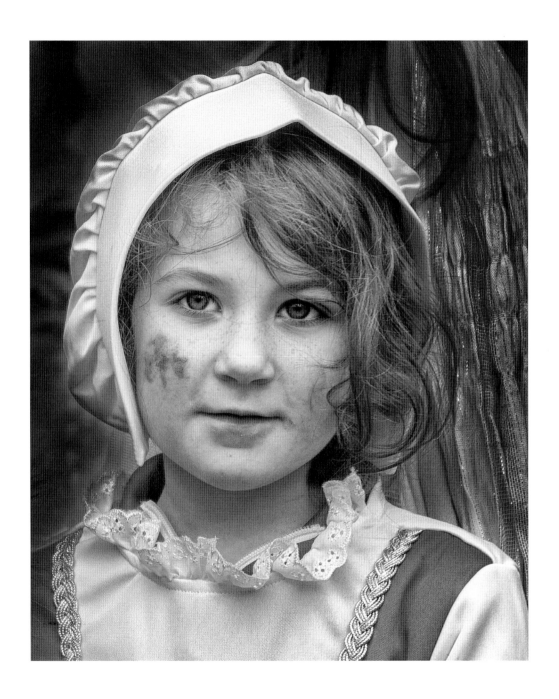

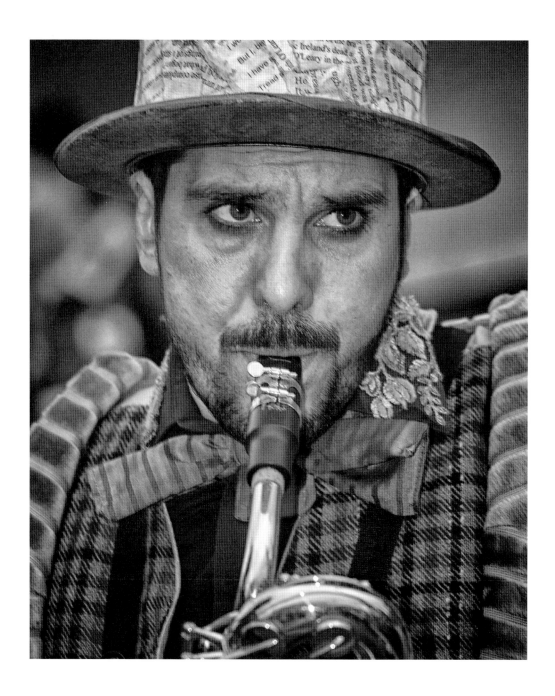

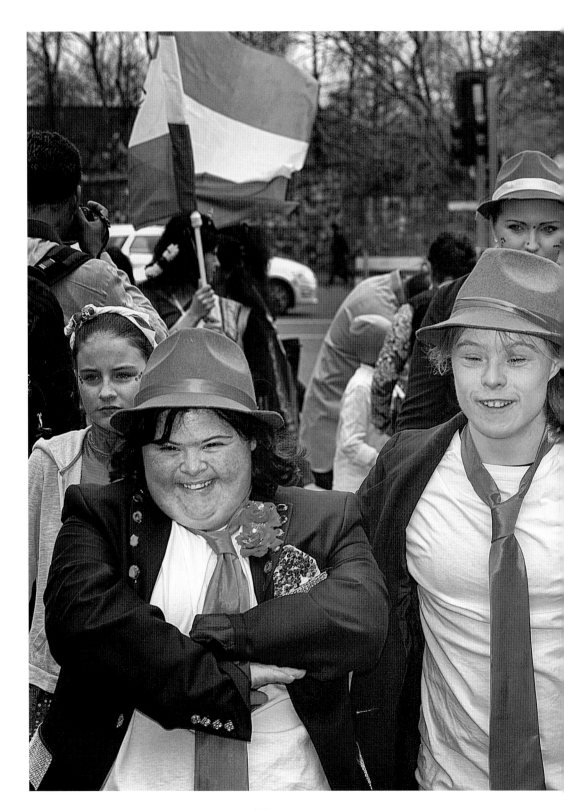

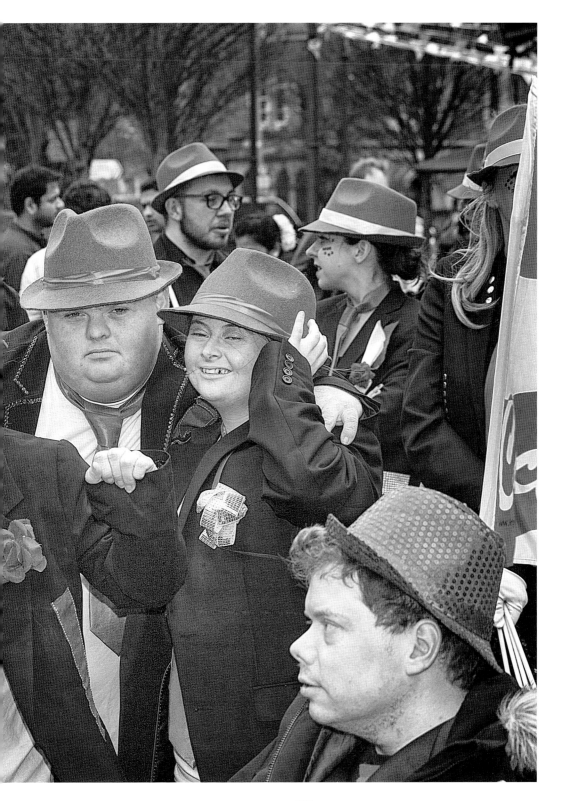

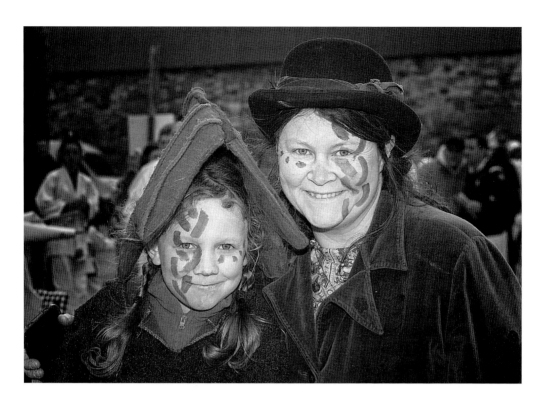

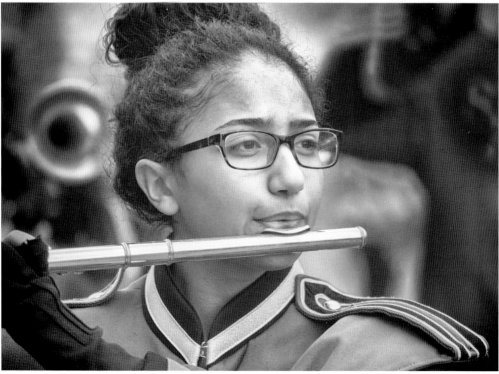

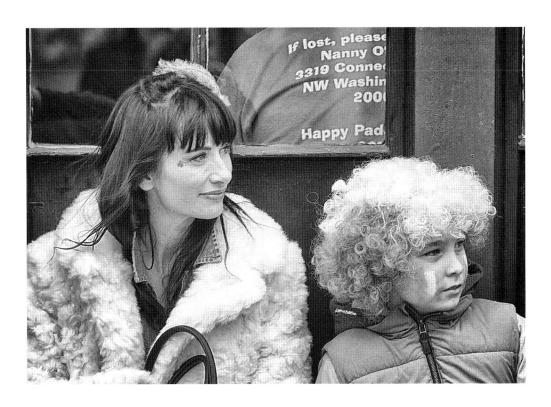

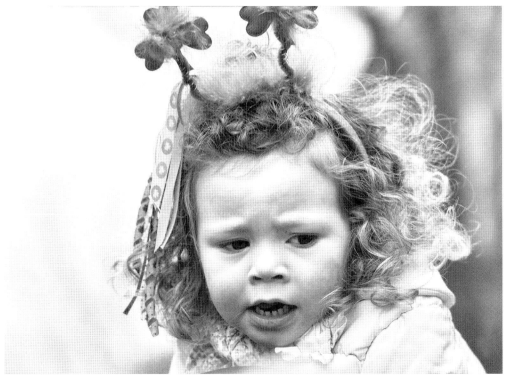

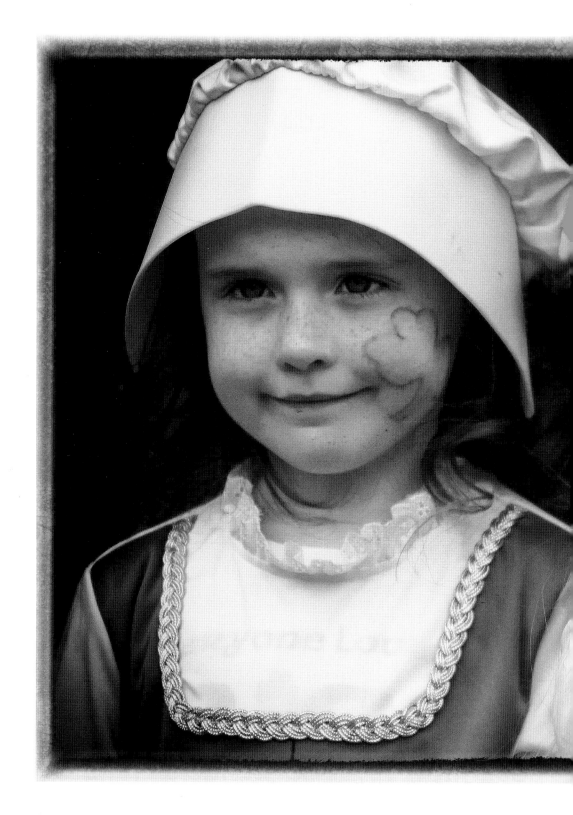

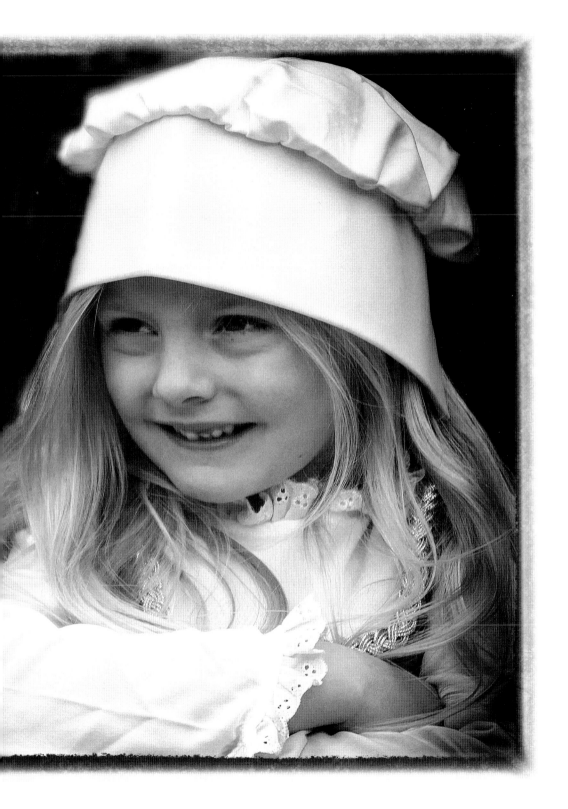

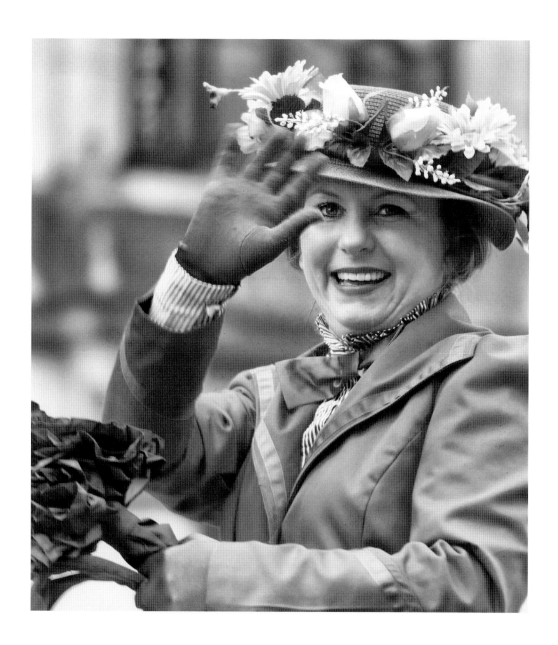

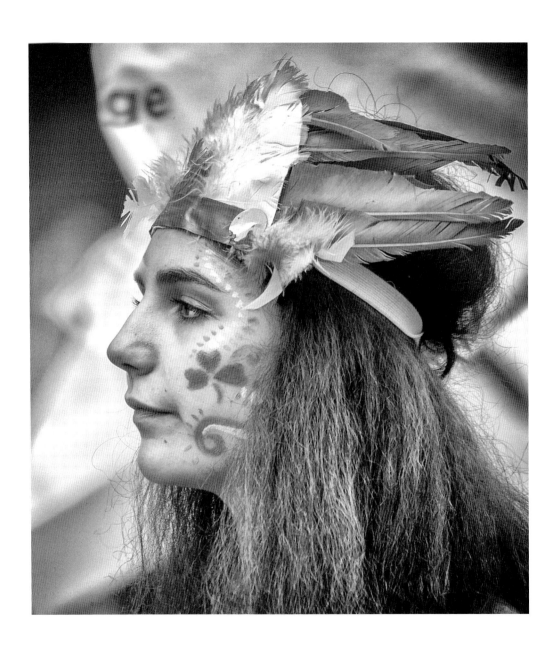

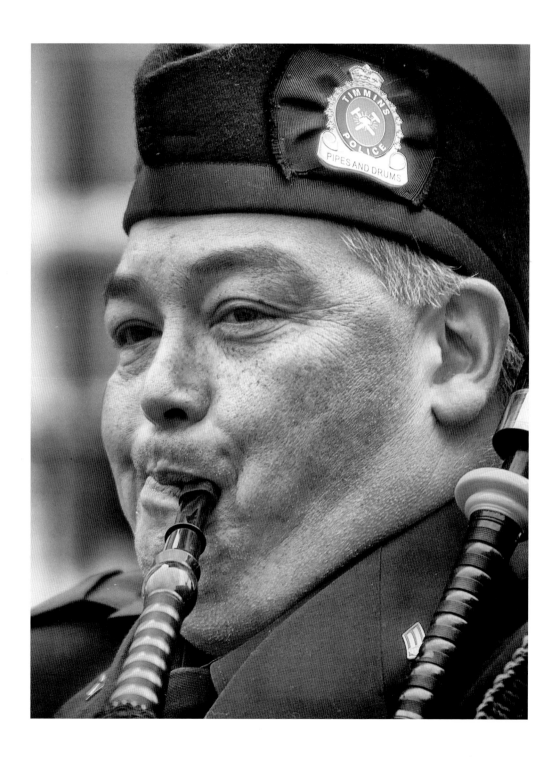

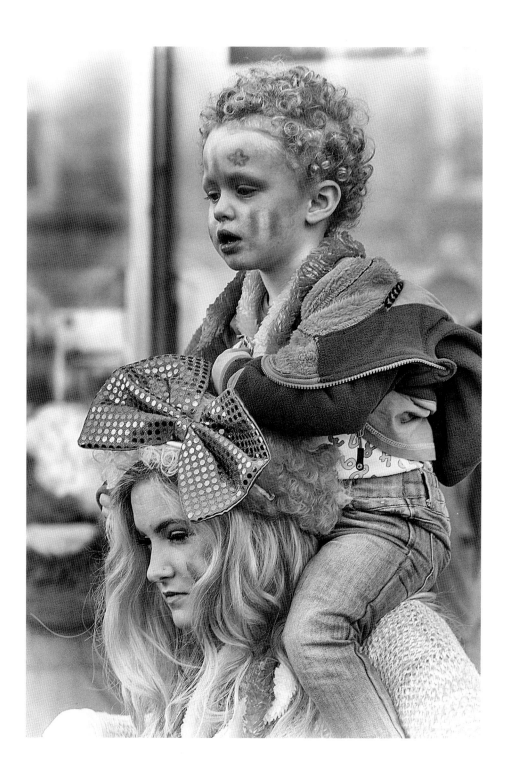

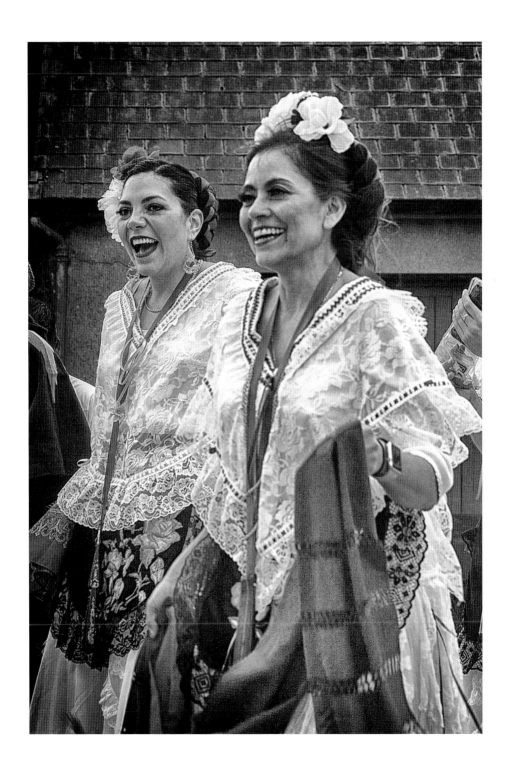

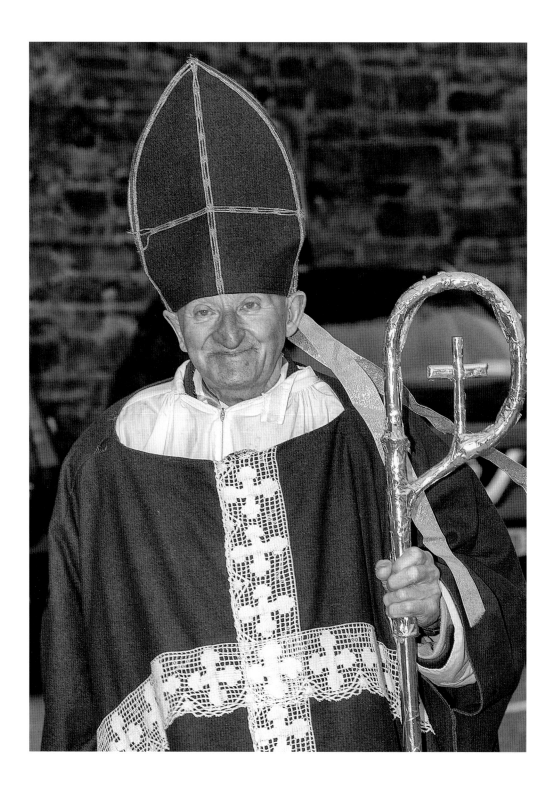

The Cork Eucharistic Procession

I was drawn to photograph the Cork Eucharistic Procession in the summer of 2016 because I remembered it as a huge event each year in the fabric of my early childhood growing up in Cork.

The first Cork Eucharistic Procession took place in the mid-1920s when some of the city's businessmen approached the then Bishop of Cork, Daniel Cohalan, with the idea of a procession to mark the feast of Corpus Christi. It has been an annual event ever since. It still follows the same route from the North Cathedral, down Roman Street, on to Upper John Street, along Camden Quay and over St Patrick's Bridge to the city centre and Daunt's Square. A special stage is erected at Daunt's Square, where a choir sings sacred hymns in the lead-up to the arrival of the main procession. The Bishop of Cork then gives a sermon and prays with the congregation present.

During my childhood, I remember how virtually every household in the city flew the yellow and white papal flag from the top window on the day of the procession. The downstairs windows were decorated with large sacred pictures and lit candles, and the crowds that lined the procession route very nearly rivalled the turnout for the St Patrick's Day parade on 17 March.

Back then, once a young boy reached Confirmation age it was taken for granted that he would walk from his local church with the men and priests of the parish to link up with the main procession in the city centre. (Nowadays, of course, young girls in their dazzling white Communion dresses and the women of the parish also participate.)

Through the innocent eyes of a child in Ireland during the late 1960s, I'm sure that everything must have seemed bigger and better than it actually was. To tell the truth, my abiding memory of the procession was of standing in short pants in the blistering heat (the summers of our childhood were always hotter and drier),

holding my late father's hand as we watched the soldiers from the guard of honour collapse from dehydration on the Grand Parade as the prayers and singing continued around them. This ceremony was always followed by an ice cream cone for each of us on the long trek home up Summerhill.

As the parade was a big part of the tradition and history of the city, I felt it was important to record the event for posterity. I also wanted to stand with my son and have the next generation witness the events as I did all those years ago. Furthermore, given that the influence and importance of the church has diminished considerably in the intervening years, I was keen to see what the event looked like now, through the eyes of a fifty-something adult.

The images that follow were taken at the 2016 ceremony, which was the ninety-first anniversary of the original event. Times and attitudes have changed in twenty-first-century Ireland and nowadays it is mostly the older generation who still partake in the event. The scarcity of young people at the procession was hardly a surprise.

I was struck, however, by the large amount of Asian, African and Eastern European communities both partaking in and watching the event, and I found myself wondering if the reality of our newfound multicultural society would be the catalyst for the re-emergence of the Catholic faith in Ireland.

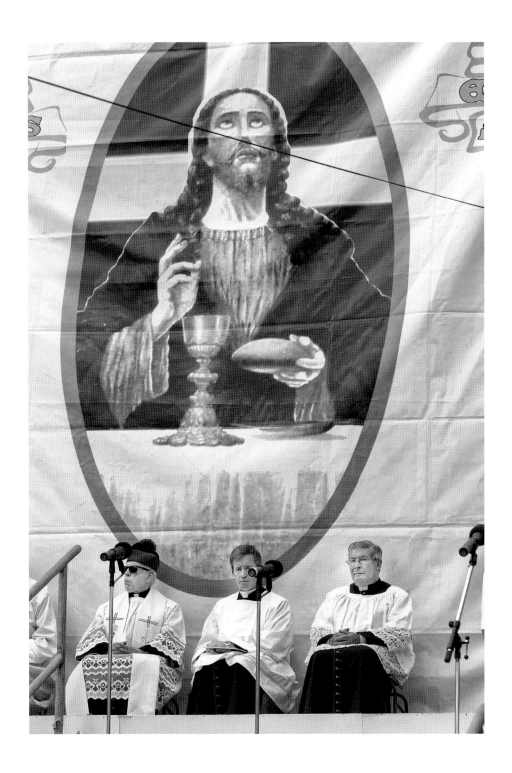

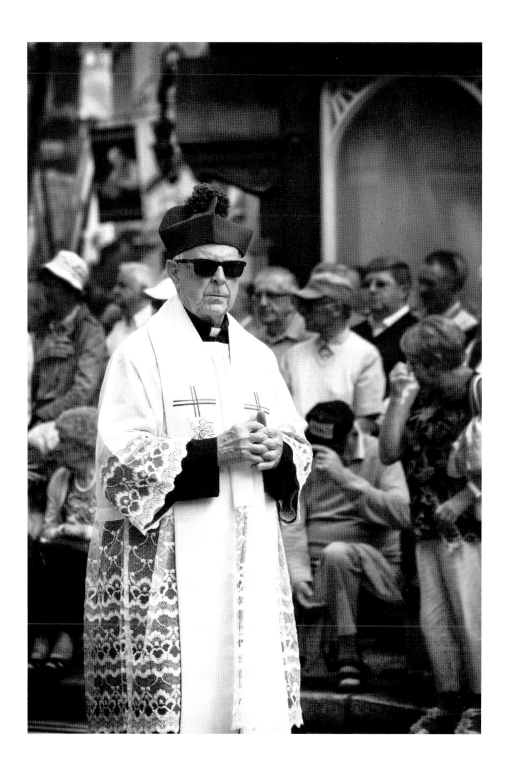

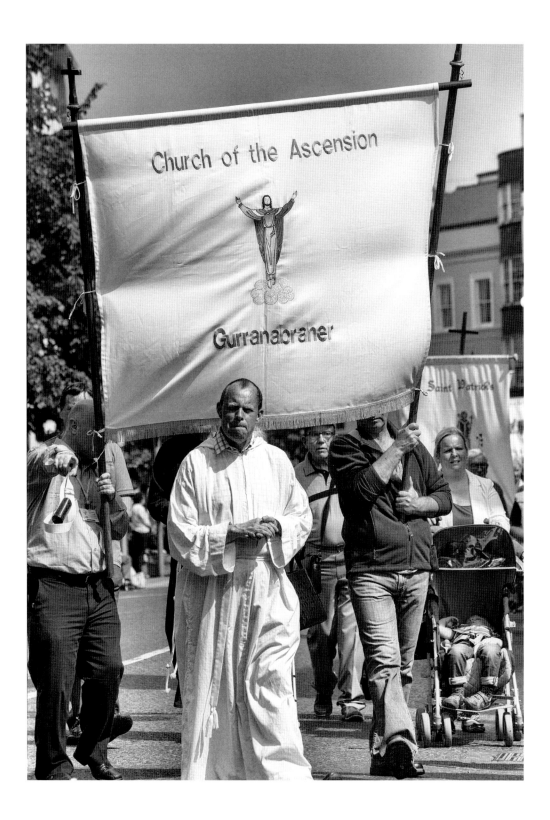

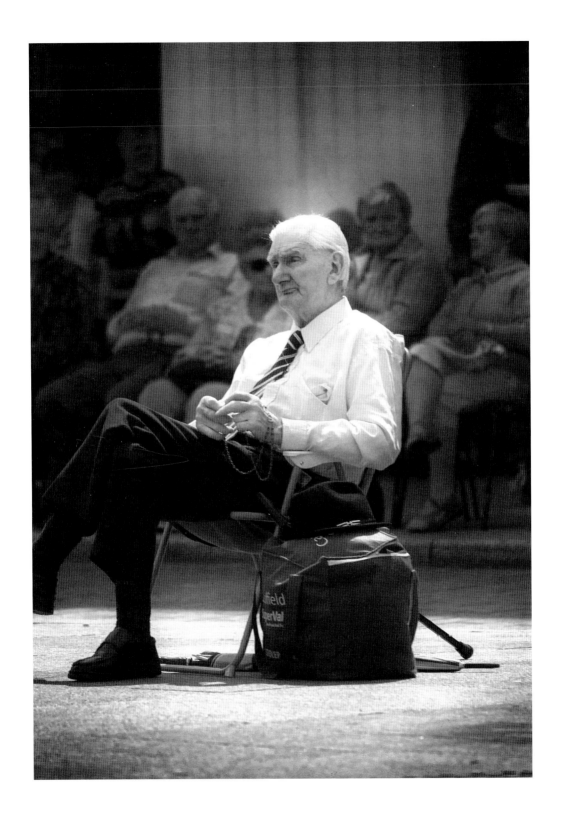

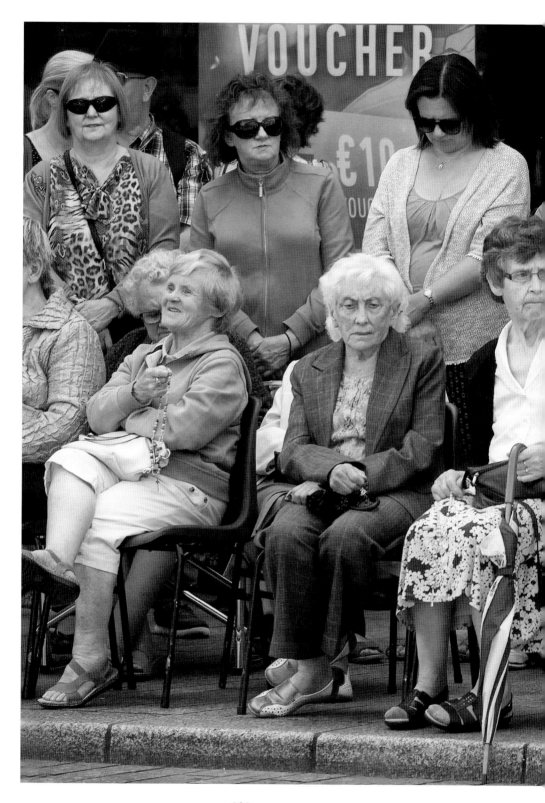

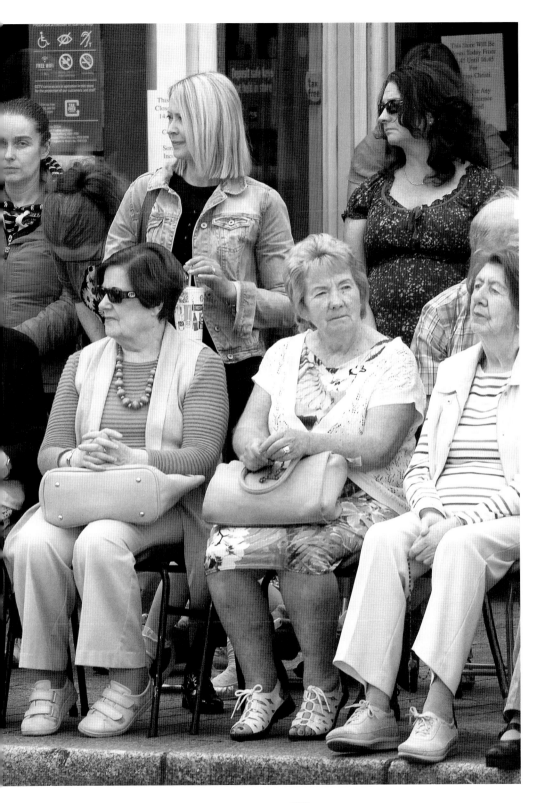

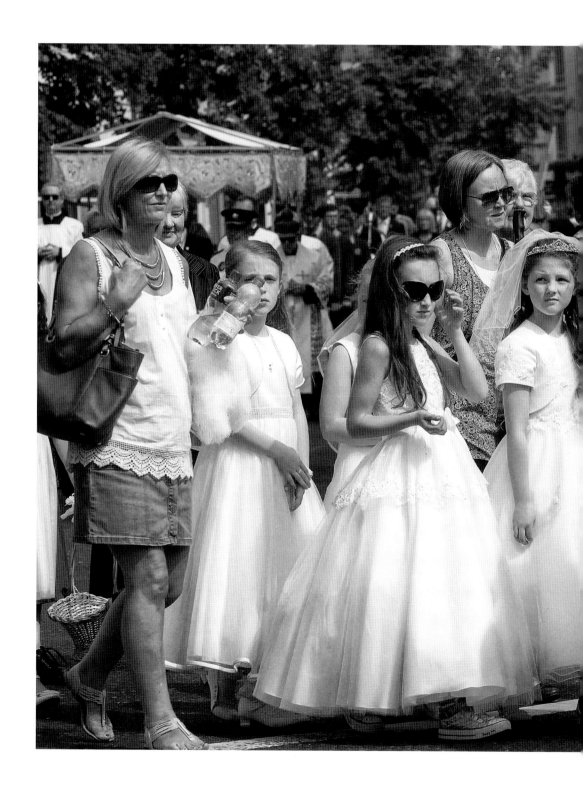

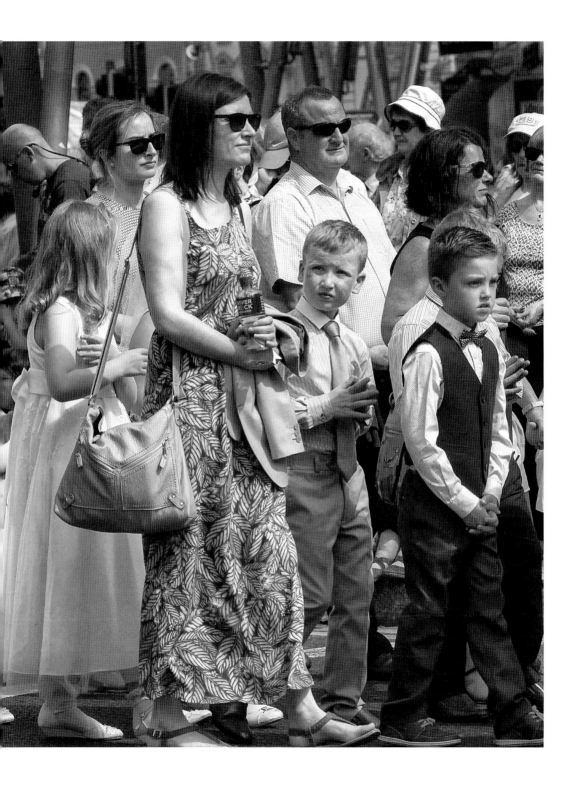

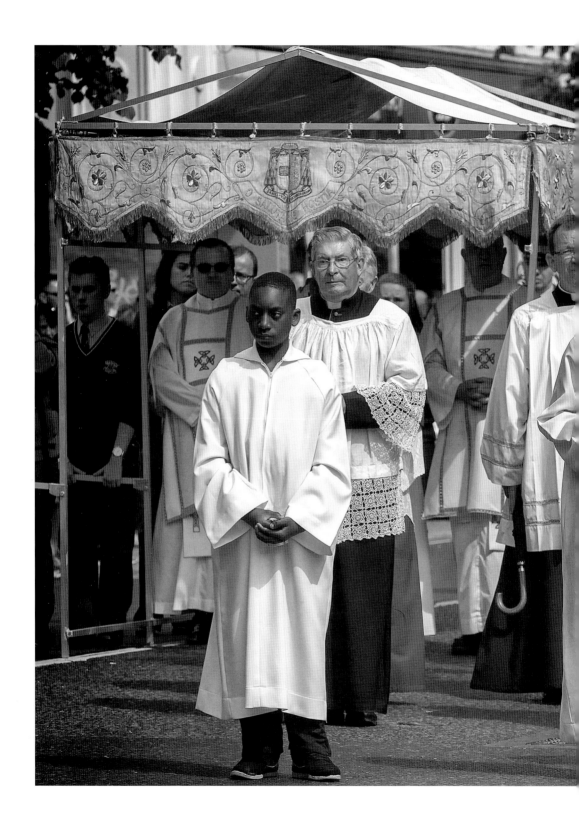

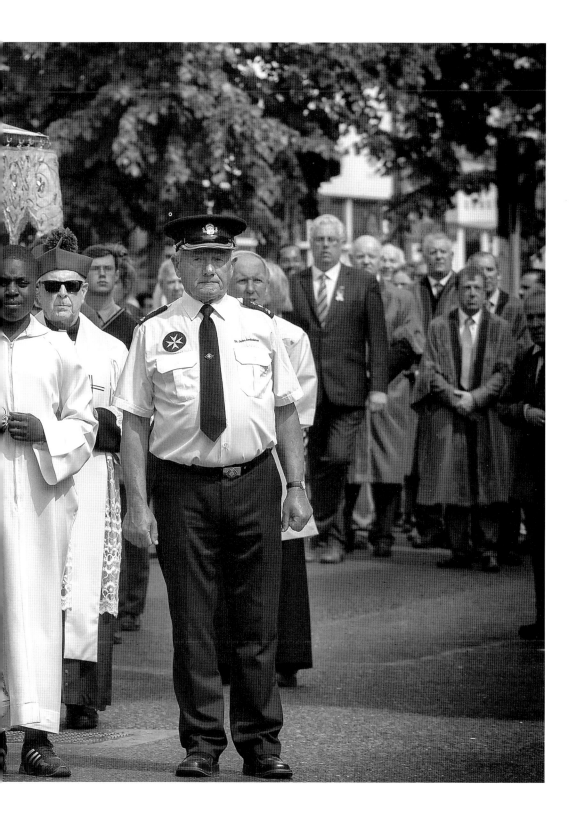

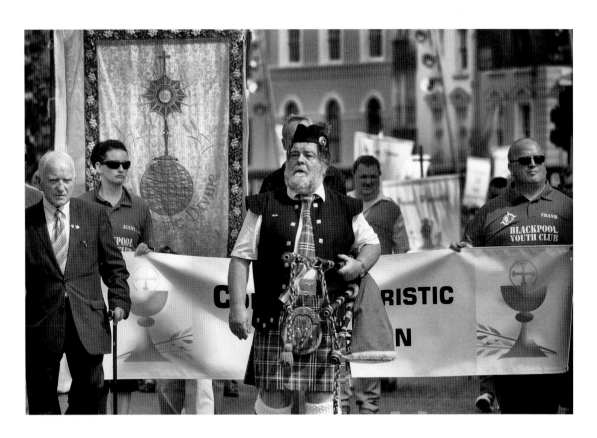

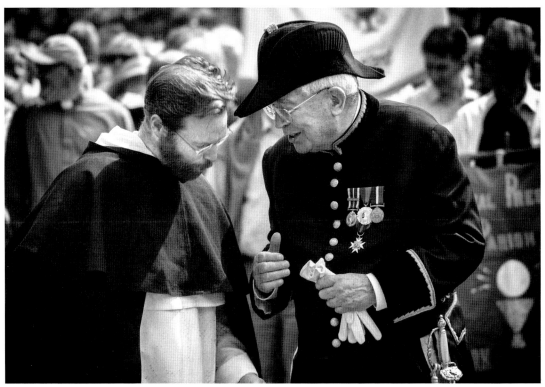

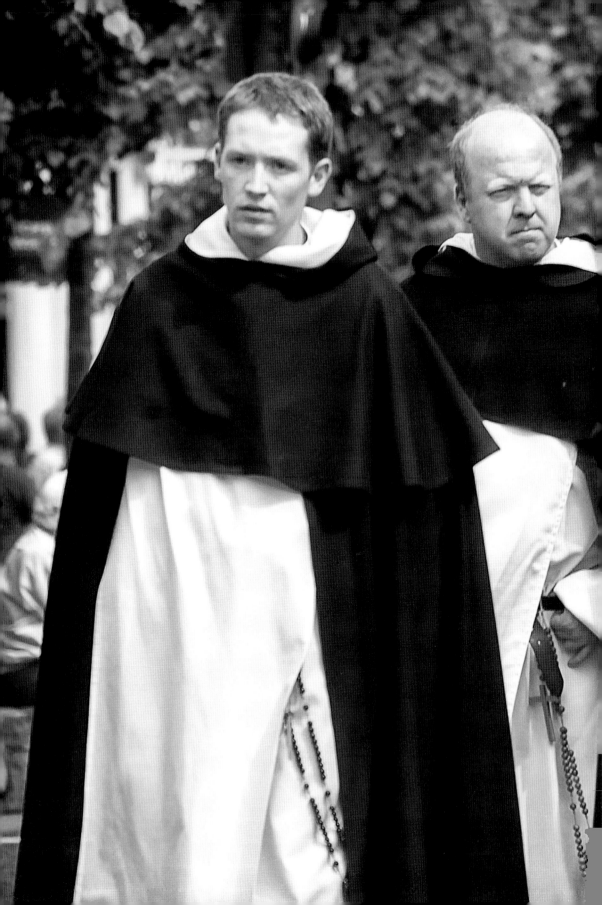

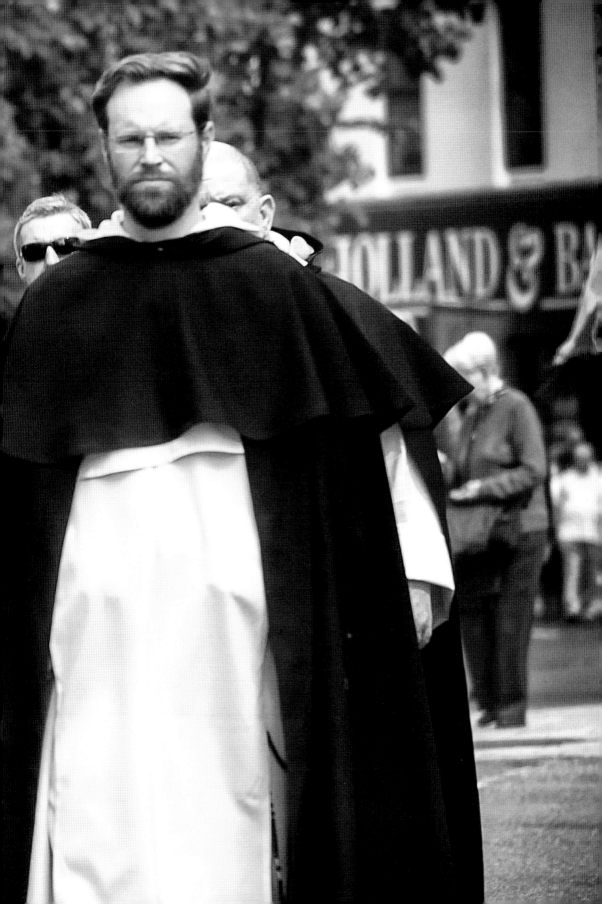

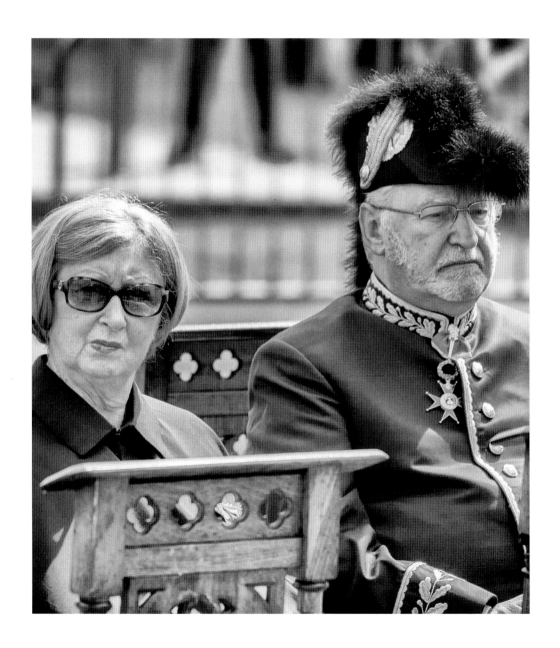

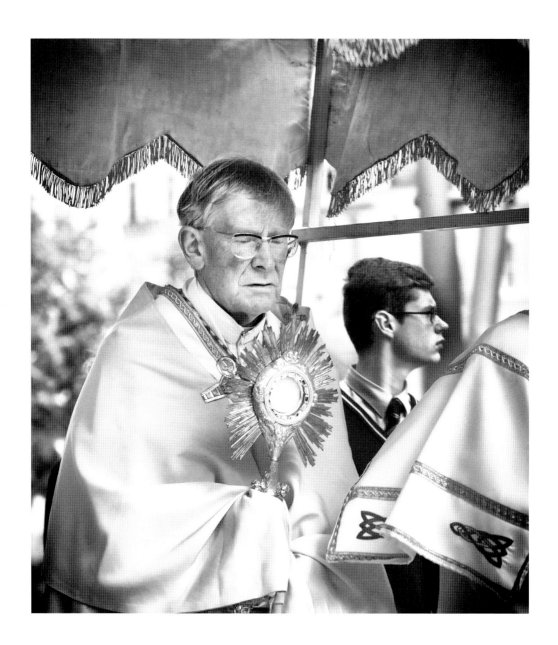

The Vintage Festival

The annual summer vintage festival is a feature of virtually every parish in Ireland. It invariably happens on a Sunday in July and usually brings the entire population of the locality out in a show of community spirit and celebration.

The aim is usually to raise much-needed funds for local charities, community projects and sporting organisations, and the format tends to involve a display of old machinery and vintage cars, a dog show, bouncy castles, donkey rides for the children, possibly a demonstration by a traditional blacksmith and various stalls selling tea and cakes along with locally grown produce and preserves.

These images were taken at the Roberts Cove Vintage Festival, which takes place every year in a field high up over the village of Roberts Cove, Co. Cork, and overlooking the ocean. A more spectacular and picturesque backdrop for a festival would be difficult to find.

I wandered around with my camera for several happy hours (before the rain came) snapping local children on the bouncy castle and fairground rides, older gentlemen extolling the virtues of the local 'men's shed' (a branch of the Irish Men's Sheds Association, a charity set up to promote social interaction and improve well-being for adult men of all ages) to anyone interested, enthusiasts lovingly polishing their vintage cars and dog lovers waiting patiently with their freshly washed and groomed canines for the dog show to get underway.

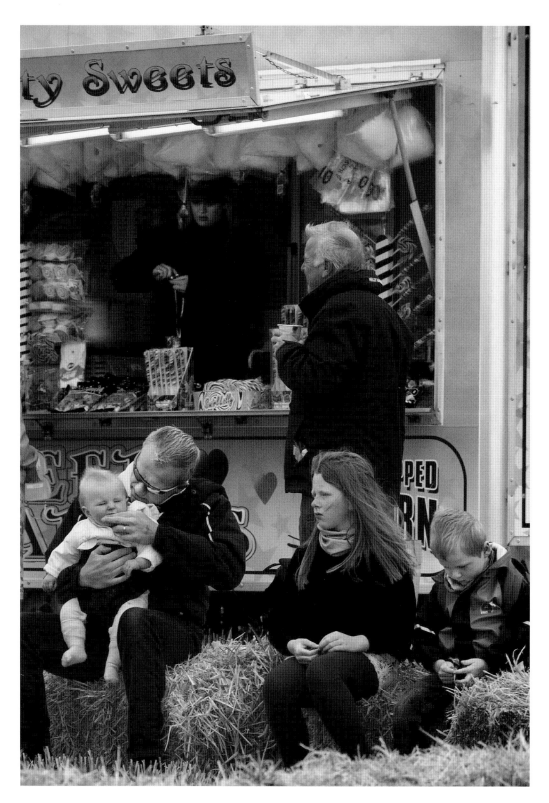

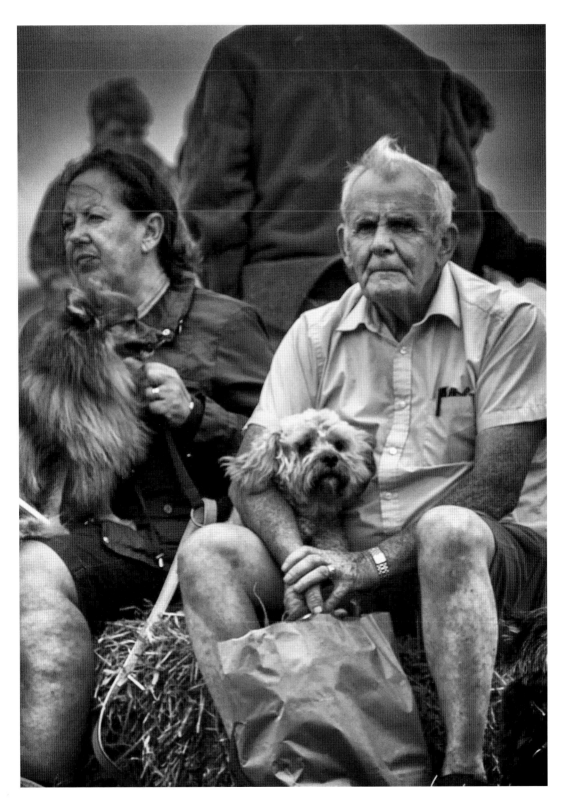

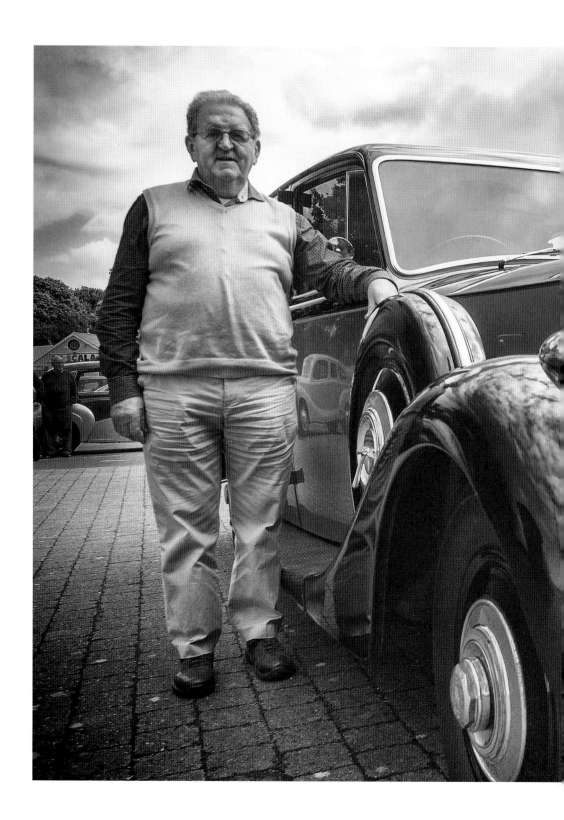

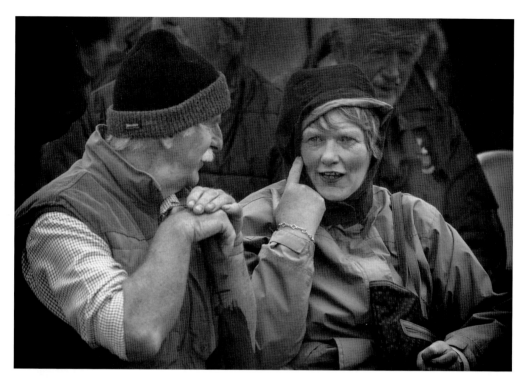

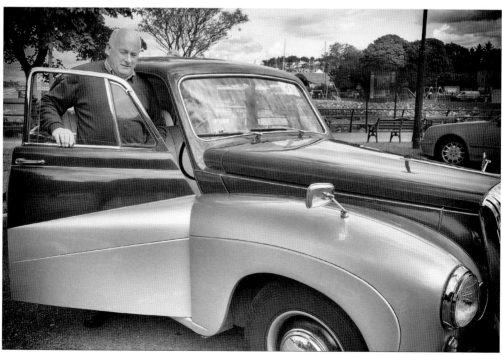

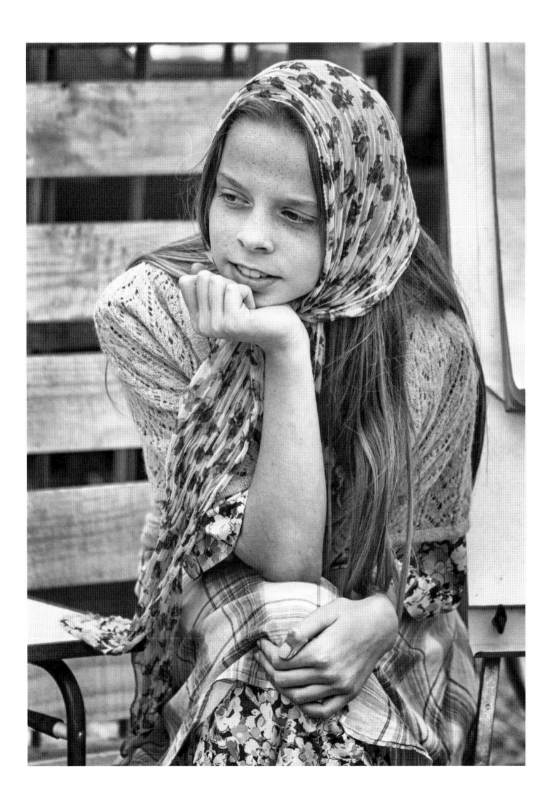

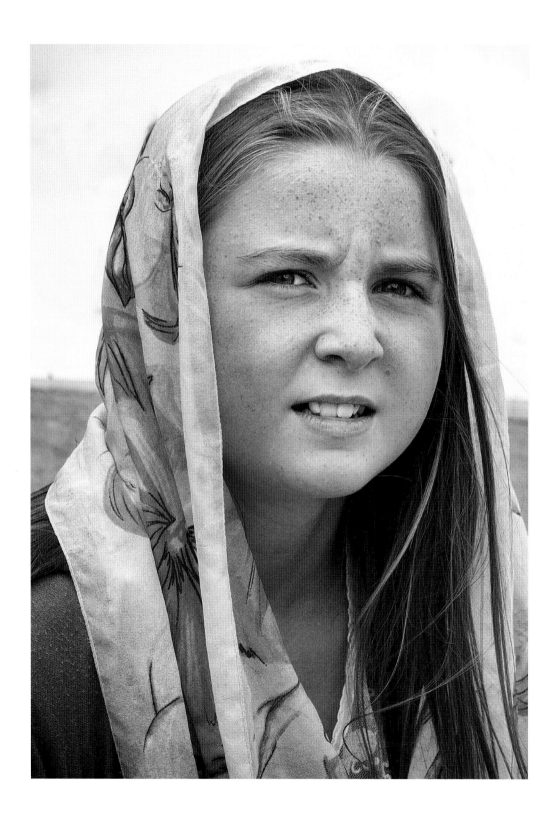

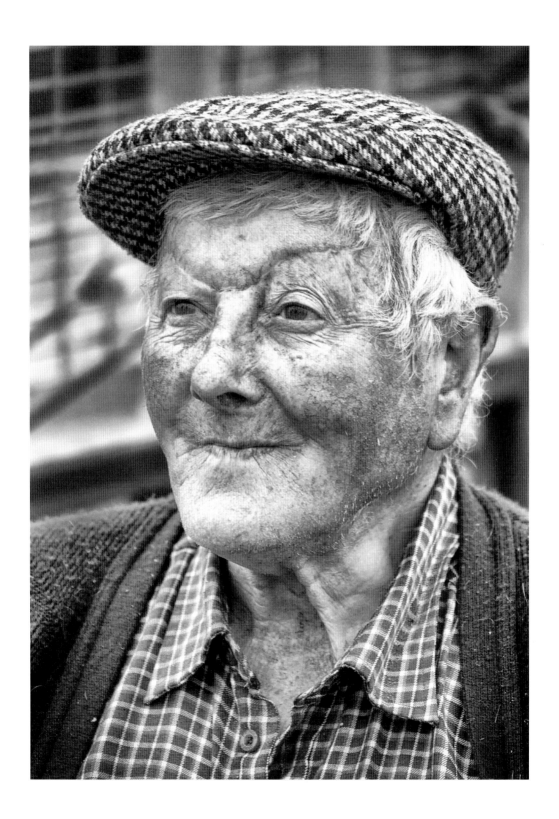

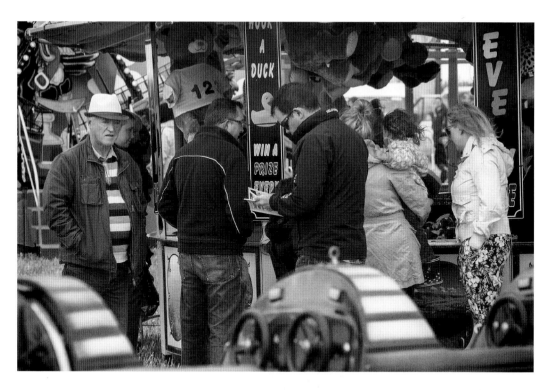

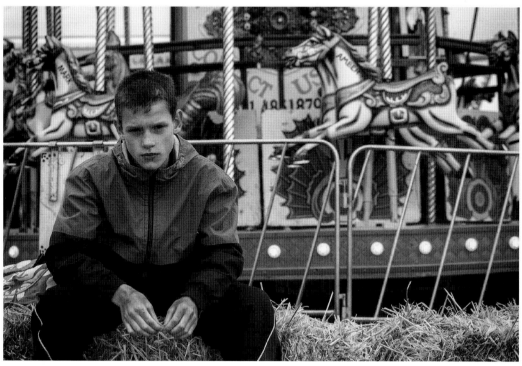

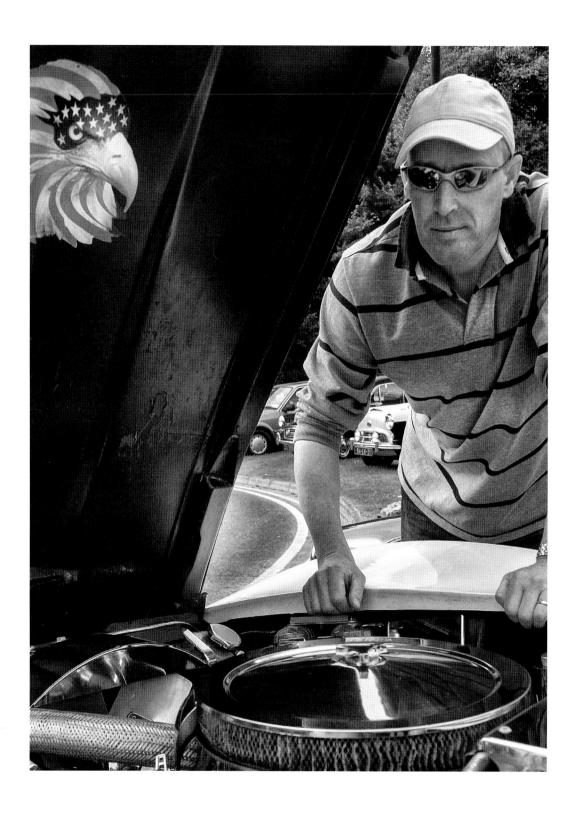

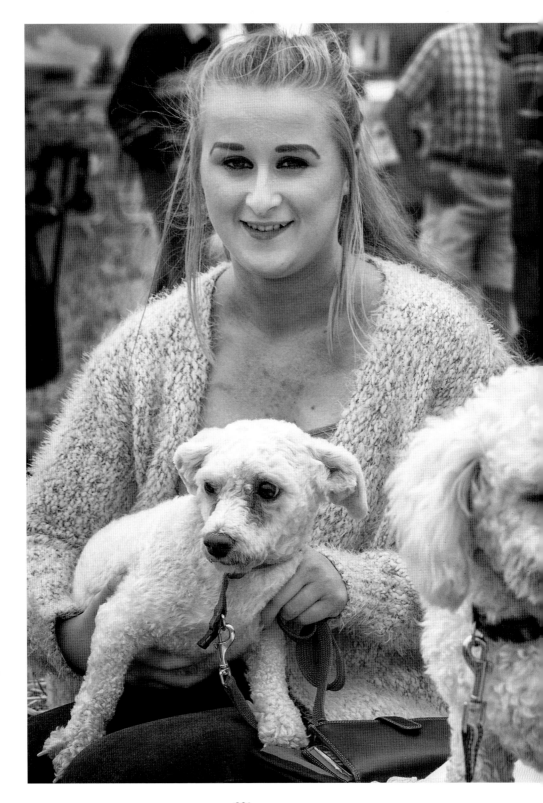

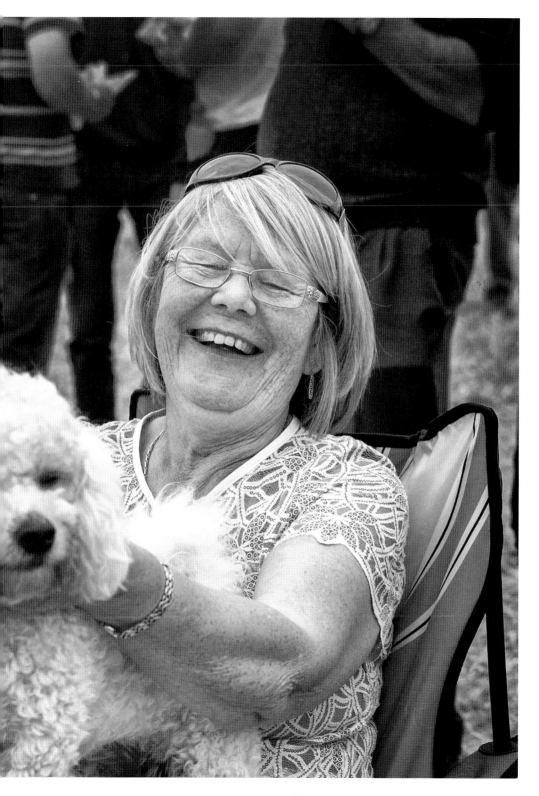

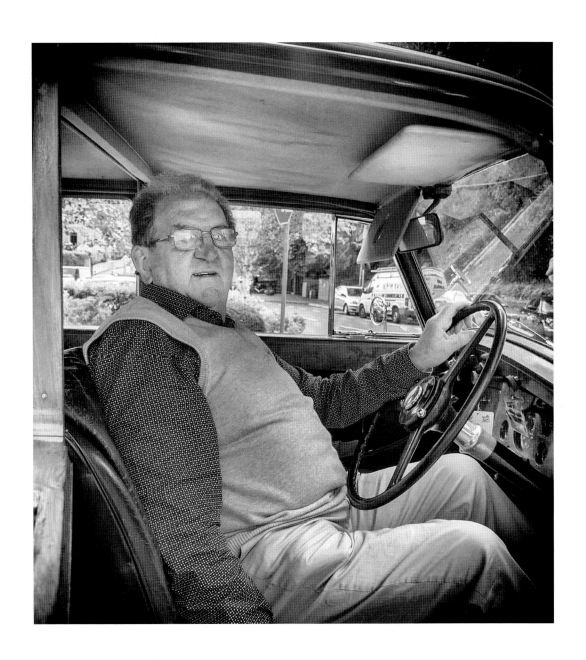

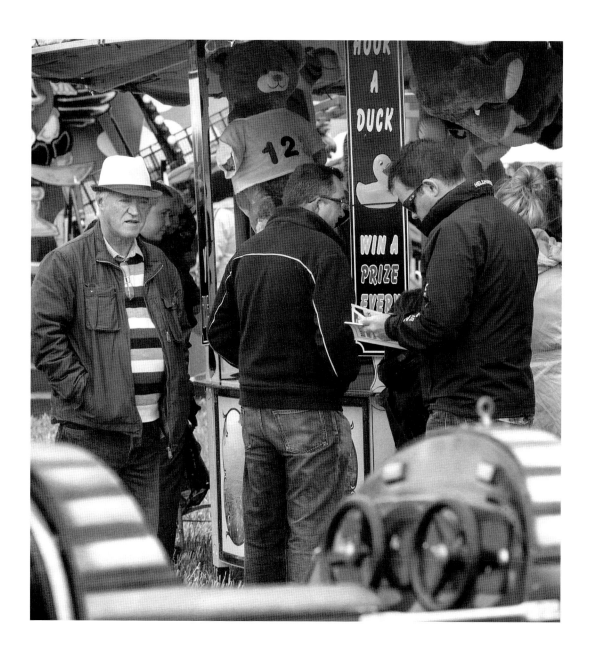

The Music

It's fair to say that one of the defining indicators of our 'Irishness' is our traditional music and songs. The importance of the handing on of the old tunes from generation to generation is immeasurable and, if the vast numbers of young people attending the Fleadh Cheoils in recent years are anything to go by, the tradition is in safe hands.

These Fleadh Cheoils are competitions run by the governing body of traditional Irish music, Comhaltas Ceoltóirí Éireann. Each year there are county and provincial competitions, which lead – for the victors – to the All-Ireland Fleadh. The competitions are divided into different age categories from Under 12 to Senior (Over 18).

Irish traditional music has survived despite significant competition from cinema, radio and mass media for many years. It did suffer a drop in popularity from the end of the Second World War to the late 1950s, but the emergence of ballad groups like the Clancy Brothers and traditional pipers like Séamus Ennis helped sow the seeds that led to its revival in the early 1960s.

Comhaltas Ceoltóirí Éireann has played a pivotal role in the resurgence of interest in learning to play traditional instruments, not just in Ireland but worldwide, and I am delighted to have the opportunity to document our wealth of young talent in this book.

The bulk of the images were taken in 2016 at the Fleadh Cheoil na Mumhan (the Munster Fleadh) in Listowel, Co. Kerry and at Fleadh Cheoil na hÉireann (the All-Ireland Fleadh) in Ennis, Co. Clare. Both fleadhs brought huge numbers of performers and spectators to the venues, and the enthusiasm and hunger for knowledge was very evident, even to an uninitiated spectator like me.

I will certainly be returning to these events again, as they are hugely uplifting and enjoyable affairs.

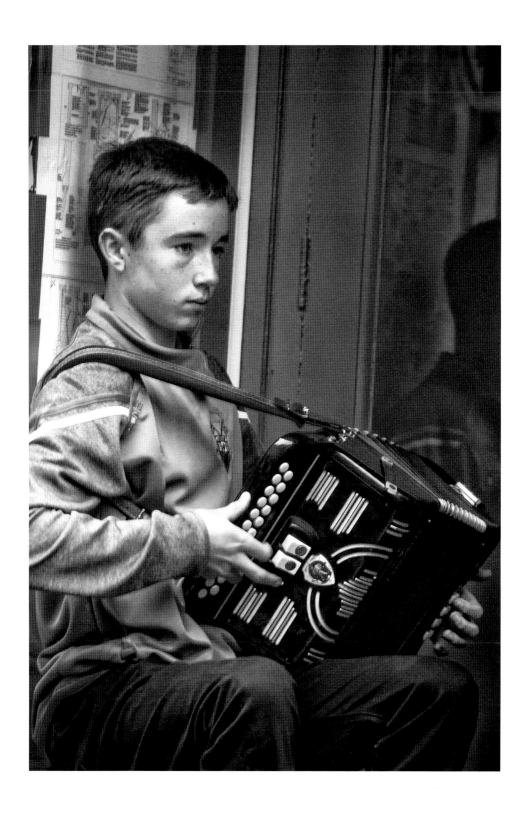

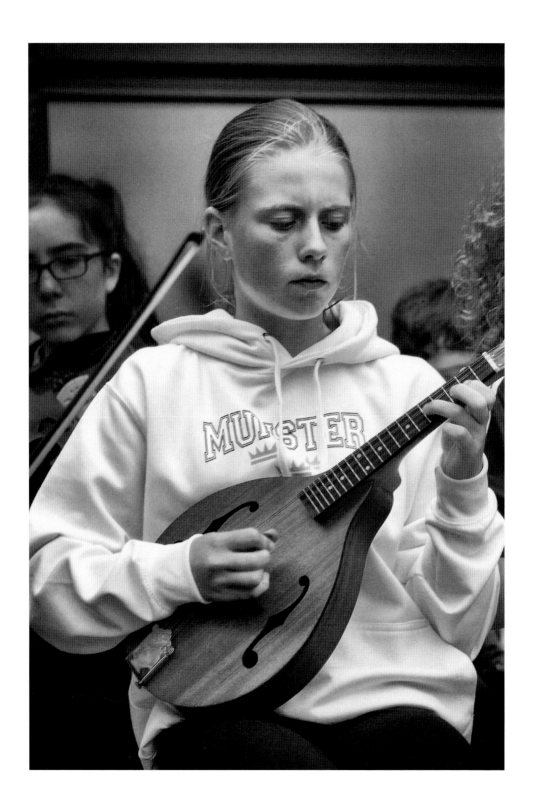

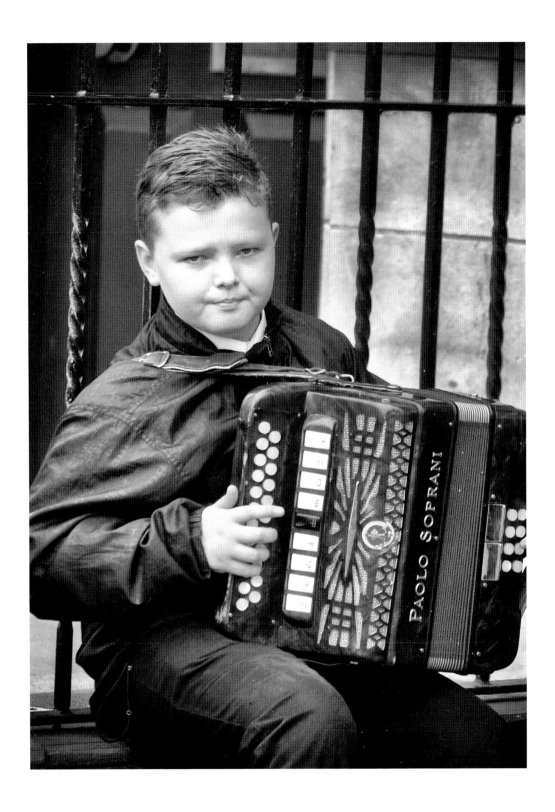

233

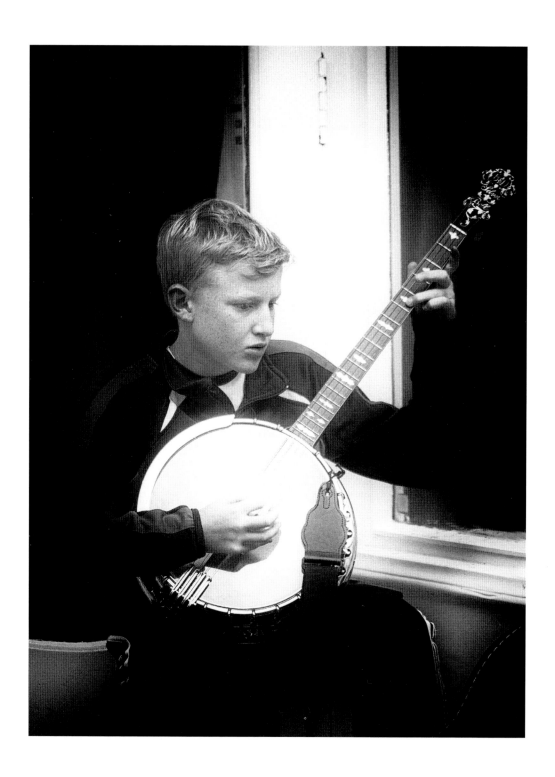

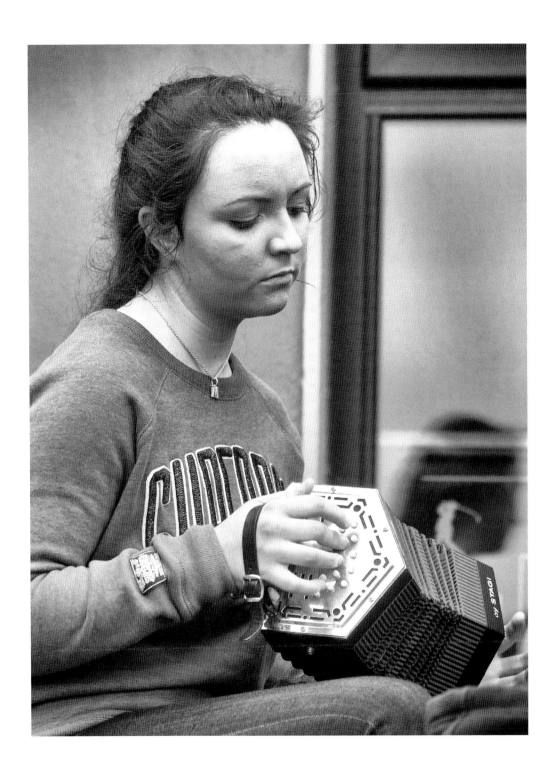

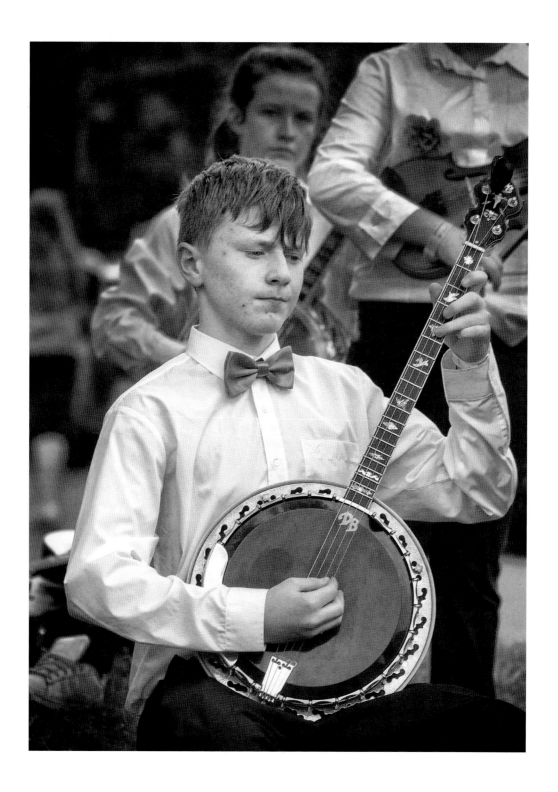

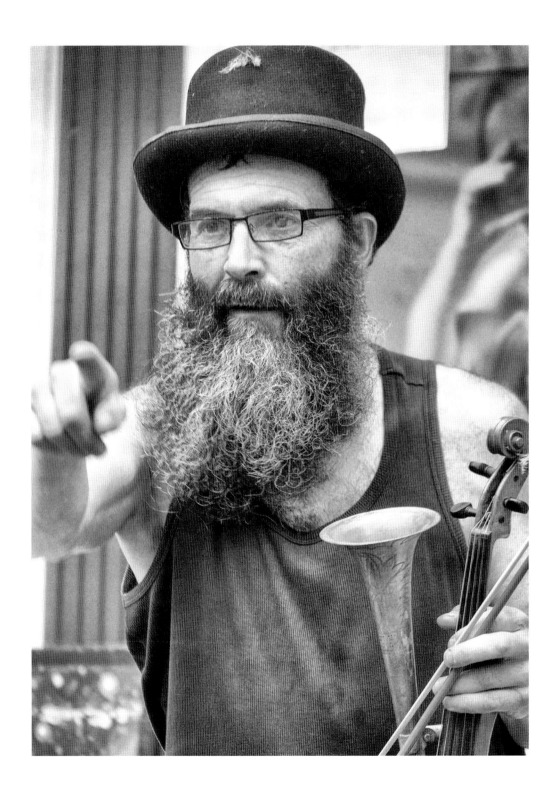

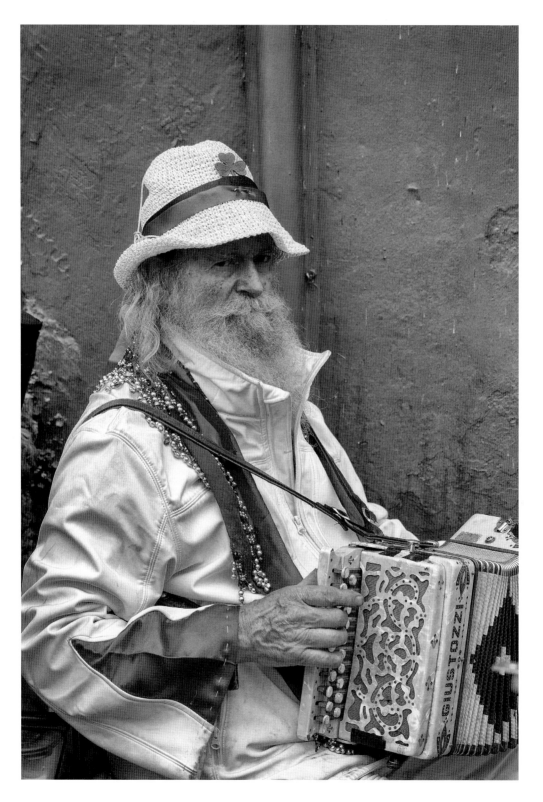

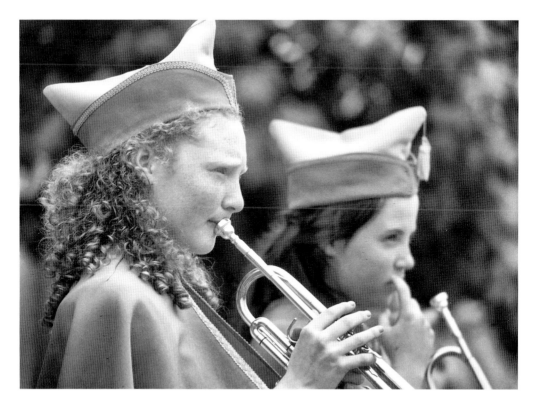

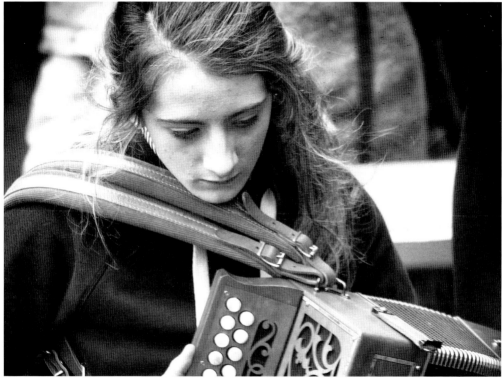

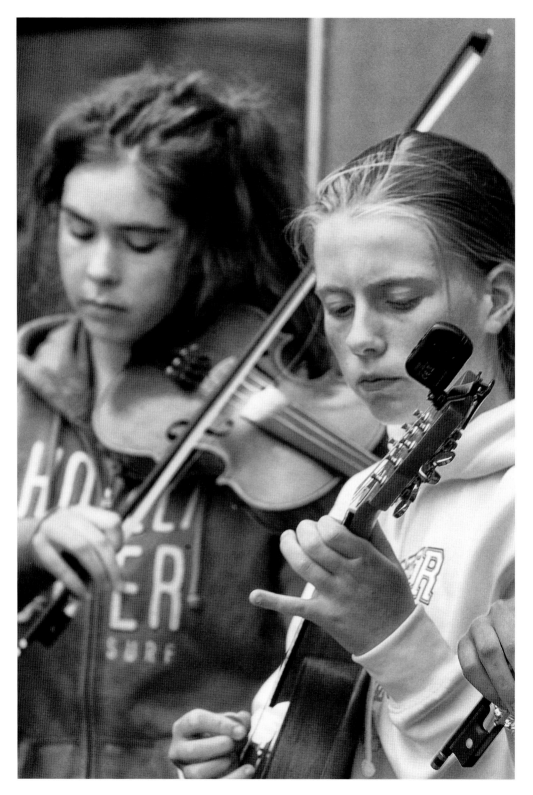

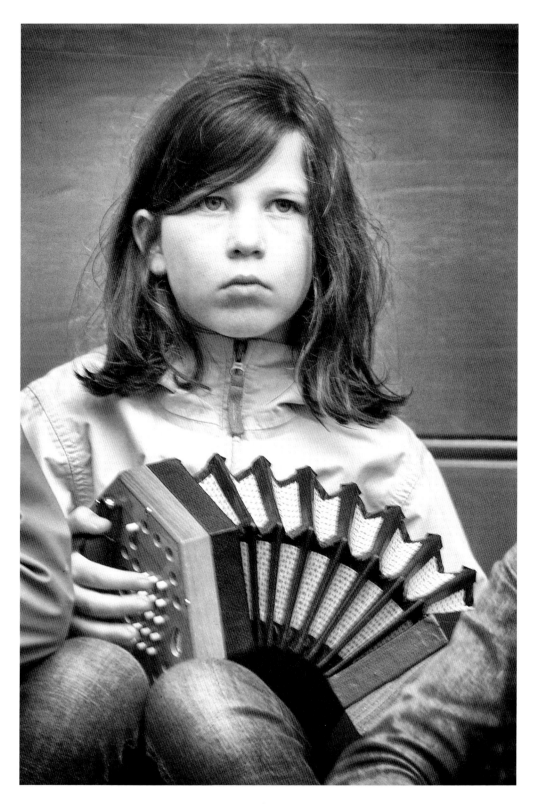

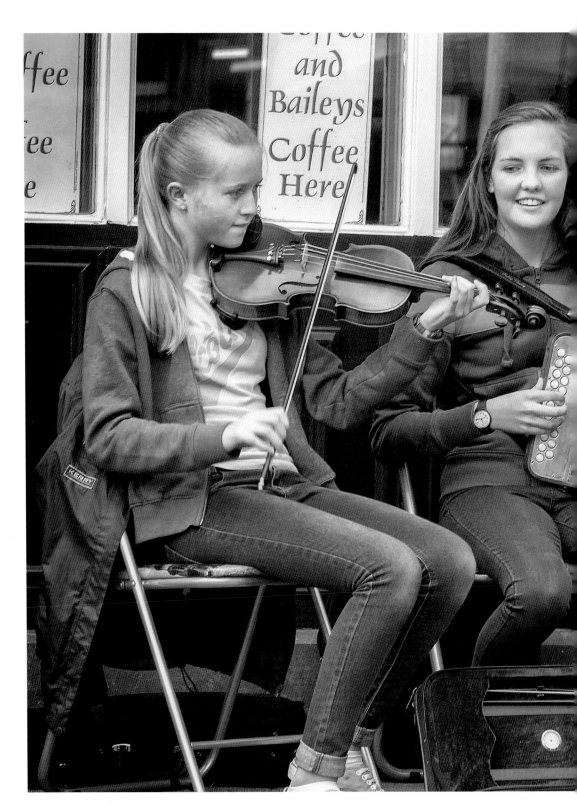

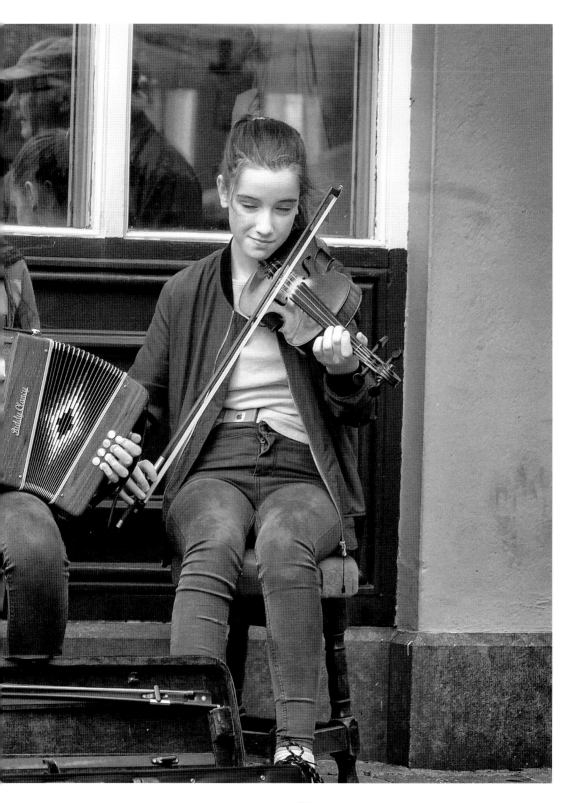

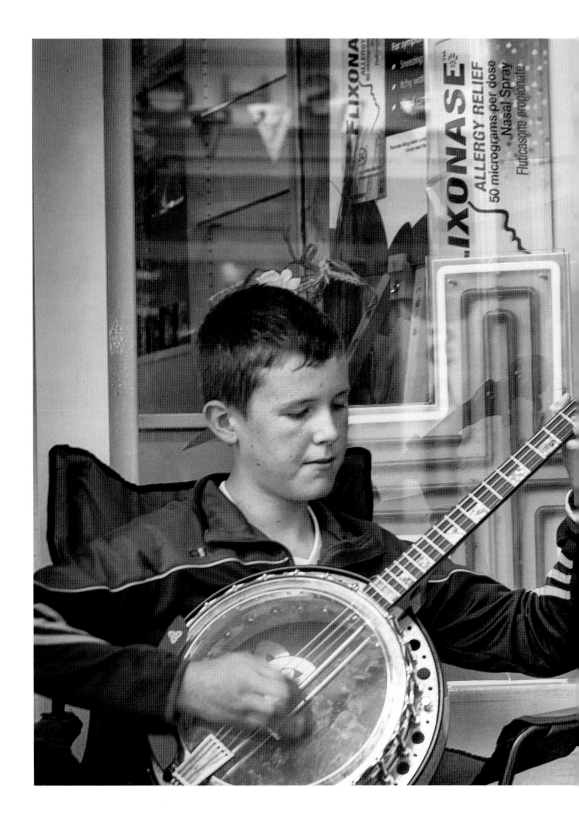

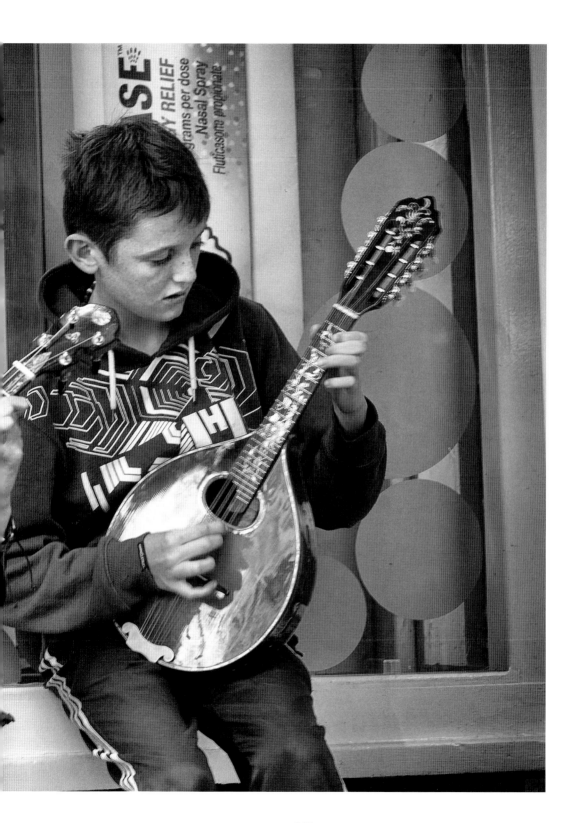

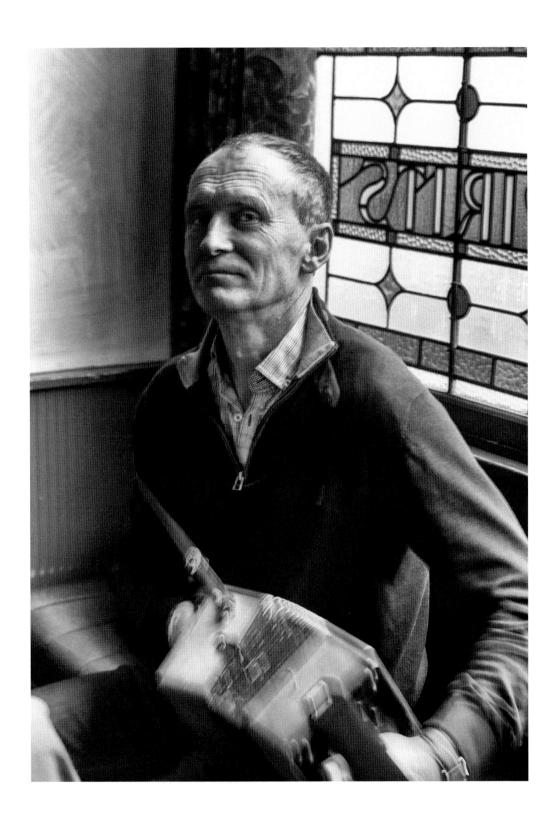

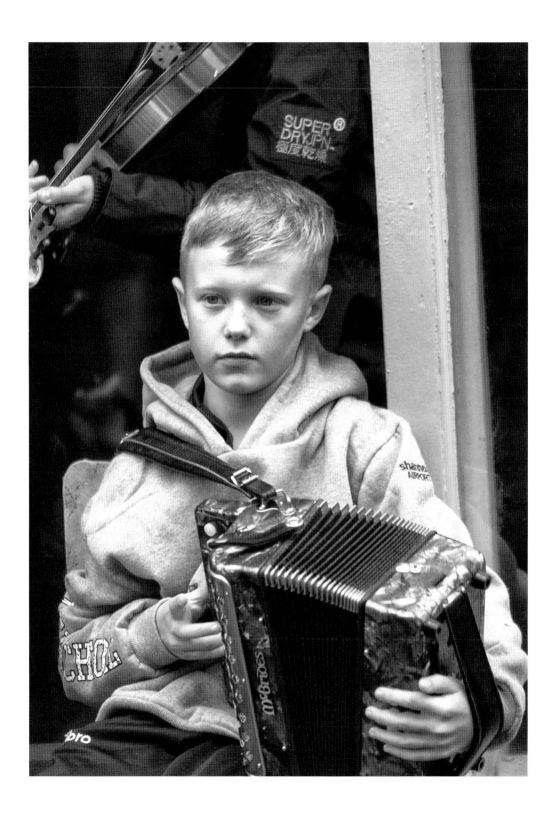

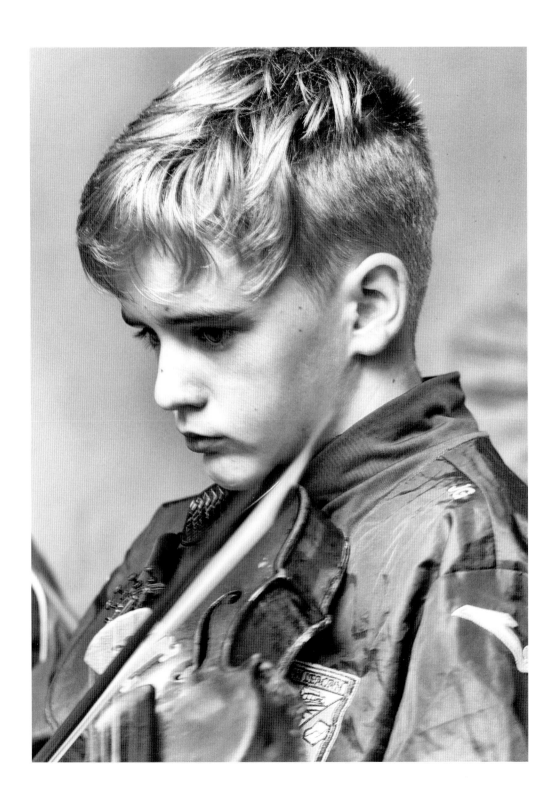

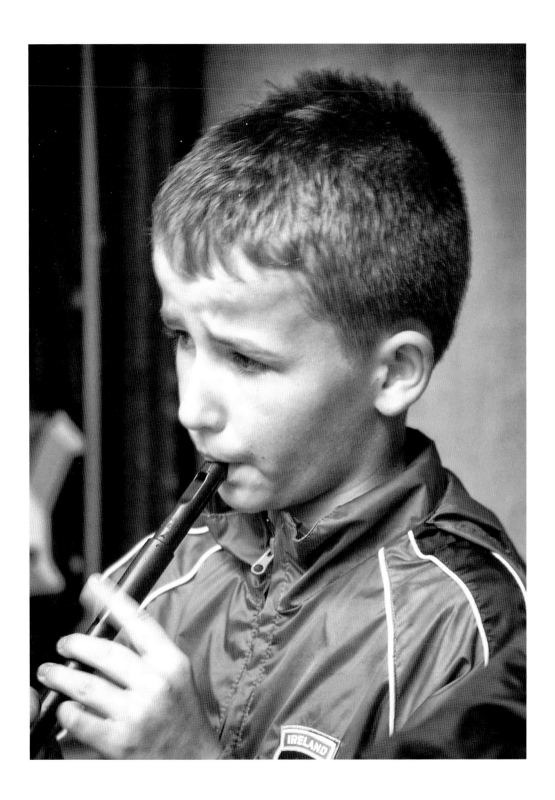

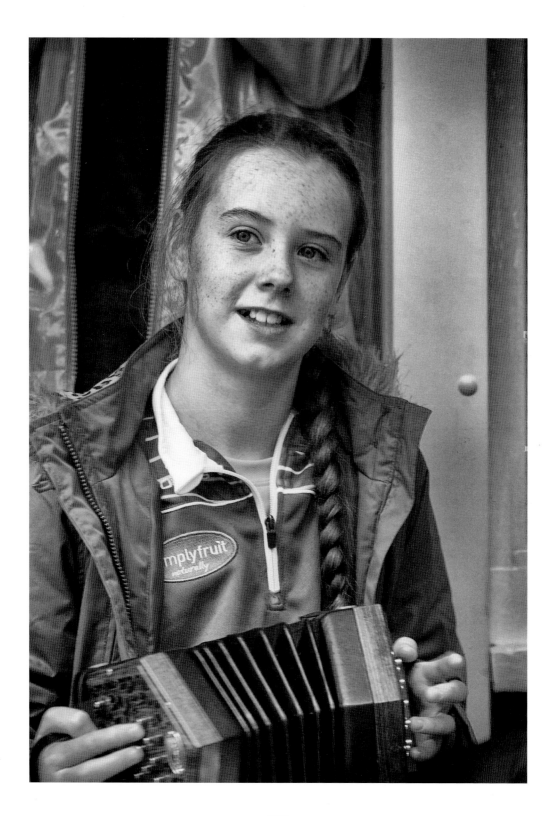

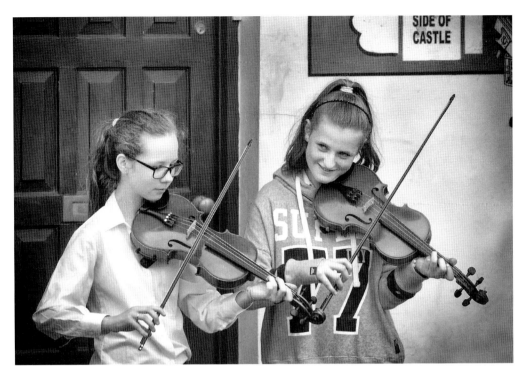

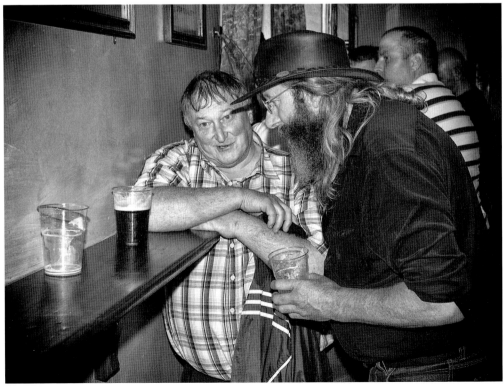

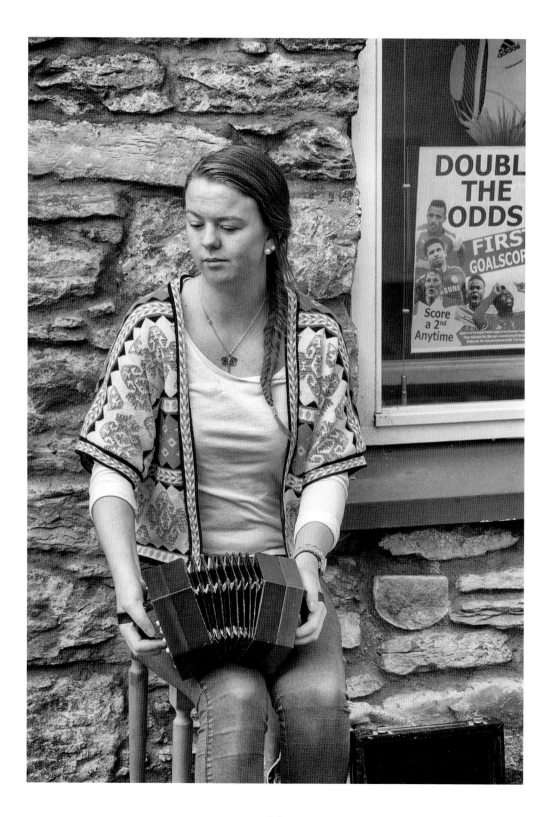

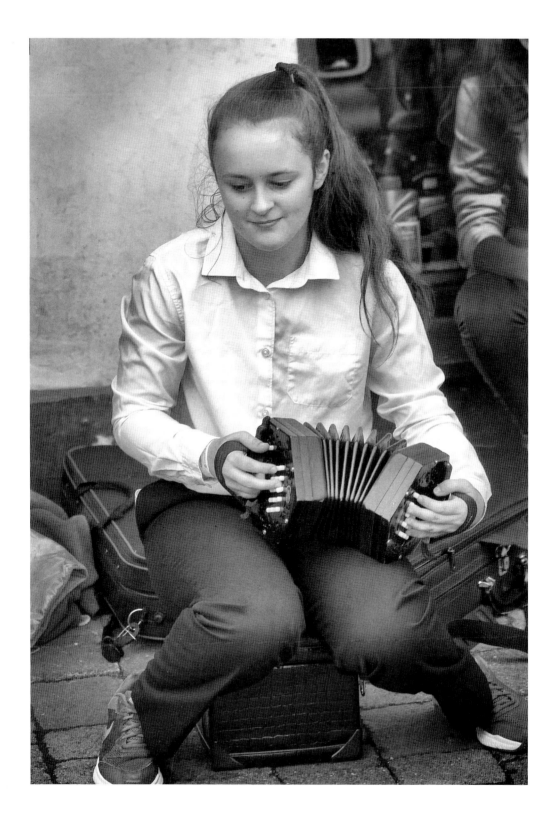

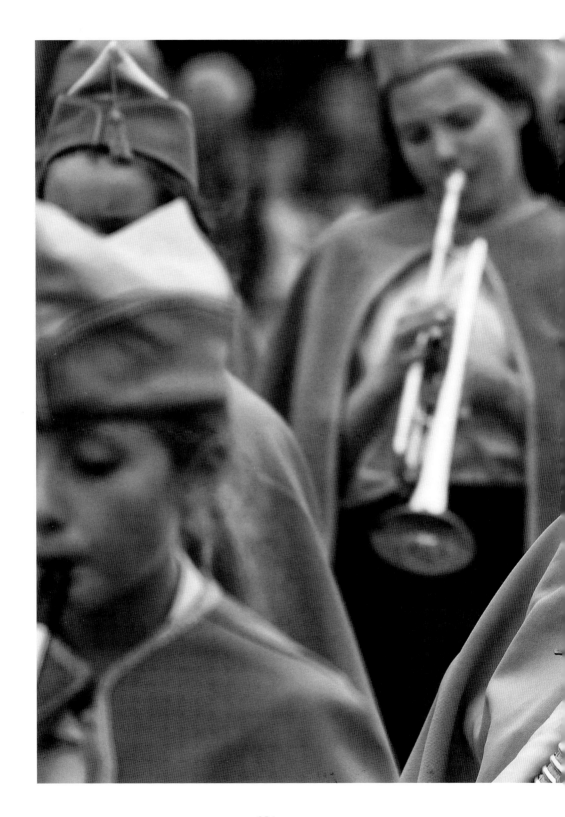

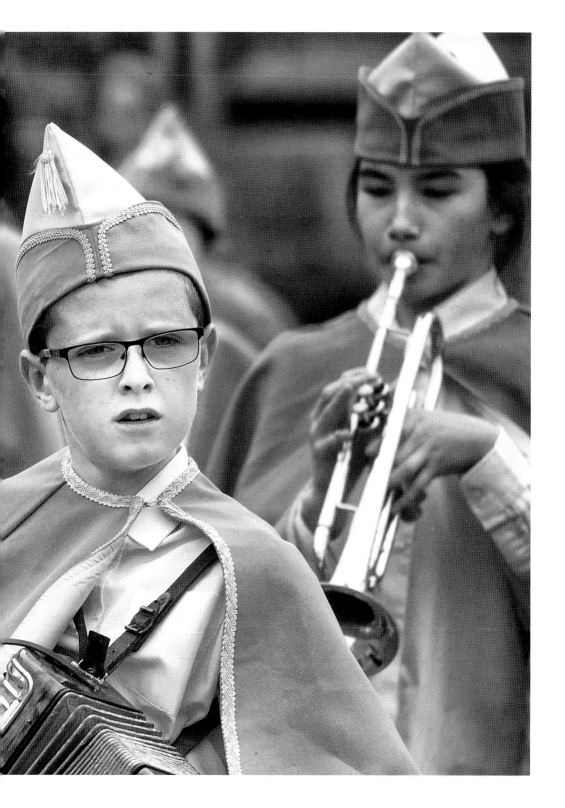

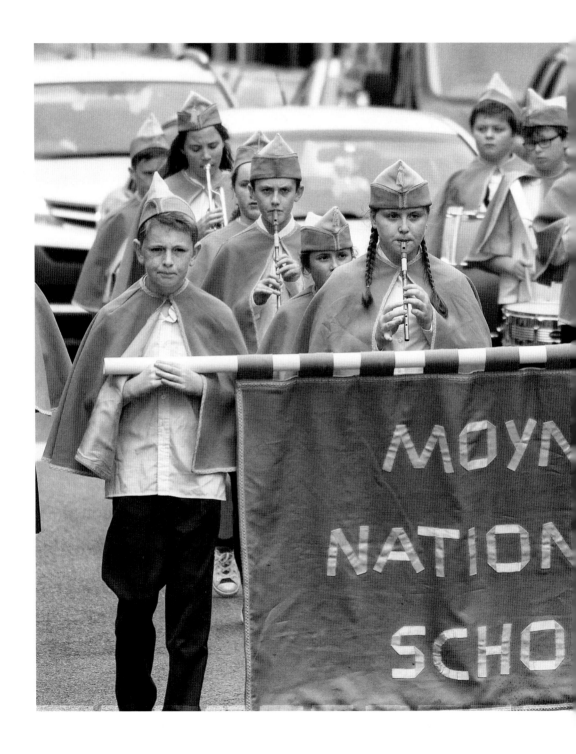

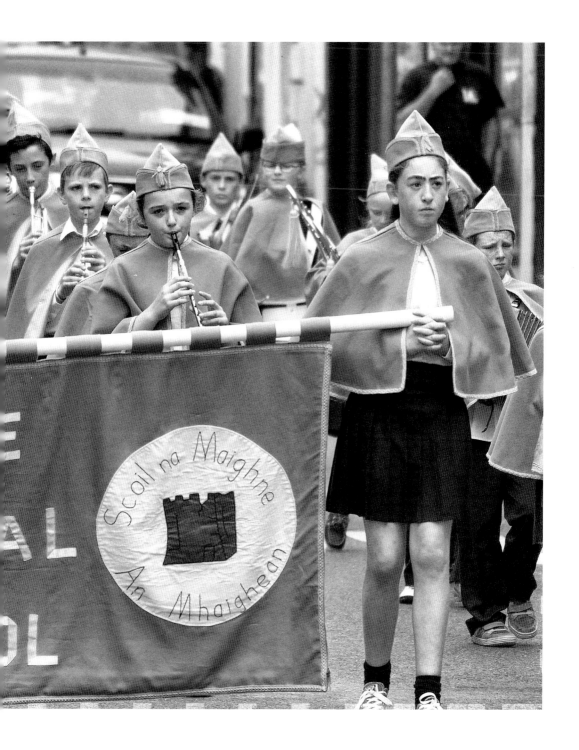

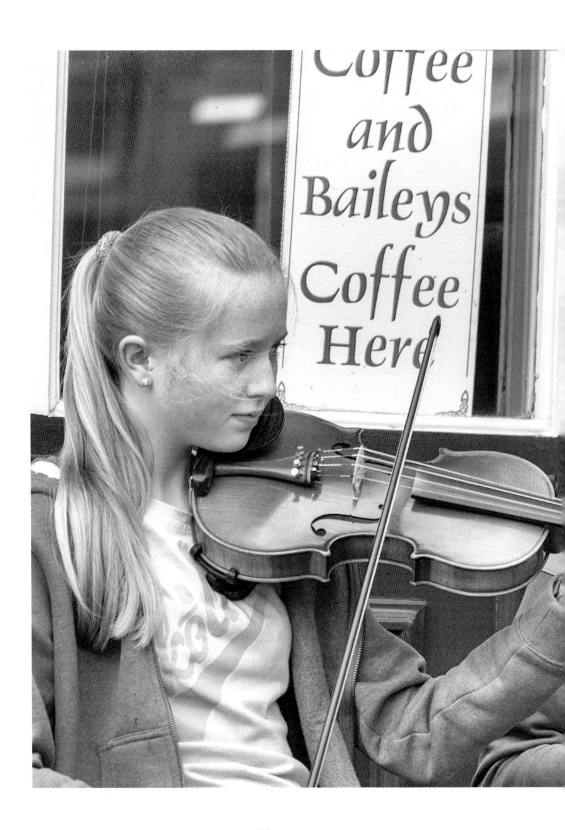

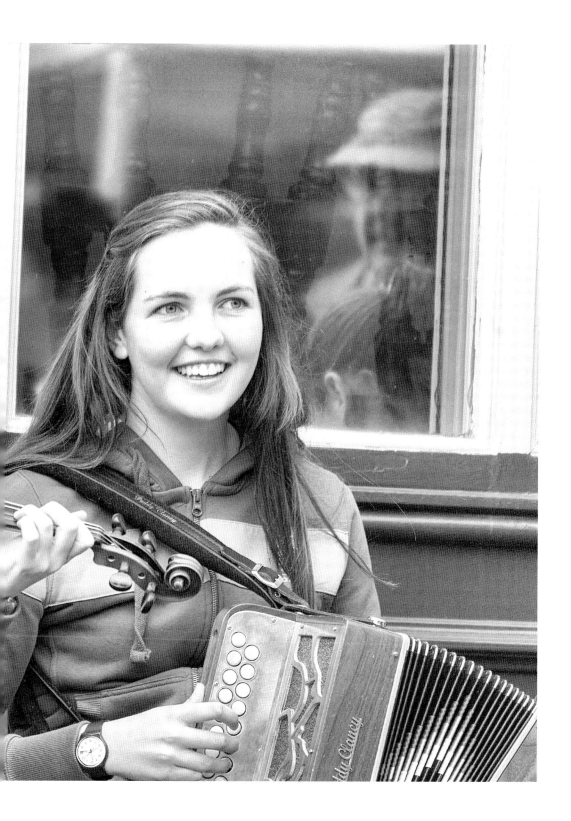

The Irish in Conversation

We Irish have a unique ability to meet a complete stranger and, within a few minutes, know the other person's life history and family tree, as well as having identified at least four common acquaintances. It's no wonder that for a small nation on the edge of Europe, we have produced some of the world's greatest writers, poets, talkers and storytellers.

These impromptu conversations can take place over a cup of tea or a pint of Guinness. They can happen outside the local parish church following Mass on Sunday morning, on the sideline at a hurling match, around the fireside on a winter's night, or, as in these pictures, following a chance encounter at the myriad of festivals, fairs and gatherings that take place throughout rural Ireland virtually every week.

Friends typically form into small groups of two or three, where they then swap stories, debate the hot topics of the day and update each other on the local gossip since they last met. I've regularly heard a conversation begin with 'I can only stop for a minute, I'm in a fierce hurry' and then return an hour later to see the same two still at it, having long forgotten what it was that so urgently needed to be done elsewhere.

How often have we heard a man say that his wife could 'talk for Ireland'? Yet the pictures in this chapter show that men are no slouches either when it comes to gossip.

I suppose it's part of what makes us uniquely Irish and, as I went through my photographic collection to choose the images for this book, it became obvious early on that 'The Irish in Conversation' deserved a special chapter all to itself.

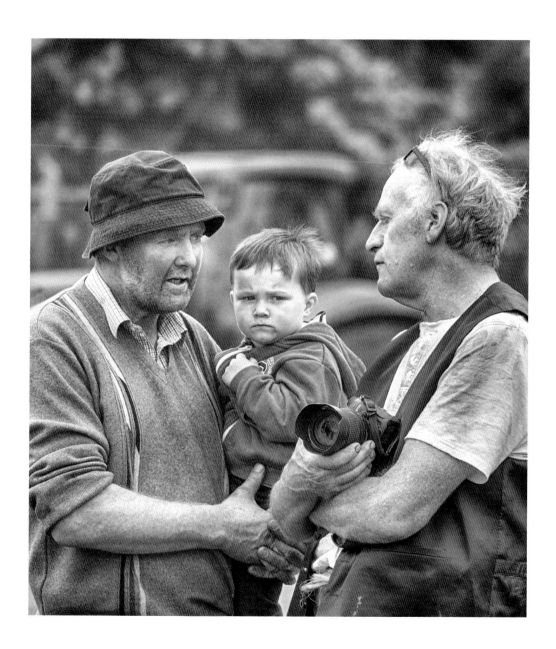

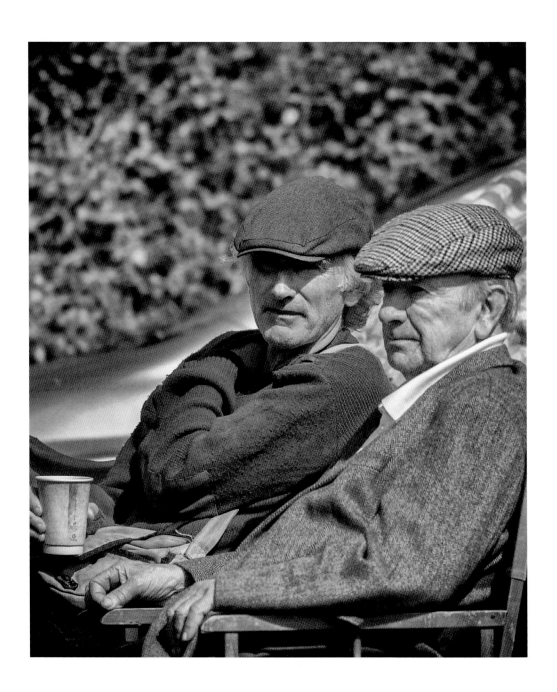

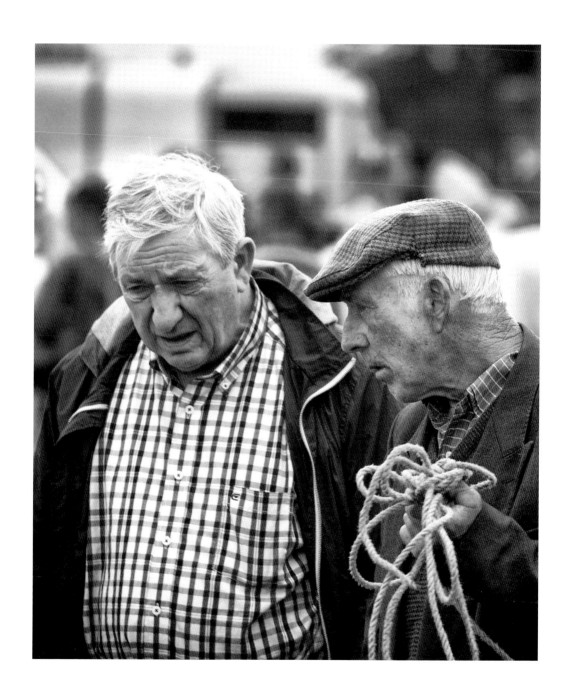

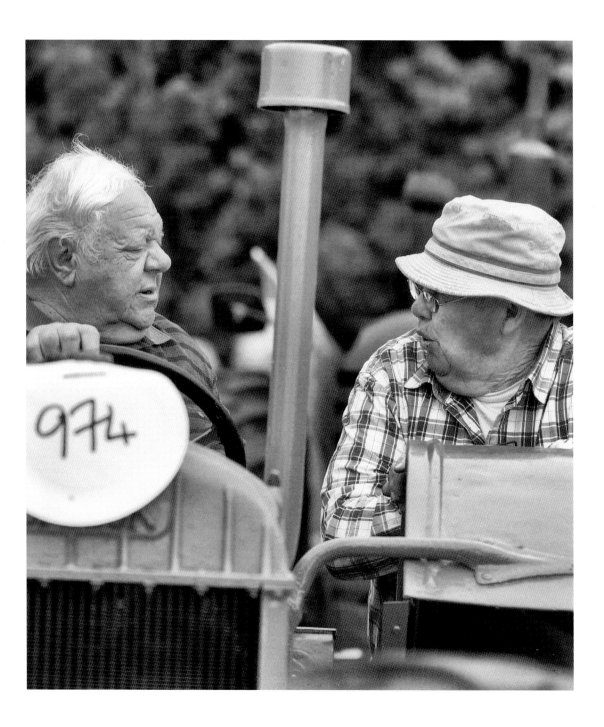

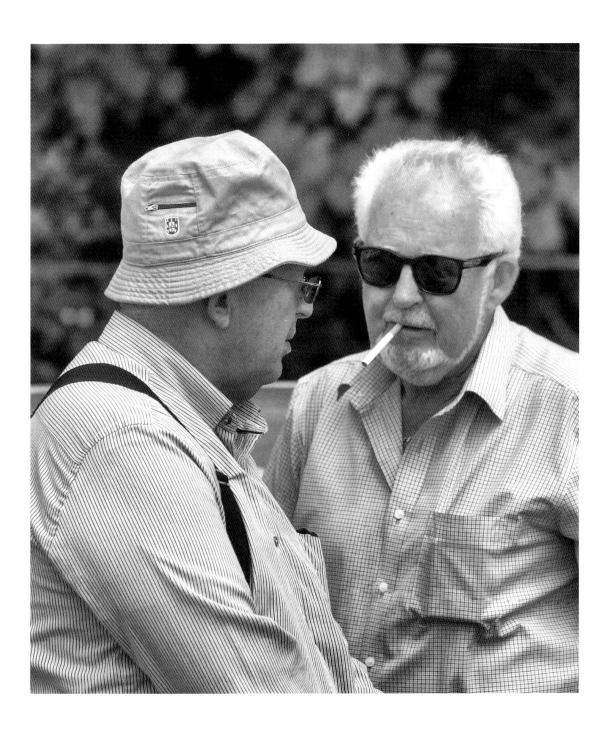

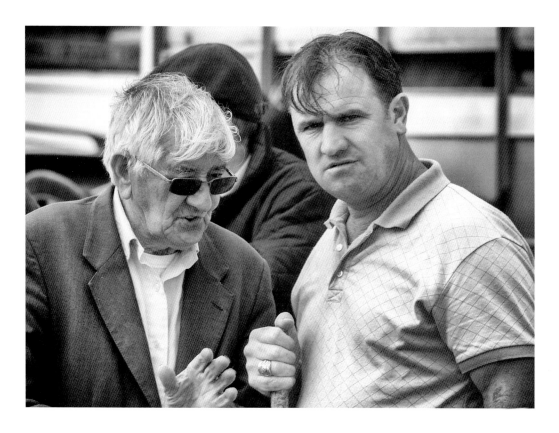

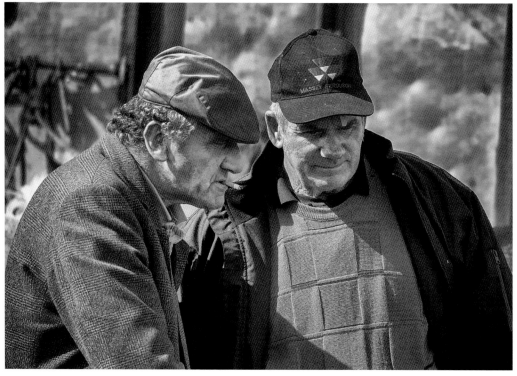

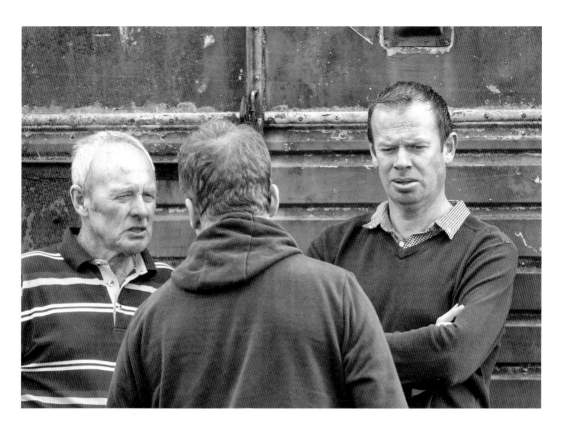

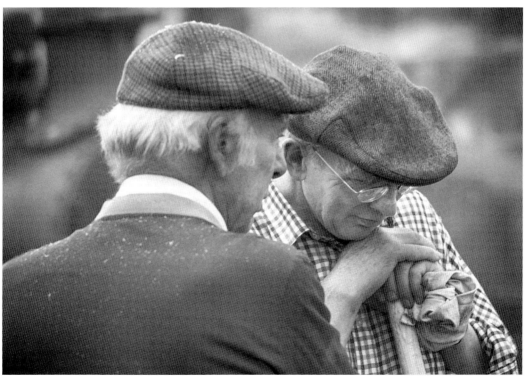

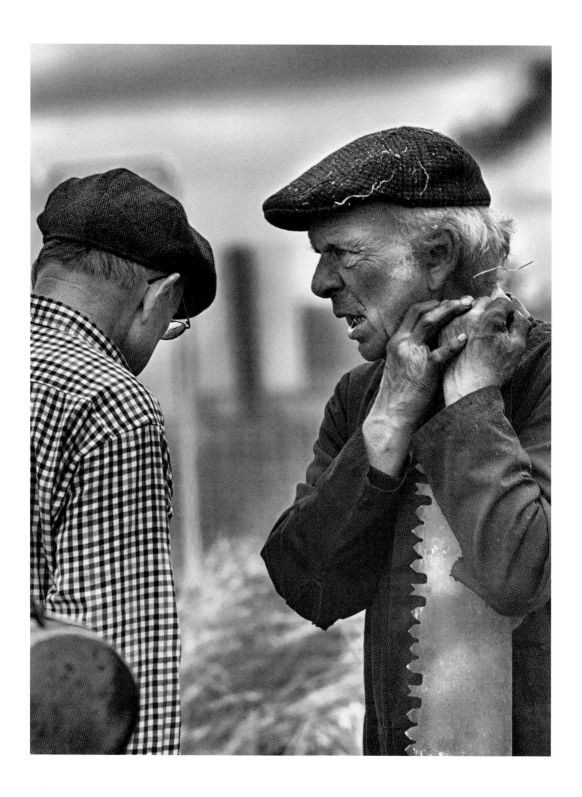

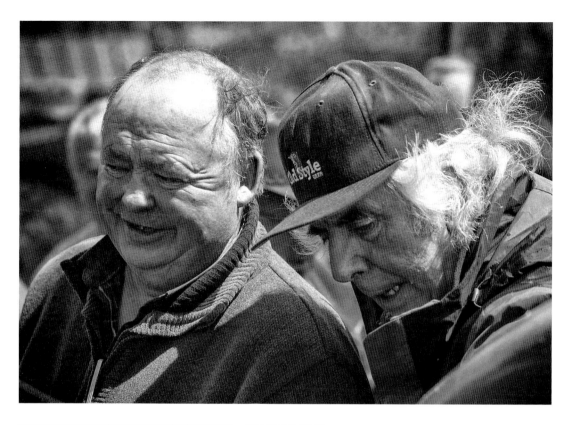

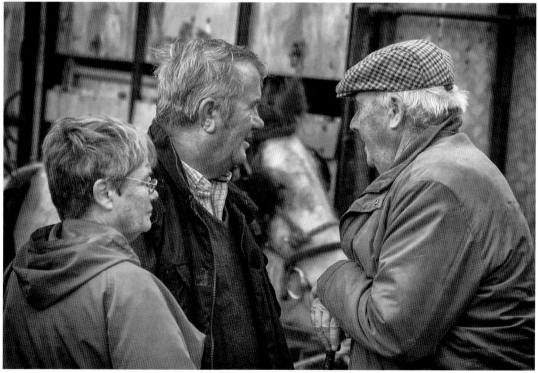

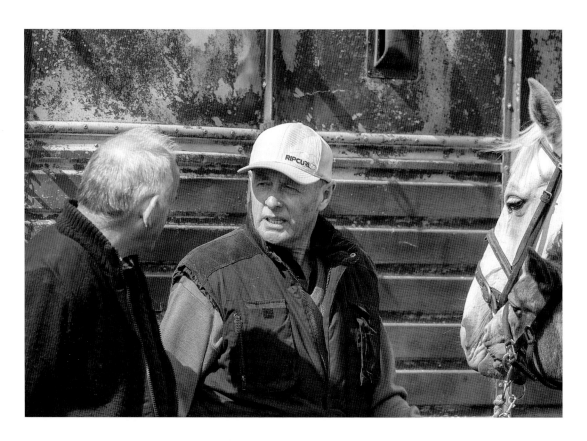

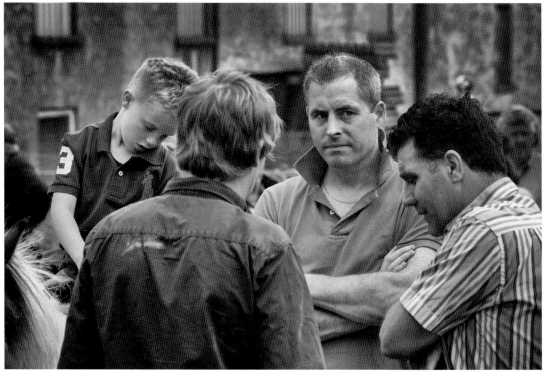

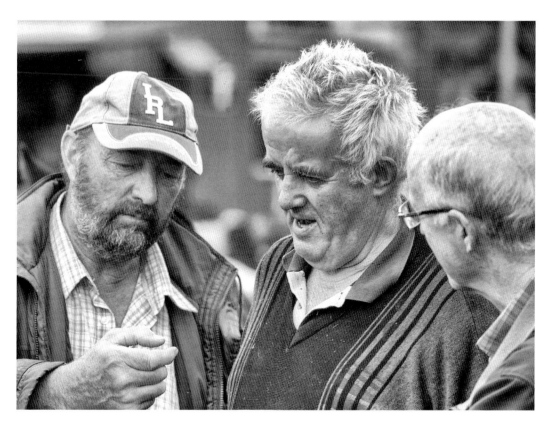

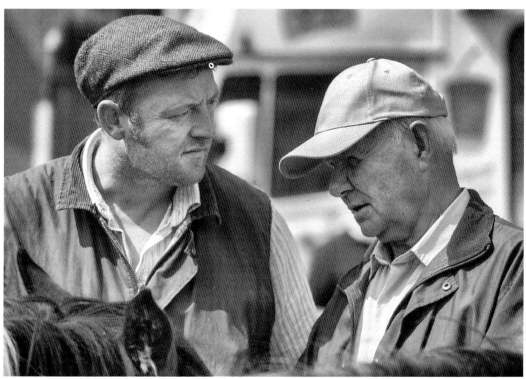

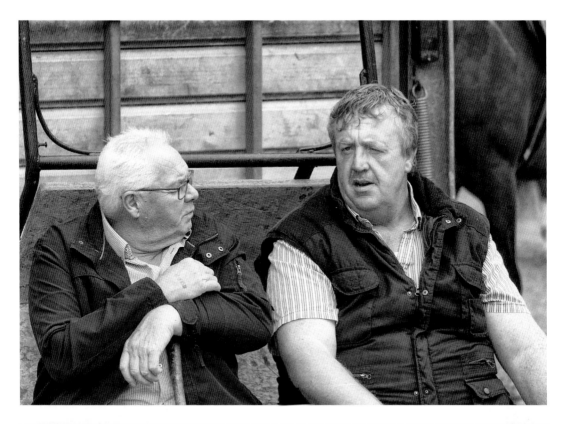

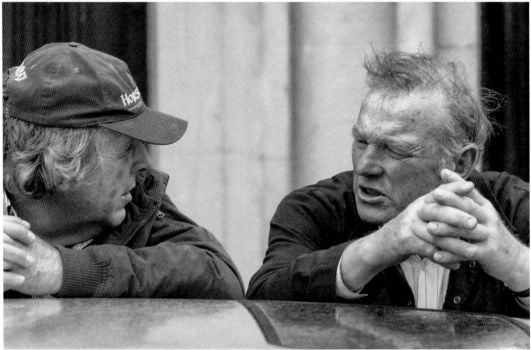

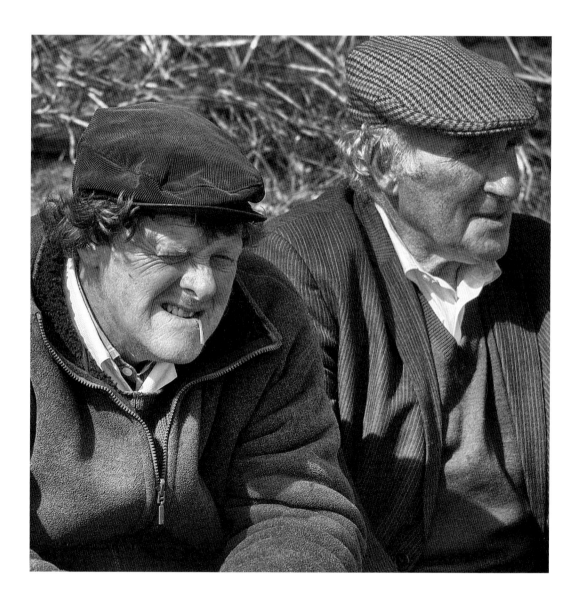

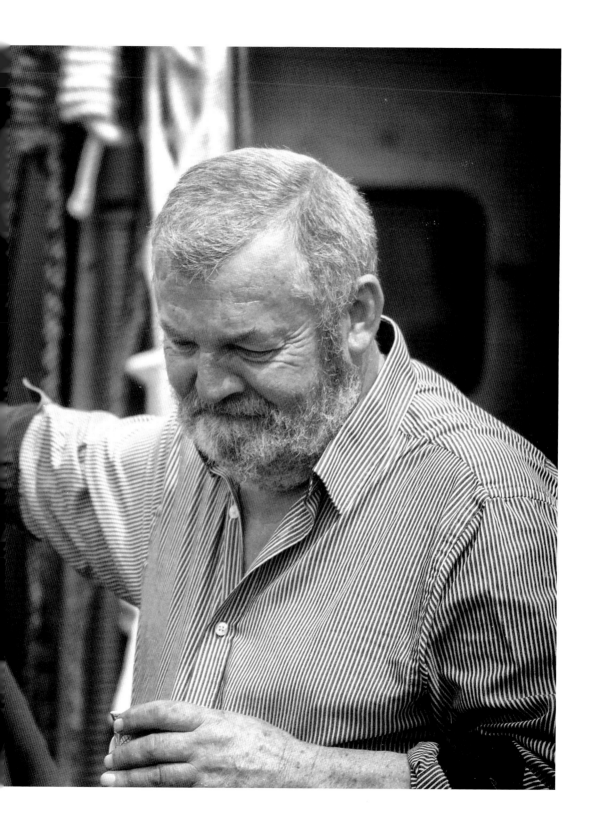

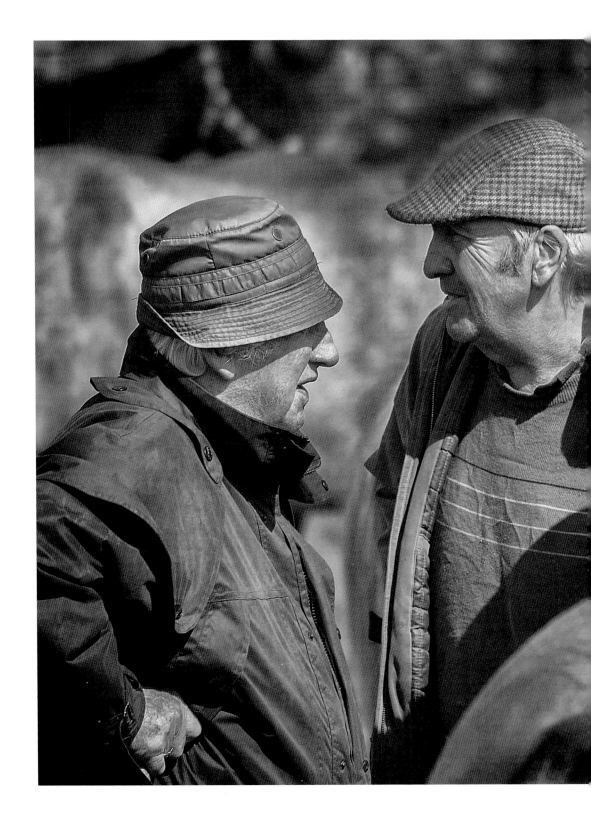

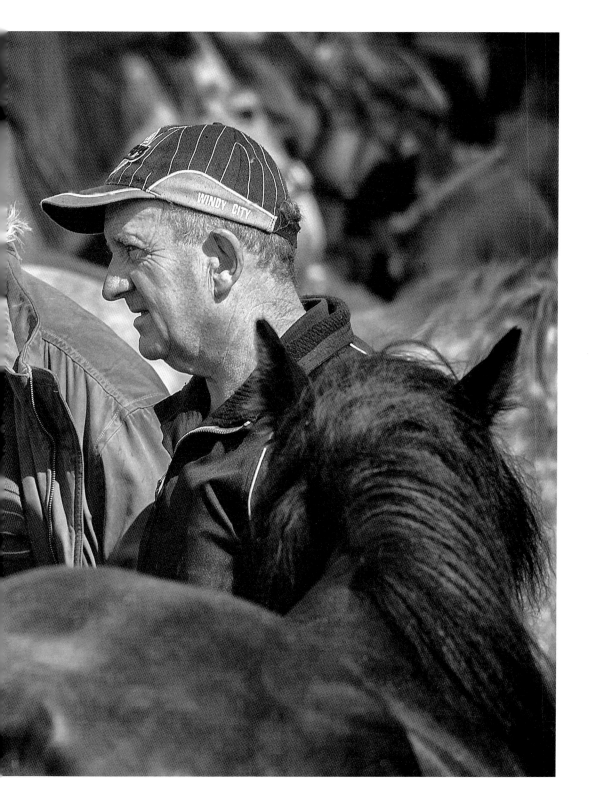

The Wren Boys

The story surrounding the capture of St Stephen (the first Christian martyr) is thought by many to form the basis for one of the most enduring traditions in rural Ireland – hunting the wren. According to the story, St Stephen was hiding in a bush in an effort to evade soldiers sent to capture him, when a wren landed nearby and began chirping loudly, thus drawing the soldiers to Stephen's hiding place.

The hunt, therefore, is said to be a form of retribution for the wren's betrayal of the saint and falls annually on the feast day of St Stephen, 26 December. So if you are travelling around rural Ireland on this day and are accosted by a group of young men and women decked out in colourful fancy dress and playing traditional instruments, sit back and enjoy the spectacle, as these are the 'Wren Boys'. One of the group will carry the wren bush, to which will be attached a small effigy of the bird. They will request a small donation towards the 'burial of the wren', which they have supposedly hunted earlier. This request will come in the form of a song, usually a variation on these lines:

The wren, the wren, the king of all birds
On Stephen's Day was caught in the furze.
Up with the kettle and down with the pot
Give us our answer and let us be off.
Knock at the knocker, ring at the bell
Give us a copper for singing so well.

Later in the day, the money collected is traditionally used to purchase drink, and in times past fighting often broke out between rival groups.

In the town of Carrigaline, Co. Cork – where these photos were taken – the Wren Boys festivities run in tandem with the Christmas outing of the South Union Hunt, a branch of the Irish Pony Club that has been in existence for over 150 years. The union draws members from a large area of south Co. Cork, and meets twice weekly during the hunting season that runs from November to 1 March.

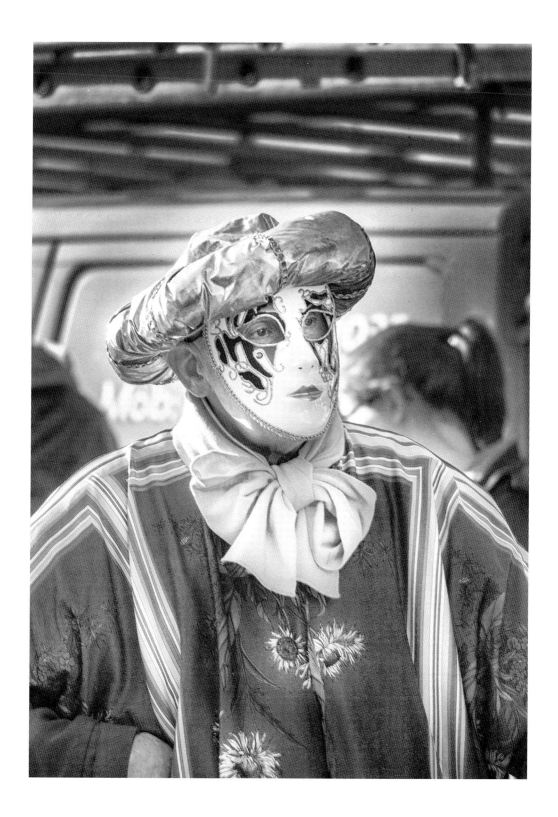

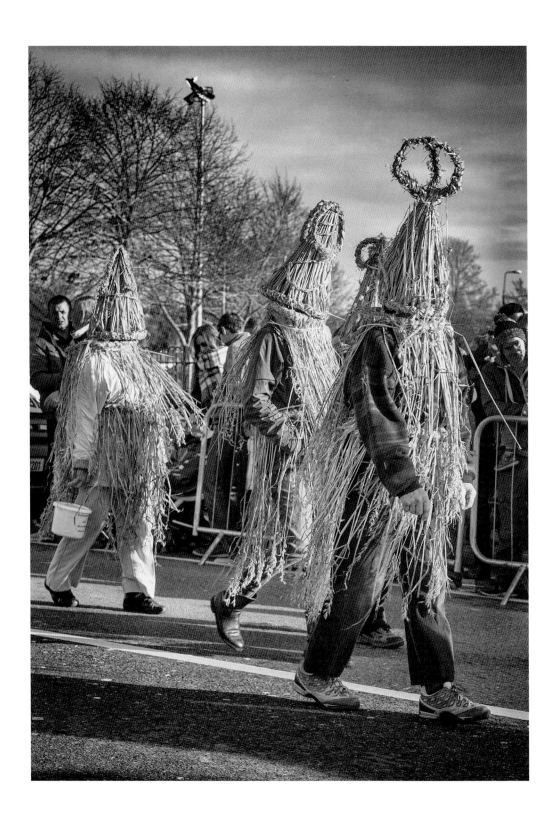

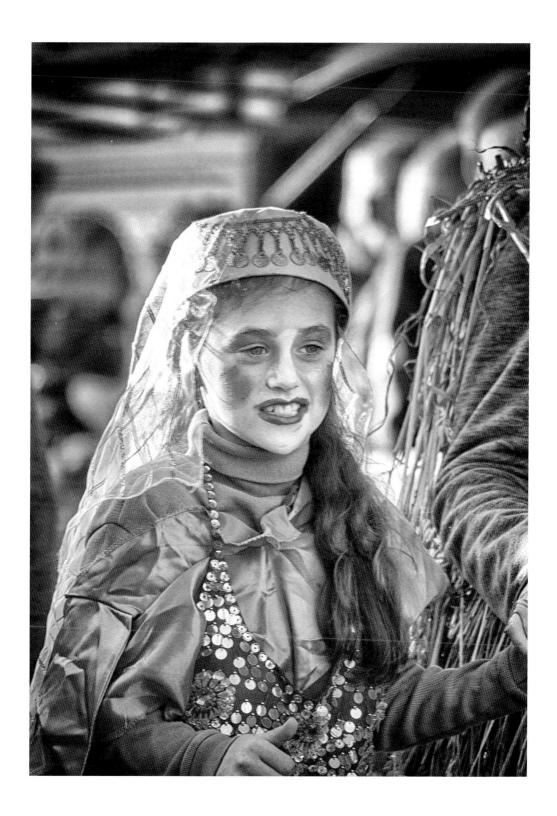

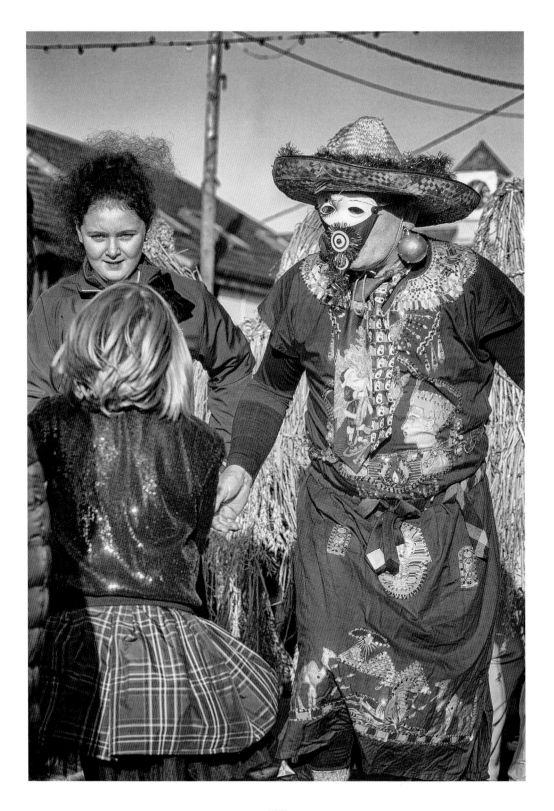

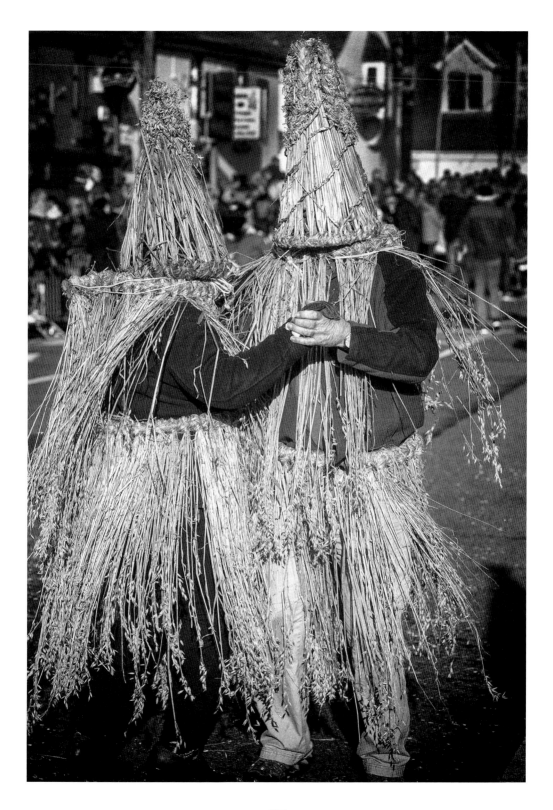

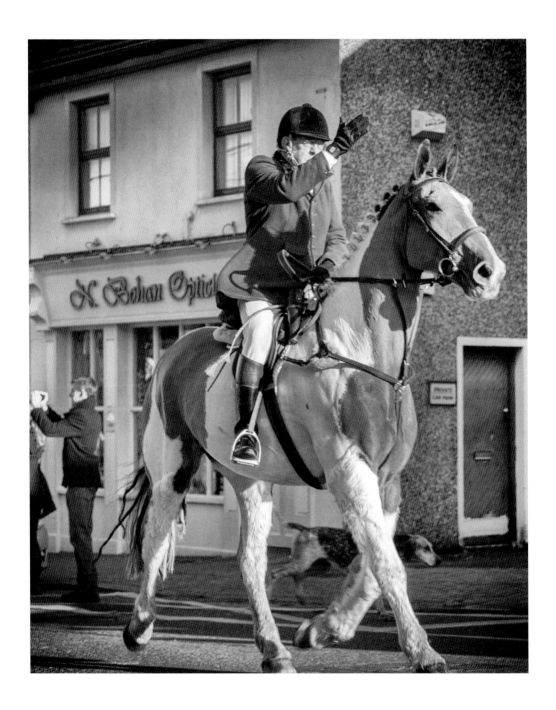

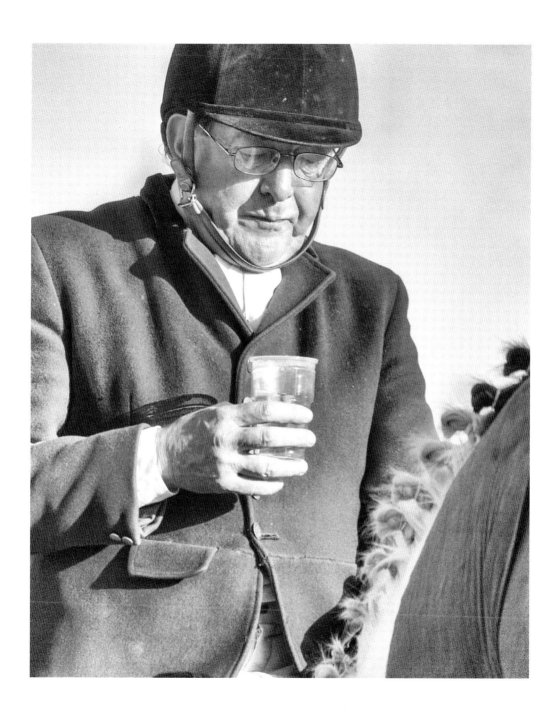

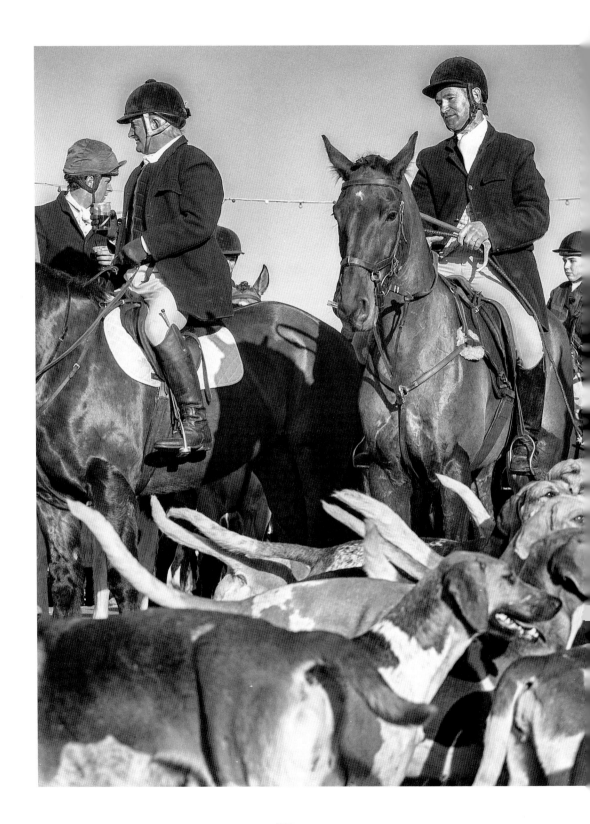

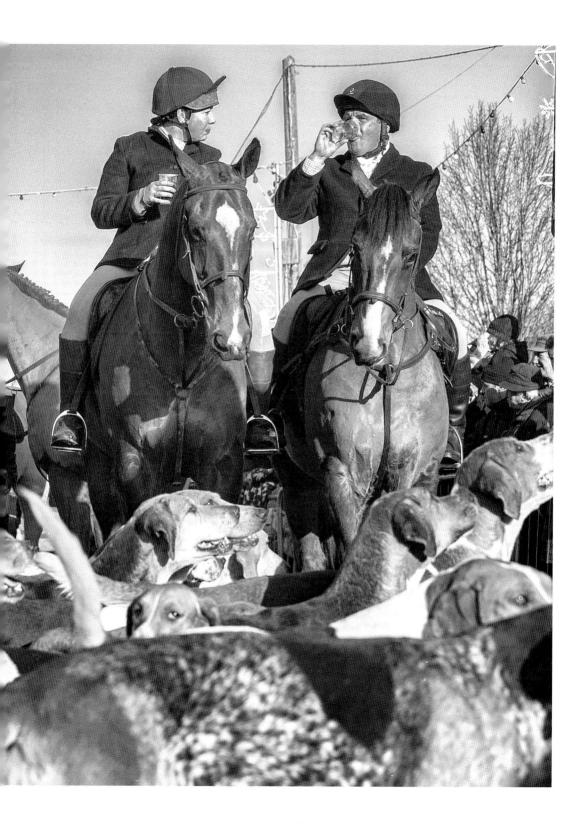